IMAGES
of America

OLD IRVING PARK

IRVING PARK HISTORICAL SOCIETY HOUSEWALK MAP

STARTING POINT
1 - 3850 N. TRIPP AVE.
 MT. OLIVE LUTHERAN CHURCH

HOMES
2 - 3733 N. LOWELL AVE.
3 - 3827 N. KENNETH AVE.
4 - 3905 N. KENNETH AVE.
6 - 4050 N. KILDARE AVE.
8 - 4132 N. KEELER AVE.
9 - 4165 W. BERTEAU AVE.
10 - 4055 N. KEYSTONE AVE.

GARDENS
A - 3740 N. KEELER AVE.
B - 3801 N. KEELER AVE.
C - 4001 N. TRIPP AVE.
D - 4165 W. BERTEAU AVE.
E - 4226 N. KEDVALE AVE.
F - 4122 N. KEDVALE AVE.
G - 4122 N. KEYSTONE AVE.

FOOD & REST STOPS
5 - 3801 N. KEELER AVE.
 IRVING PARK METHODIST CHURCH
7 - 4047 N. KEELER AVE.
 IRVING PARK PRESBYTERIAN CHURCH

GARAGE & YARD SALES
SEE PAGE 24 FOR LISTING

The neighborhood boundaries of Old Irving Park are, roughly, the following: Montrose Avenue to the north, Addison Street to the south, Pulaski Road to the east, and the Milwaukee Road railroad (Kolmar Avenue) on the west. This map of Old Irving Park was prepared by the Irving Park Historical Society for its 1994 housewalk. (Courtesy Irving Park Historical Society.)

ON THE COVER: Hundreds of thousands of young men were drafted into the US military during World War I. Here, drafted men board the train at the Irving Park train station in 1917. They have been processed and are wearing their tags as they prepare to leave for military service. A large crowd of family and friends—including men, women, and children—stand on the elevated train station, saying their blessings and farewells to their loved ones. The men are hanging out of the train windows, shaking hands and waving goodbye. (Courtesy Chicago History Museum.)

IMAGES
of America

OLD IRVING PARK

Wilfredo Cruz

with the assistance of the Irving Park Historical Society

ARCADIA
PUBLISHING

Published by Arcadia Publishing
Charleston, South Carolina

Library of Congress Control Number: 2013933848

For all general information, please contact Arcadia Publishing:
Telephone 843-853-2070
Fax 843-853-0044
E-mail sales@arcadiapublishing.com
For customer service and orders:
Toll-Free 1-888-313-2665

Visit us on the Internet at www.arcadiapublishing.com

This book is dedicated to my wife, Irma, and to our children, Wilfredo Cruz Jr., Daniel Cesar, and Alexandra Irma. I appreciate the inspiration and assistance you provided me during the time I worked on this project.

Also to my godmother, Theresa Hernandez,
a world traveler who loved Chicago

CONTENTS

ACKNOWLEDGMENTS

I wish to express my gratitude to Columbia College Chicago for granting me a sabbatical. The college also awarded me a faculty development grant. The sabbatical and grant were most valuable in helping me to fund, research, and write a major portion of this book.

I am most grateful to the Irving Park Historical Society for its assistance. The society's archival materials, specifically its collection of historic photographs, significantly improved this project. The assistance of its staff facilitated the completion of this book.

A thank-you goes to the Old Irving Park Association for its insight and support. From the very beginning, certain key members of this organization expressed unwavering faith in the value of this project. That support was inspiring.

I also extend a sincere thank-you to many organizations and institutions that permitted me to use their photographs or archives. These institutions include the following: Irving Park Historical Society, Northwest Chicago Historical Society, Chicago History Museum, Chicago Public Library Harold Washington Center, Conrad Sulzer Regional Library, Chicago Fire Department, Chicago Fire Department Engine Company 69, Chicago Park District, Chicago Transit Authority, Carl Schurz High School, Hiram H. Belding School, Disney II Magnet School, St. Viator School, St. Edward School, St. John's Episcopal Church, Irving Park United Methodist Church, Irving Park Baptist Church, St. Viator Church, St. Edward Church, Salvation Army Irving Park Community Center and Church, Irving Park Lutheran Church, Mount Olive Church, Irving Park YMCA, Lydia Home Association, Swedish American Museum, and North Park University.

Special gratitude is extended to various individuals who helped me with this project in so many ways. I really appreciate their assistance. These individuals include: James Natoli, Richard Lang, Frank Suerth, Marlena Ascher, Julie Lynch, Kris Prescott, Wendy Jo Harmston, Missy Goldberg, Heather S. Yutzy, Bogdana Chkoumbova, Ersi Santiago, Erica Dorantes, Sue Rissetto, Kiki Schotanus, Angela and Bob McCormick, Linda Valenzo, Marge Tiritilli, Vicky Hadaway, Cindy McTigue, Lee Diamond, Marty Jennings, Ralph Greenslade, Nora Byrne, Fern Hacker, Daniel Pogorzelski, and George Borovik.

Thank you to Amy K. Perryman, associate publisher at Arcadia Publishing. I appreciate her helpful suggestions on improving the book and her support throughout the project.

INTRODUCTION

Chicago is a patchwork of diverse neighborhoods. Each has its own particular strengths, challenges, and shared history. Chicago is aptly dubbed "the city of neighborhoods." It is the people from the neighborhoods who contribute to the city's vitality. The city officially recognizes 77 community areas. Yet within these larger areas are over 200 smaller neighborhoods.

And among Chicago's neighborhoods, Old Irving Park is indeed a crown jewel. It is peaceful, family-oriented, and has a suburban-like charm. It is residential, with a rich history and over a century of memories. It is a part of Irving Park, a community area on the city's north side. Other neighborhoods that comprise Irving Park—all with nice homes and good amenities—are Independence Park, the Villa, West Walker, California Park, Merchant Park, Little Cassubia, and Kilbourn Park.

Irving Park's history began roughly in 1869, when four New Yorkers, Charles T. Race, John S. Brown, Adelbert E. Brown, and John Wheeler, purchased 160 acres of farmland from Major Noble. They later purchased another 80-acre farm from John Gray. Instead of farming, the men decided to sell plots of their land to newcomers. Their vision was to create an upscale suburb seven miles from Chicago. In 1869, the town was established.

The Chicago & North Western Railway agreed to make regular stops at Irving Park if the developers built a train station. Charles T. Race paid for the depot's construction, and the railroad attracted new settlers. The name chosen for the new suburb was "Irvington," after author Washington Irving. But another town in Illinois already used that name, so "Irving Park" was selected.

The birthplace of Irving Park is today known as Old Irving Park. Its borders are Montrose Avenue to the north, Addison Street to its south, Pulaski Road to the east, and the Milwaukee Road railroad on the west.

This was the area where families first settled when the suburb of Irving Park was platted in 1869. The first homes were built here, and essential town services were established, including the train station, general store, post office, fire station, bank, public school, and church. The town hall and police station were built nearby.

Charles T. Race and the other founders made handsome profits selling land. With their wealth, the businessmen built ornate mansions for their families along Irving Park Road between 1869 and 1872. They became prominent community members. After the Great Chicago Fire of 1871, additional residents came to the area and built smaller, less luxurious homes.

But Irving Park—part of Jefferson Township—could not meet the needs of its growing population, which numbered 640 in 1884. Residents faced hardships, such as a lack of quality drinking water, unpaved sidewalks and streets, and poor drainage. After heavy rains, mud streets were impassable. Finally, Jefferson Township residents voted for annexation to Chicago. Annexation took place on June 29, 1889, along with Lake Townships, Lake View, Hyde Park, and portions of Cicero. Through the annexation, Chicago more than doubled, gaining 130 new square miles and a quarter of a million more people.

After annexation, former Irving Park suburbanites embraced their new urban lifestyle. They welcomed modern infrastructure like clean piped water, paved streets and sidewalks, sewers, public transportation, garbage collection, and better fire and police protection. The new amenities lured even more residents. Between 1895 and 1914, over 5,000 residential structures—of which 1,200 were multifamily buildings—were erected in Irving Park. From 1910 to 1920, Irving Park's population grew from 14,748 to 42,467. In 1930, it peaked at 66,783. Early immigrant families were Germans and Swedes. They were later followed by working-class Russians, Poles, and Irish. Still later, many Latinos arrived. Families grew, and schools, churches, and businesses multiplied.

However, by the mid-1950s, Chicagoans increasingly preferred a suburban lifestyle. Stable, good neighborhoods like Old Irving Park steadily lost residents who migrated to the suburbs. Also, in the late 1950s, construction of the Northwest (now Kennedy) Expressway—which opened in 1960—tore through the heart of Old Irving Park and forced the destruction of many homes and businesses. The strong sense of community was disrupted as families had to move elsewhere. The neighborhood became stagnant as older homes fell into disrepair or became vacant.

In the early 1980s, however, Old Irving Park experienced a renaissance as more people discovered its hidden charm. Folks realized that the neighborhood was a good place to raise a family. Younger couples began buying older homes and meticulously restoring them. A new community pride emerged as residents nicknamed their neighborhood "Old Irving Park." In 1983, the Old Irving Park Association was formed to bring residents together and improve the neighborhood. In 1984, an offshoot of the association, the Irving Park Historical Society, was founded to encourage the preservation of historic homes, specifically in Old Irving Park.

The neighborhood became "hot." Property values soared but were still reasonably priced. Couples, hoping to get the best bang for their buck, quickly purchased homes that were for sale. Older courtyard apartment buildings were suddenly rehabbed or converted into condominiums. And in the mid-1990s, housing developers bought out several large businesses, razed the structures, and constructed new, single-family homes.

The Irving Park community is 45 percent Latino, 41 percent white, and 14 percent other ethnic groups, according to the 2010 US census. Old Irving Park has an interesting mix of ethnic and socioeconomic groups. Most residents are white, with a growing presence of Latinos, Asian Americans, Indians, and Filipinos. Its residents include retirees, blue-collar workers, and professionals, such as teachers, college professors, city workers, nurses, bankers, and lawyers.

Today, some neighborhoods unfortunately face serious problems, like gangs, drug dealing, and street violence. Old Irving Park, however, has low crime. Homeowners proudly maintain their houses, which sit on ample lots. And the neighborhood boasts such amenities as convenient Metra and CTA train transportation to downtown and the airport, easy access to the Kennedy Expressway, free street parking, and good public and parochial schools.

There are visible reminders of the neighborhood's earlier era. A small, single-truck Chicago Fire Department station is tucked away on a residential street. Stately churches sit on quiet street corners exuding a neighborly spirit. Various churches and schools have held centennial celebrations. And old, majestic trees stand in every street.

The neighborhood has seen many changes. But it is still a thriving community with character, nice homes, and a legacy of civic-minded individuals and organizations.

One

THE EARLY YEARS

Since the 1700s, Native American tribes, such as the Potawatomi, inhabited Chicago. Native Americans established small villages, raised crops, fished, and hunted. But through the Chicago Treaty of 1833, the federal government forced tribes west and then seized their lands.

In 1830, John Kinzie Clark became the first land claimant in what was to become Jefferson Township. In 1843, Major Noble established his farm, which he sold in 1869 to Charles T. Race and his business associates. Irving Park was founded in 1869, and other developments were soon added. In 1874, John Gray began selling portions of his large farm. His development, called Grayland, extended west from Kostner Avenue to Cicero Avenue, between Irving Park Road and Addison Street. It grew around the Grayland station of the Milwaukee Road railroad. His brother William subdivided a portion of his farm at Six Corners and called it Grayland Park.

Three subdivisions east of Pulaski Road were developed in the late 1890s. West Walker is located between Montrose Avenue and Irving Park Road and is characterized by large single-family homes in late Victorian, American Foursquare, and Revival styles. Samuel E. Gross developed the area south of Irving Park Road known as the "Gross Boulevard addition to Irving Park." Housing stock is similar to that of West Walker. The Villa is an area roughly bounded by Addison Street and Avondale Avenue, Pulaski Road, and Hamlin Avenue. Most homes are bungalows in the Prairie and Craftsman styles.

The first child born in Irving Park, on August 30, 1869, was named Irving Park Jones. The first town store was built in 1870, and the first post office started in 1871. The first marriage was that of J.B. Juliand and Martha Brown, daughter of Erastus Brown, on September 12, 1872. The first death was that of Charles T. Race's daughter Della Race on November 26, 1870.

In 1888, the Irving Park Woman's Club was formed to promote civic improvement and education. Ella LaBagh, a noted club leader, was a pioneer in nature preservation. The club continued its good work until it disbanded in 1994. In the early 1900s, residents organized the John Gray Improvement Association of Irving Park. Association members paid dues and formed civic committees. They devoted themselves to improving and beautifying the neighborhood, specifically the area that is Old Irving Park.

In 1910, residents established an independent park district. They created eight local parks, the largest of which is Independence Park. In 1933, however, the Irving Park District was consolidated with the Chicago Park District. In the 1920s, many large apartment buildings were constructed in Irving Park. During the Great Depression, some families lost their homes due to foreclosures. Some larger homes were converted into rooming houses.

Today, elderly residents hold fond memories of Old Irving Park. Bob McCormick, 80, recalls his pleasant childhood and teenage years. He remembers the popular theaters, drugstores, and restaurants that are no longer around. He recalls the good money he earned as a teenager working long hours at a local coal company. And he remembers his studious but fun-filled days at Carl Schurz High School, from which he graduated in 1948.

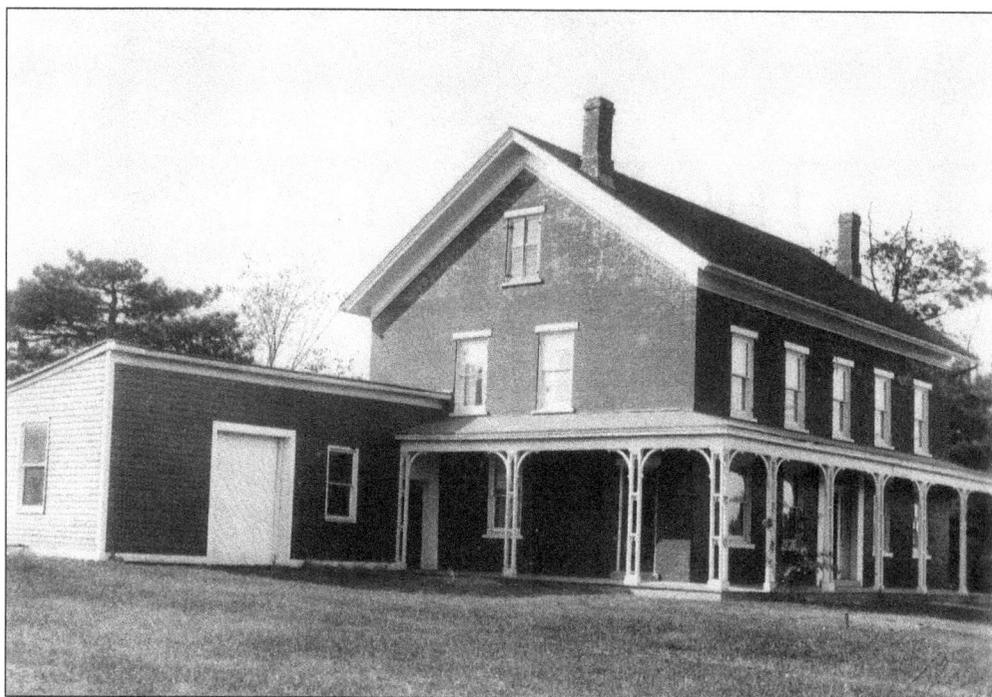

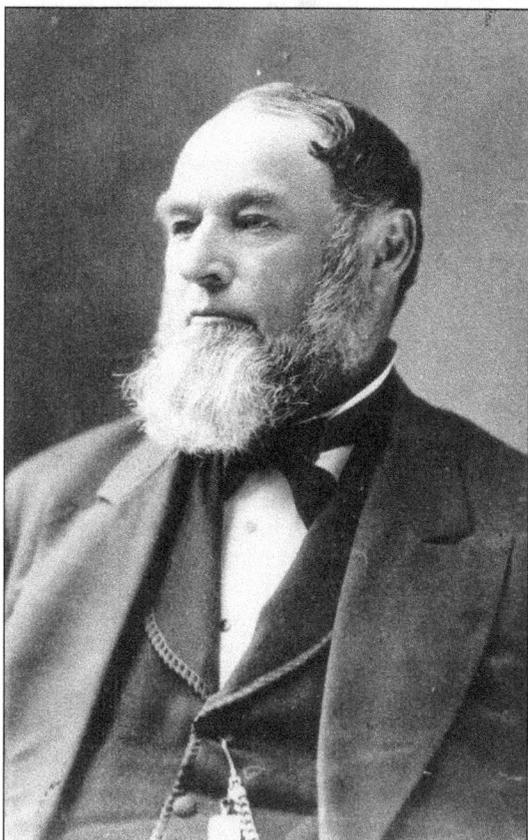

The Dickerson Tavern, on Milwaukee Avenue near Belle Plaine Avenue, was built in 1841. It was the birthplace of Jefferson Township. Chester Dickerson bought the inn from E.B. Sutherland in 1846. Prominent citizens met at the inn and established Jefferson Township (named for Pres. Thomas Jefferson) in 1850. The township was incorporated in 1872, and the popular inn, seen here around 1910, served as its temporary town hall. Legend says that Abraham Lincoln and Stephen Douglas were guests at the inn, which was razed in 1929. (Courtesy Chicago History Museum.)

John Gray was a founder and prominent citizen of Jefferson Township. He began subdividing and selling portions of his large farm in 1874. His development, called Grayland, just west of Old Irving Park, grew around the Grayland train station of the Milwaukee Road railroad. He established his home in Old Irving Park. Gray, seen here around 1858, served as the first Republican sheriff of Cook County. (Courtesy Irving Park Historical Society.)

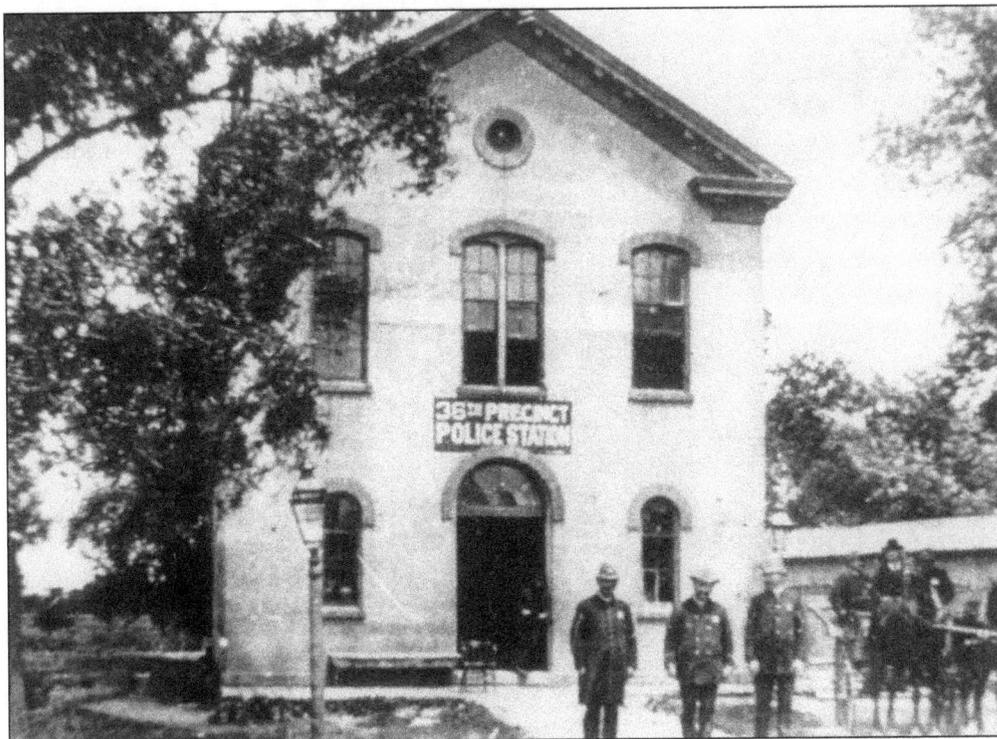

Jefferson Township Town Hall was located at the southeast corner of Irving Park Road, Milwaukee Avenue, and Cicero Avenue (Six Corners). It was built in 1862 on land donated by John Gray. The Jefferson Township High School opened on the second floor of this building in 1870, and John Gray was elected school trustee. When Jefferson Township was annexed by Chicago in 1889, this building served as a police station. (Courtesy Carl Schurz High School.)

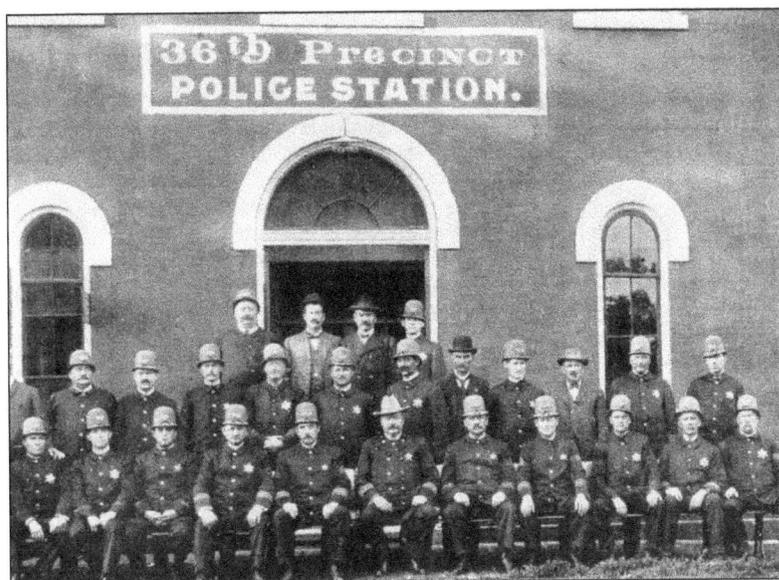

This c. 1907 photograph shows members of the Chicago Police Department's 36th Precinct police station. This building was torn down in 1922. (Courtesy Frank Suerth.)

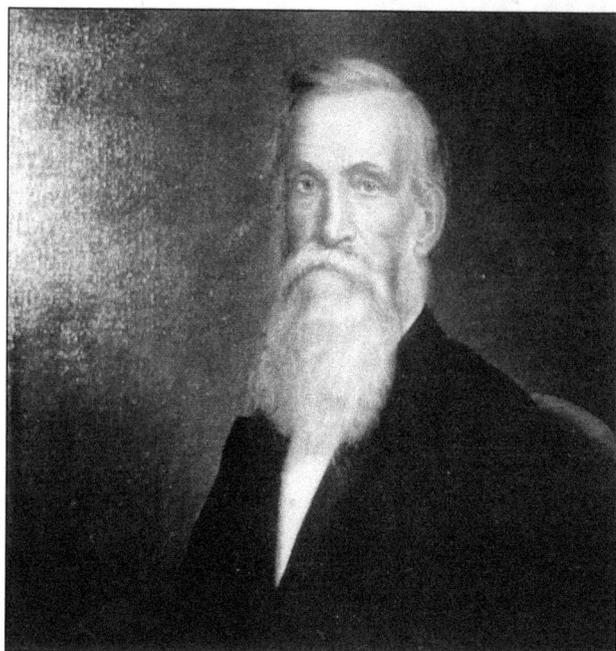

This is a mid-1870s oil painting of Charles T. Race. He was the principal founder of the suburb of Irving Park. A successful businessman and prominent community member, Race was very involved in religious and civic affairs. He passed away in April 1888 and is buried in Graceland Cemetery. This painting, along with one of Race's wife, is in the home of a Race relative in Barrington, Illinois. (Courtesy Irving Park Historical Society.)

THE ORIGINAL

IRVING PARK

Land and Building Company.

HOUSES for Sale on Long Time and Built to Order on Terms to Suit.

MONEY TO LOAN FOR BUILDING PURPOSES,

AT IRVING PARK.

A DESIRABLE RESIDENCE PLACE,

With Water Works in complete working order, and connected with every Dwelling Sold by its

SHADY STREETS, FINE SCHOOLS, CHURCHES AND STORES.

Only Six Miles from center of Chicago, reached by Railroad in twenty minutes, commutation fare seven cents.

TRAINS TO AND FROM CHICAGO NEARLY EVERY HOUR IN THE DAY.

C. T. RACE, Irving Park,
R. T. RACE, " " } Proprietors.
S. A. RACE, New York.

R. T. RACE & CO.,

REAL ESTATE, LOAN AND NOTE

BROKERS,

167 *Madison Street, Room* 1, CHICAGO, ILL.

Charles T. Race organized the Irving Park Land and Building Company, a major real estate firm. His relatives and other associates joined the company. This is the company's 1874 advertisement for the sale of plots of land and homes. The advertisement touts the suburb's "shady streets, fine schools, churches and stores." Charles's brother, Stephen A. Race, was the father of Richard T. Race. Everett Chamberlin published this advertisement in his 1874 book *Chicago and Its Suburbs*. Chamberlin lived in Old Irving Park. (Courtesy Everett Chamberlin.)

This is a front view of the mansion of Charles T. Race, located at 4122 West Irving Park Road. The three-story brick house, which occupied over 12 city lots, was surrounded by trees, flowers, manicured lawns, and elaborate gardens. The mansions of well-to-do residents once lined both sides of Irving Park Road. This mansion was eventually razed. By the early 1940s, most of the mansions—with the exception of the Stephen A. Race mansion—were torn down. (Courtesy Irving Park Historical Society.)

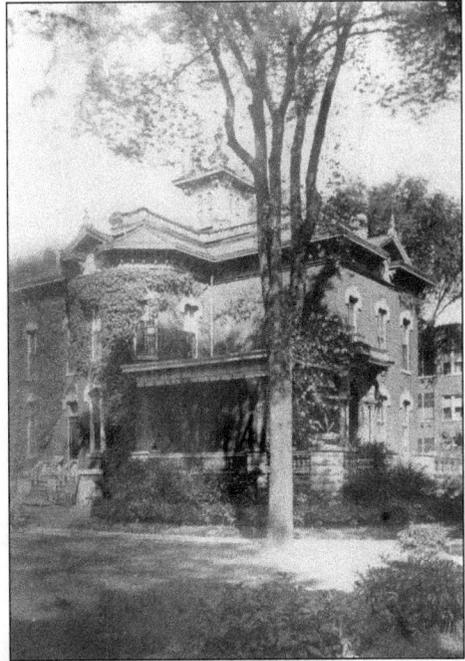

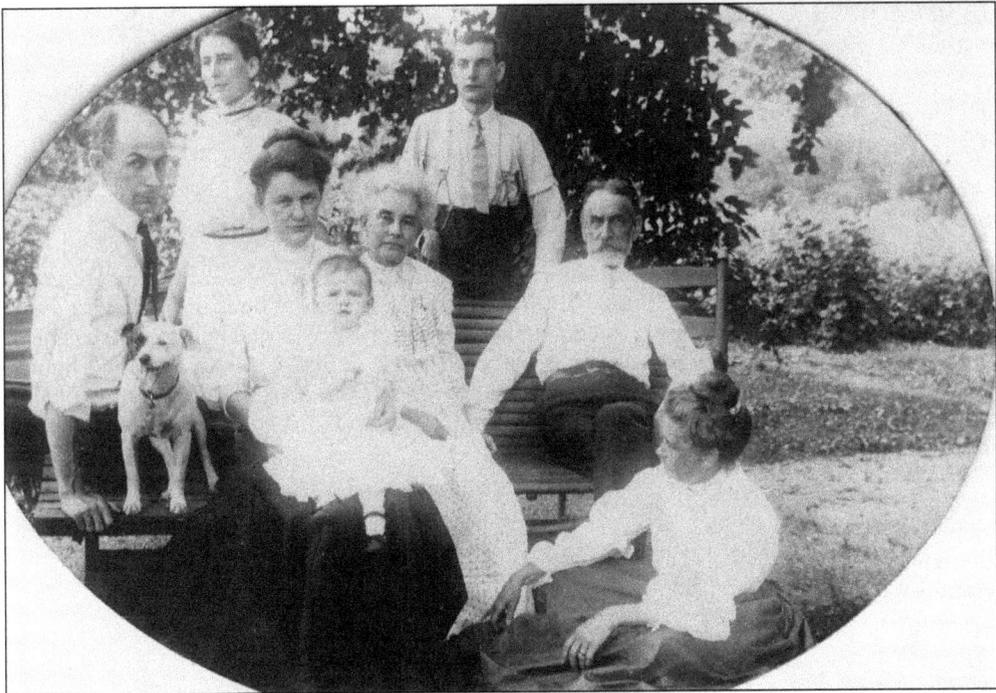

Adelbert E. Brown, a dentist, was a key founder of Irving Park. The extended Brown family is shown here in 1908. They are, from left to right, (seated on ground) Emma Brown (Adelbert E. Brown's sister); (on bench) Leander Brown, Mrs. Leander Brown (holding daughter, Orlanda), Mrs. Adelbert E. Brown, and Adelbert E. Brown; (standing) Eleanor Brown and Adelbert Brown Jr. The mansion of Adelbert E. Brown, built in 1872, was located at the northwest corner of Irving Park and Pulaski Roads. (Courtesy Irving Park Historical Society.)

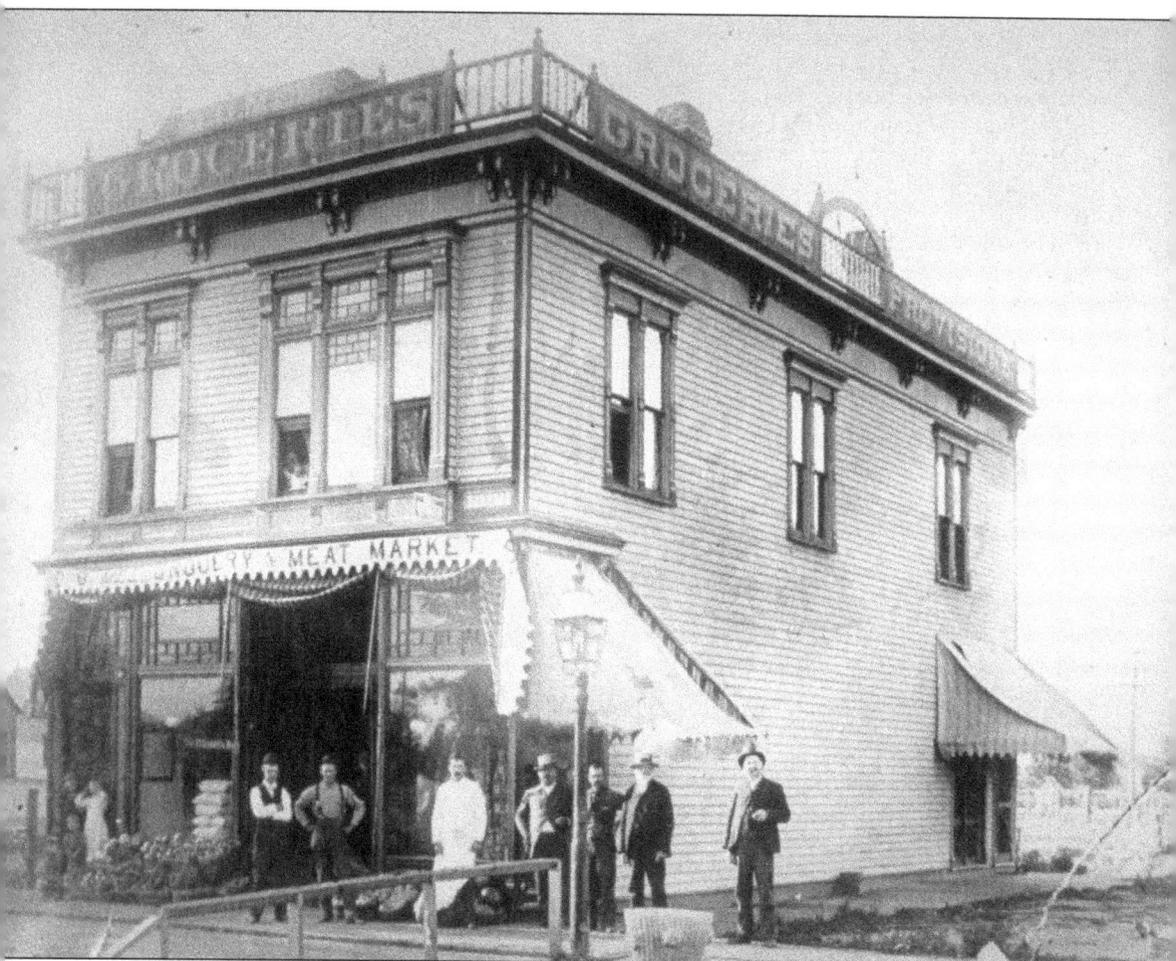

D.D. Mee Grocery, 4200 West Irving Park Road, was the first store built in Old Irving Park, around 1870. Constructed by Henry Nichols, it was the community's social hub. Besides a general store, it served as a temporary postal station, a pay telephone station, a toll station, and a branch library. It became Brown's Drug Store in the late 1890s and, later, Fox's Drug Store. In 1990, it was designated a Chicago Landmark by the Commission on Chicago Landmarks. (Courtesy Irving Park Historical Society.)

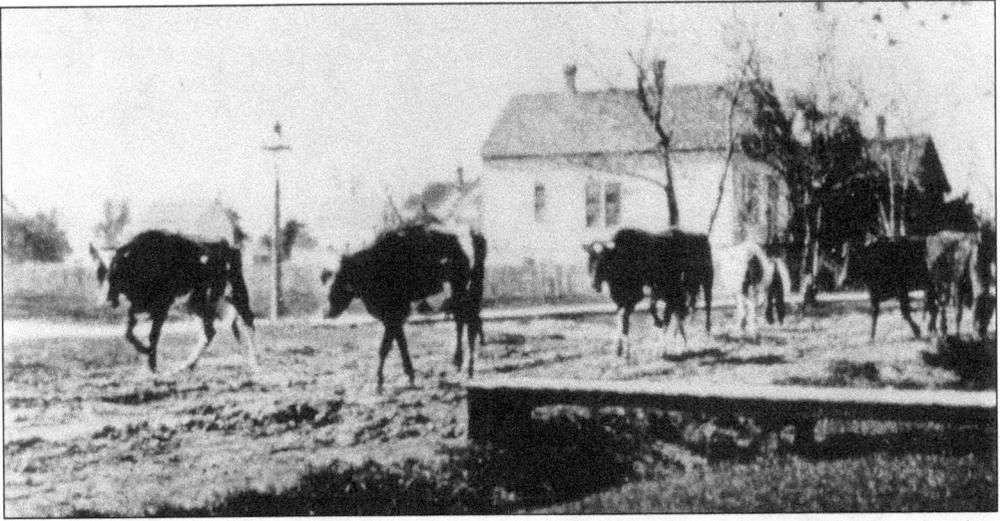

A family's cows head south on Kedvale Avenue near Irving Park Road about 1890. Many families at the time raised chickens and geese and had cows, horses, and other livestock. Many also had backyard vegetable gardens. Much of the land was undeveloped prairie and farmland. Sidewalks and walkways to the homes were made of wooden planks, and the streets were unpaved. (Courtesy Irving Park Historical Society.)

An extended family gathers at 4309 North Kostner Avenue around 1893. The home was built in 1893, and these are likely the first owners with their relatives. Sara Minton and her husband bought the house in 1990, and they found this photograph inside the home. When the couple sold the house years later, they left this picture inside for the new owners. (Courtesy Irving Park Historical Society.)

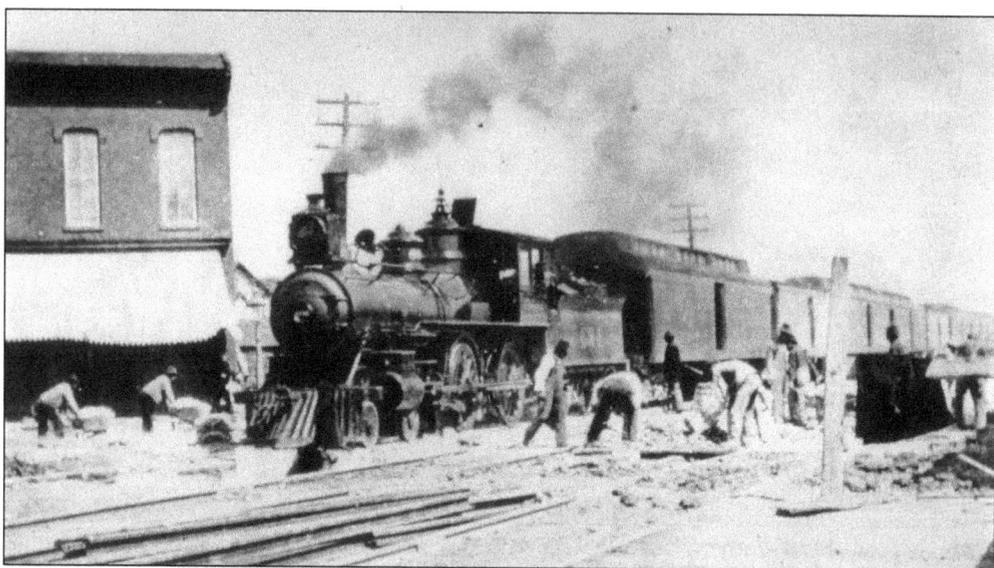

A steam locomotive bellowing smoke arrives at the Irving Park station. Railroad transportation to and from Chicago was essential to the rapid residential and commercial development of Irving Park. The Chicago & North Western Railway made hourly stops at the station. Here, in 1897, crews dismantle tracks and elevate the station above street level. This was done to ease traffic problems on major streets, such as Irving Park Road. (Courtesy Irving Park Historical Society.)

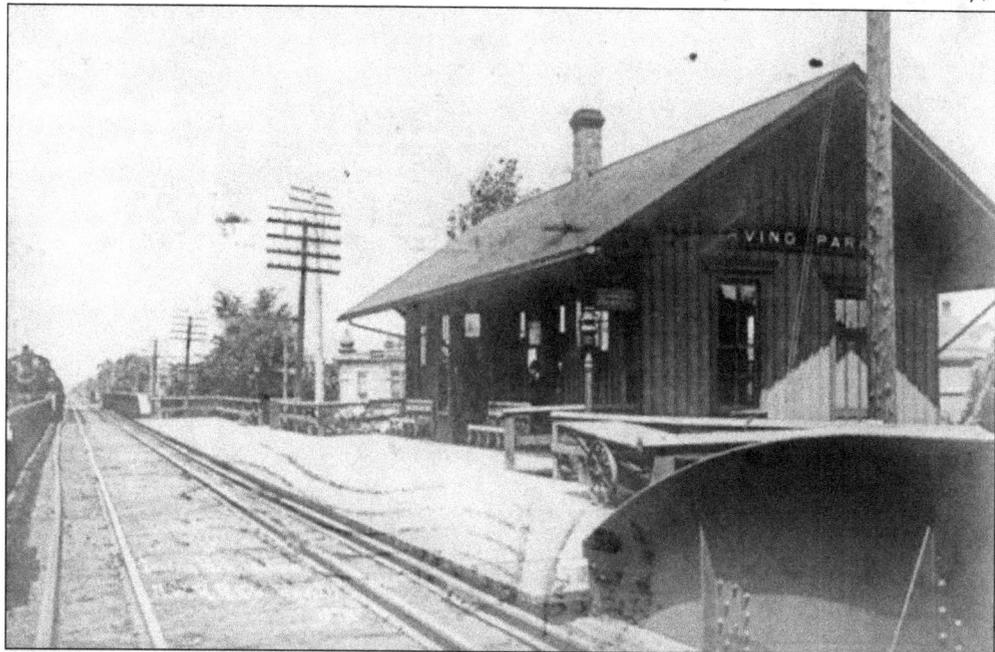

An early-1900s postcard shows the Irving Park elevated train depot. The depot was built by Charles T. Race and his associates to bring new settlers to Irving Park. In 1909, Chicago began changing the names and numbering system of its streets. The train station was located at Irving Park Road (formerly Irving Park Boulevard) and Keeler Avenue. An individual on the platform looks on as a Chicago & North Western Railway train approaches from the other side. (Courtesy Frank Suerth.)

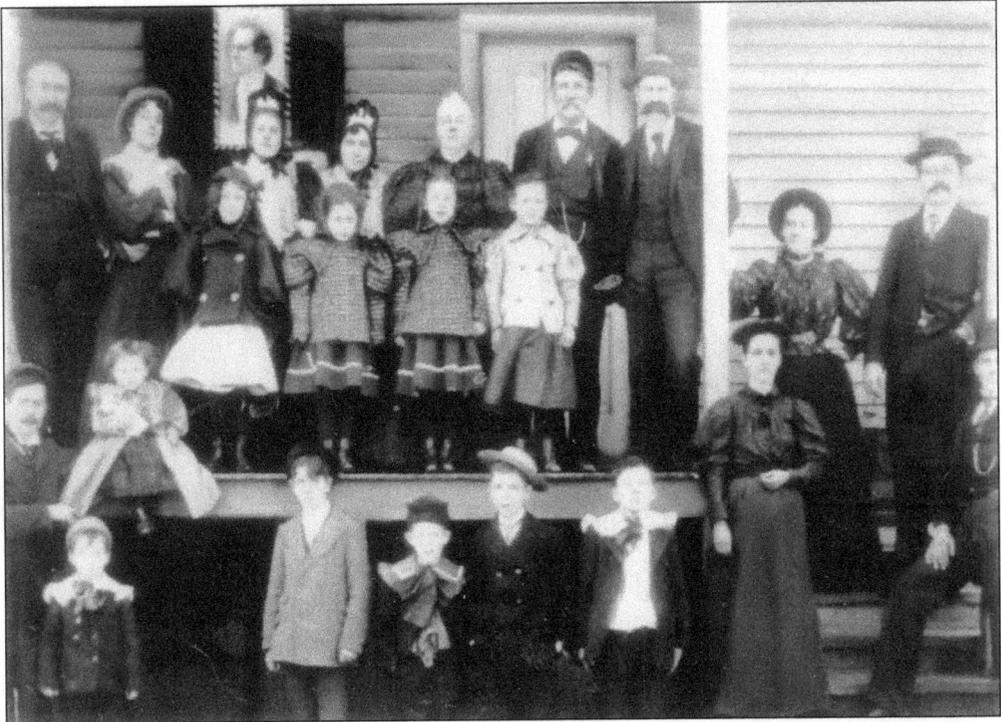

William T. Stockwell (in front of the door) stands next to his wife, Mary Isabelle, with relatives at the Stockwell home at 4354 West Berteau Avenue. Stockwell's team of horses and mules helped haul away piles of debris from the Great Chicago Fire of 1871. He worked as a brakeman and conductor for 28 years with the Chicago & North Western Railway and another nine years for the Chicago, Milwaukee & St. Paul Railway. Stockwell's four sons also worked for the Chicago, Milwaukee & St. Paul Railway. This photograph was taken around 1889. (Courtesy Irving Park Historical Society.)

William E. Stockwell (third from left) worked for 56 years with the Chicago, Milwaukee & St. Paul Railway. He was the engineer who drove the large locomotive trains on their daily runs. Here, in 1939, Stockwell is joined by fellow employees at his retirement ceremony. He and his wife lived for many years at 4135 North Kilbourn Avenue. They celebrated their 50th wedding anniversary at their home. Stockwell was one of four sons of William T. Stockwell. (Courtesy Irving Park Historical Society.)

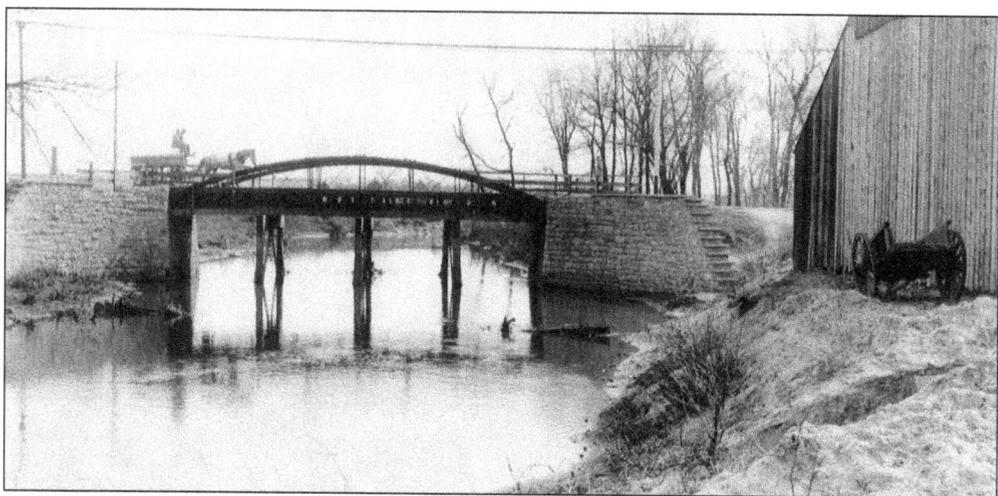

At the turn of the 20th century, residents and farmers still used horse-drawn buggies to travel and carry goods. In this 1903 photograph, two individuals travel on Irving Park Road near California Avenue (the eastern border of Irving Park). The north branch of the Chicago River flows underneath. Irving Park Road, the main thoroughfare in Irving Park, was originally used by the Potawatomi as a portage between the Chicago and Des Plaines Rivers. The trail extended to Milwaukee Avenue (now Six Corners), where a large Potawatomi village once stood. (Courtesy Conrad Sulzer Regional Library.)

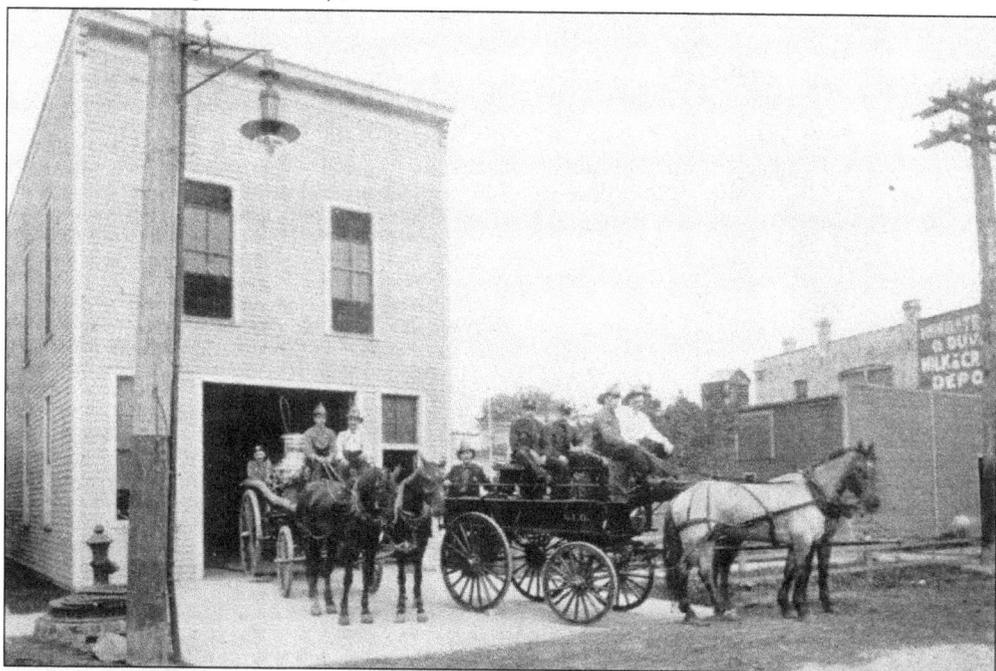

Old Irving Park's volunteer fire department was dissolved in 1891 and was replaced by better-trained, paid firefighters. Here is Chicago Fire Department (CFD) Engine Company 69 about 1908. The firefighters are posing with their horse-drawn steam fire engine and hose wagons. The two-story frame fire station was built in 1891 at 4017 North Tripp Avenue. Fire stations had horse stables in the back. In 1912, the CFD began replacing horse-drawn equipment with motorized trucks. (Courtesy Frank Suerth.)

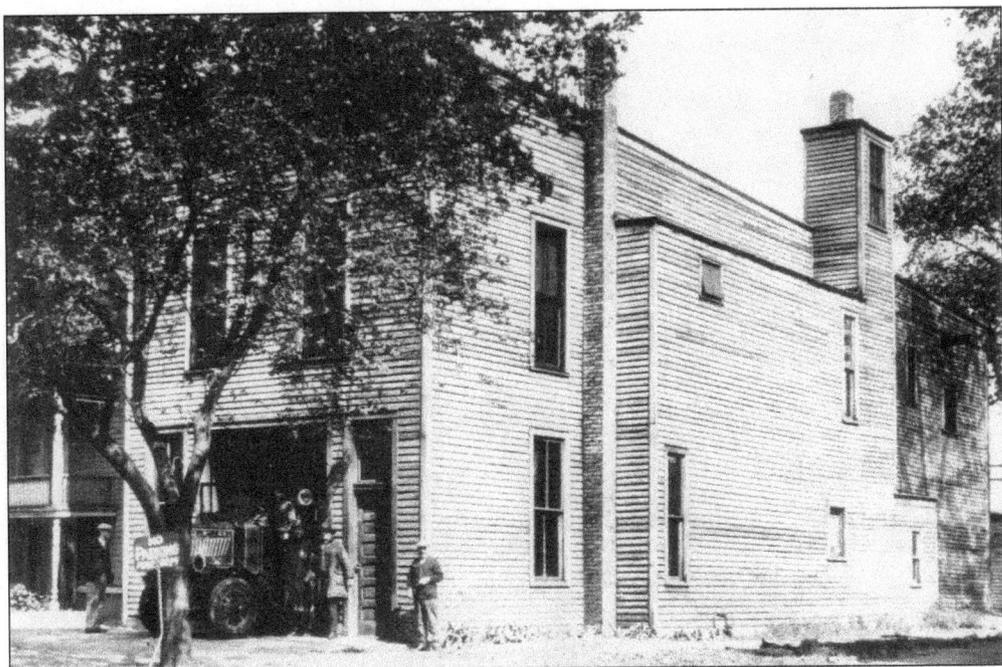

In 1922, CFD Engine Company 69 bid farewell to its hard-working horses. Steeds were replaced by a new, modern fire truck, shown here. The "hose tower," at the back of the building, was designed for air-drying fire hoses after use. (Courtesy Chicago Fire Department, Engine Company 69.)

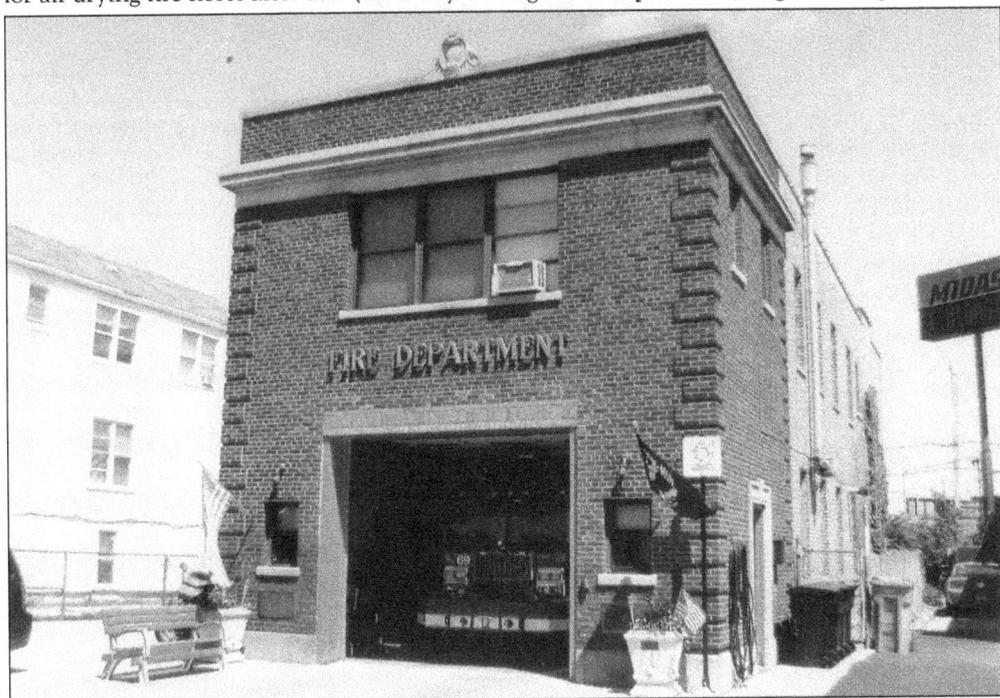

A new, brick Engine Company 69 station was built in 1936 where the old one once stood. The station was funded as a 1930s Works Progress Administration project. The company's fire truck was featured in the 1991 Hollywood movie *Backdraft*. (Photograph by Wilfredo Cruz.)

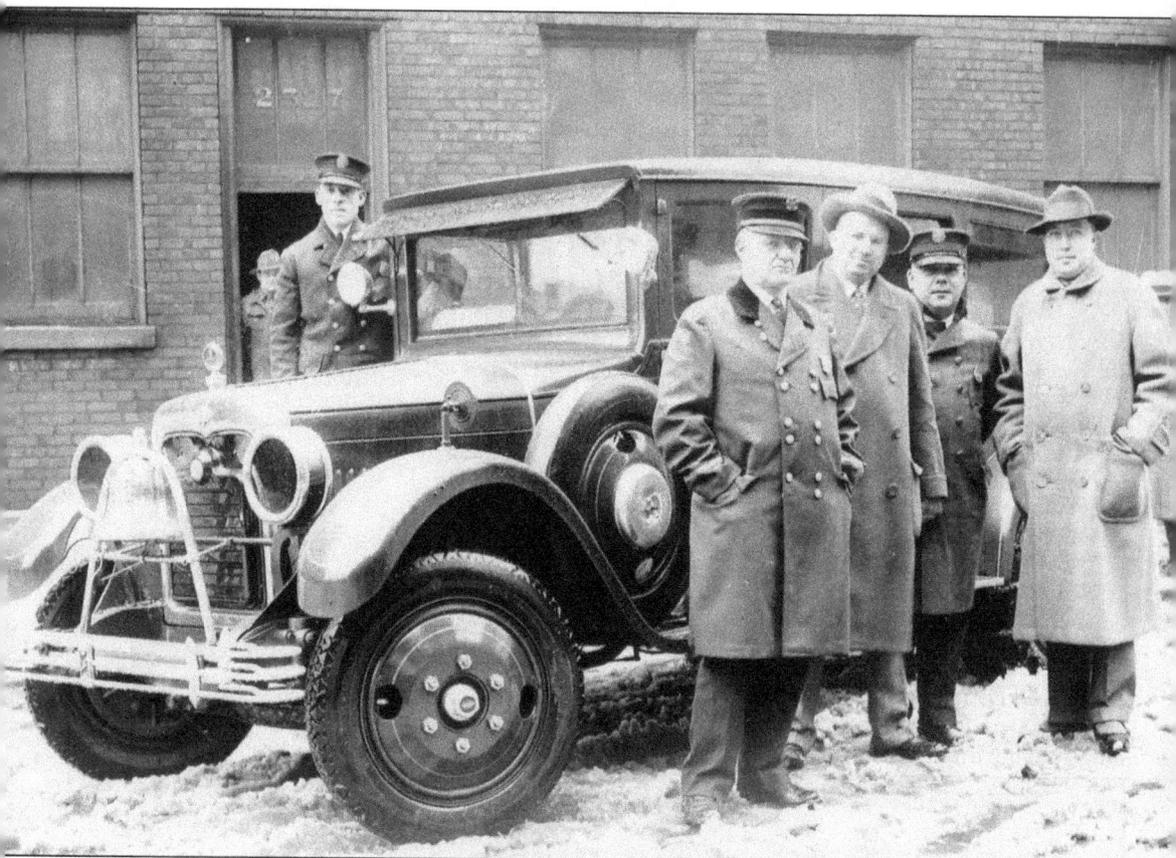

Chicago Fire Department firefighter Michael J. Corrigan (front, center) was a prominent Old Irving Park resident. He worked 61 years with the CFD on some of the city's worst disasters, including the 1903 Iroquois Theater Fire, 1910 Union Stockyards Fire, and the 1915 Eastland disaster. In 1927, he entered a burning building and saved several trapped firemen. In 1937, he became chief fire marshal (commissioner) of the CFD, a position he held for 18 years. Corrigan poses here with a group of firemen in uniforms and suits at the Glass Company in 1929. (Courtesy Chicago History Museum.)

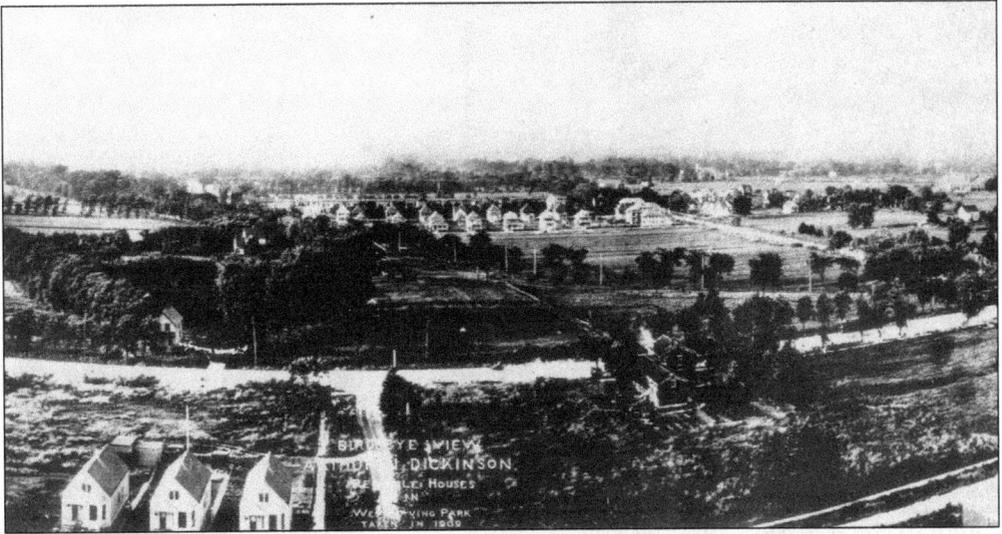

Here is an aerial view of Irving Park Road just west of Cicero Avenue in 1909. Chicago's north side, including Old Irving Park, was underdeveloped farmland in the early 1900s. Subdivisions were beginning to emerge. Arthur W. Dickerson, who had this photograph taken, was a noted developer of Chicago-style bungalows in the city and suburbs. A single block of bungalows built by Dickerson in the 1920s in Wilmette, Illinois, is listed as a National Historic District. (Courtesy Chicago Public Library, Special Collections, LMC Collection.)

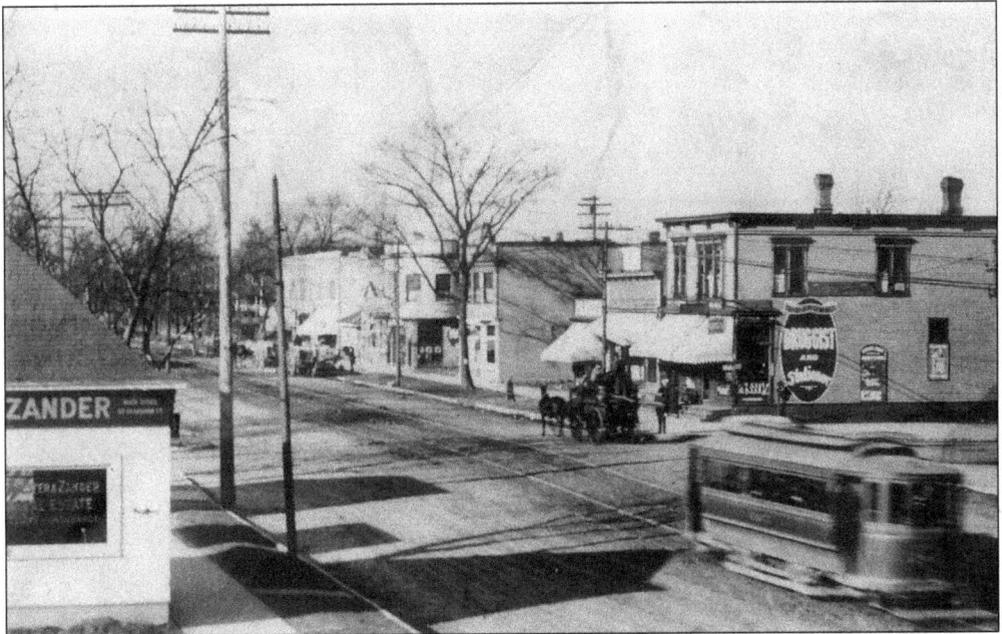

This early-1900s postcard, looking west, shows an electric streetcar sharing the road with horse-drawn buggies near Keeler Avenue on Irving Park Road. Streetcar service began on Irving Park Road in 1896. Brown's Drug Store (formerly D.D. Mee Grocery) is on the right, and the Koester-Zander real estate firm is on the left. Koester and Zander were developers of homes on Chicago's north side. The streetcar line went west to Narragansett Avenue, where the Dunning Poor House and Insane Asylum was located. (Courtesy Irving Park United Methodist Church.)

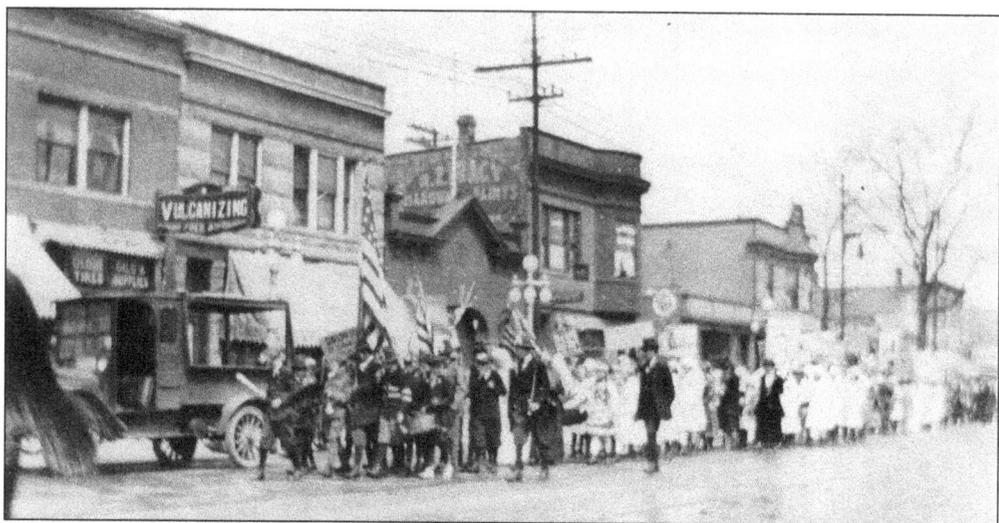

This postcard from the early 20th century shows a Fourth of July parade heading west near Keeler Avenue on Irving Park Road. Residents of Old Irving Park and the Independence Park neighborhood to the east participated in these annual patriotic parades. In the background is a tire store and the R.L. Tracy Hardware store. The post office is the third building from the left. (Courtesy Irving Park Historical Society.)

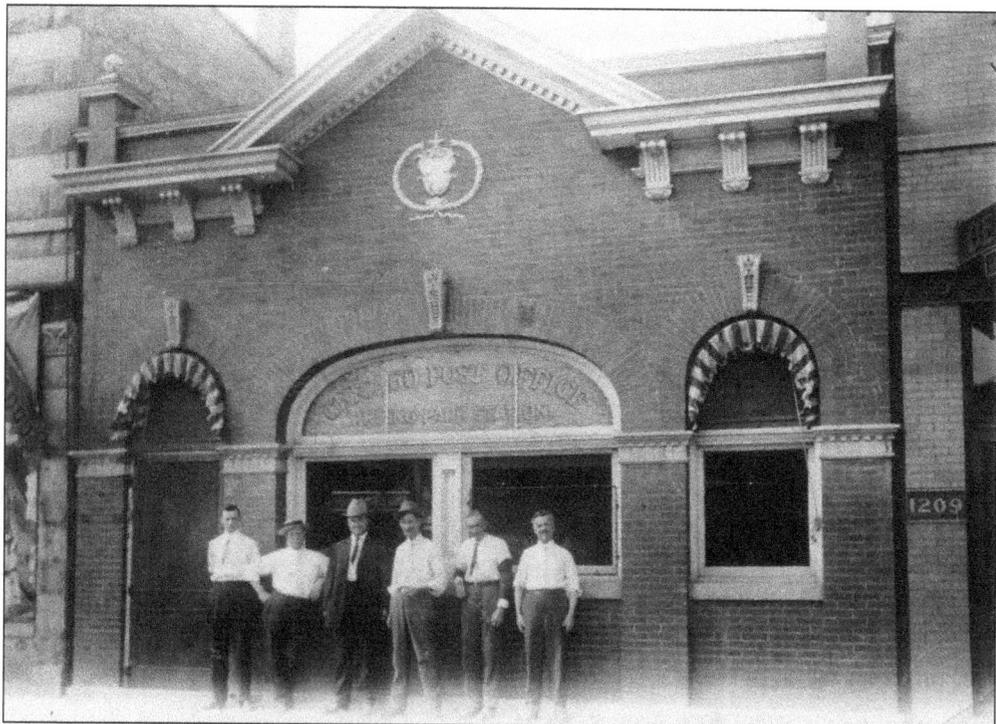

The first post office in Irving Park, shown here, was established about 1871. In 1872, Charles T. Race, key founder of Irving Park, was appointed the town's second postmaster. In this photograph, clerks and carriers pose outside of the Chicago Post Office's Irving Park Station in the early 1900s. The building just visible on the right has the old street address numbering system. The post office was located at approximately 4218 West Irving Park Road. (Courtesy Frank Suerth.)

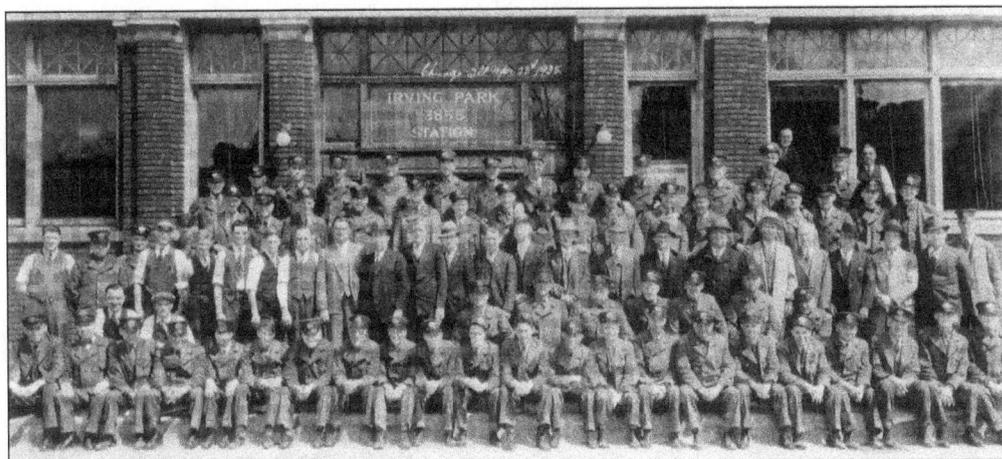

The Irving Park Post Office was eventually moved to 3855 North Cicero Avenue, at West Byron Street. Here, the station's employees and postal carriers gather in 1935. Note the increase in postal employees from the early 1900s to the time of this photograph. (Courtesy Hiram H. Belding School.)

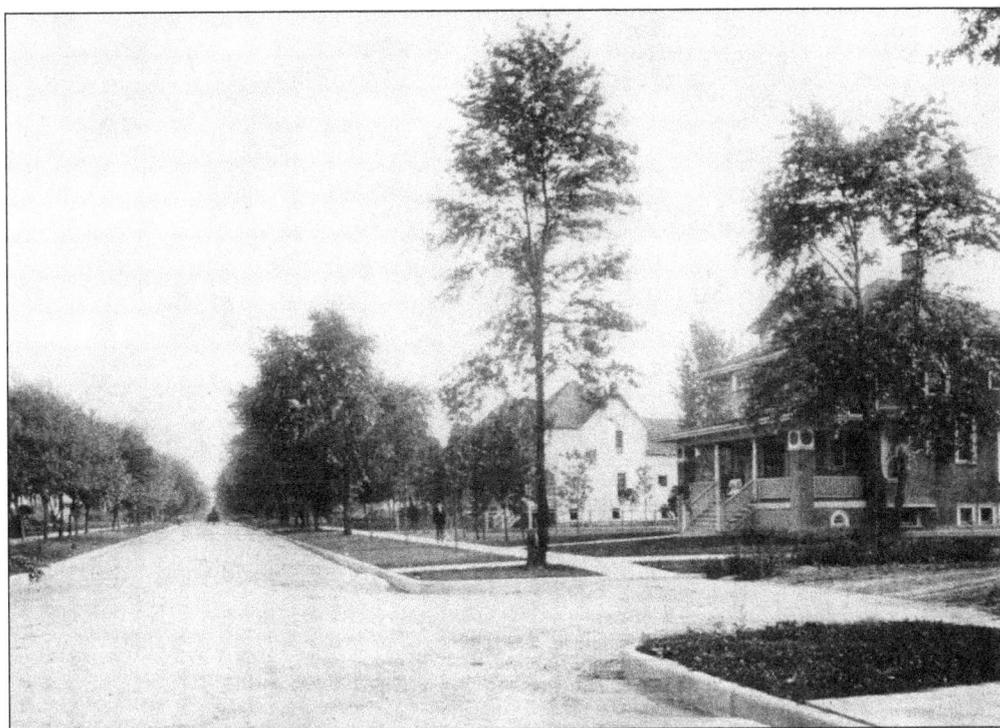

Looking north, this 1902 photograph is of the 4200 block of North Keystone Avenue at West Berteau Avenue. Infrastructure improvements are noticeable, such as curbs and paved concrete sidewalks and walkways to homes. The houses are set far back from the wide, tree-lined street. At right, a woman sits on her porch, and in the center of the photograph, a man can be seen on the sidewalk. A horse-drawn buggy makes its way in the distance. Most homes on this block were eventually torn down and replaced with multi-apartment buildings. (Courtesy Frank Suerth.)

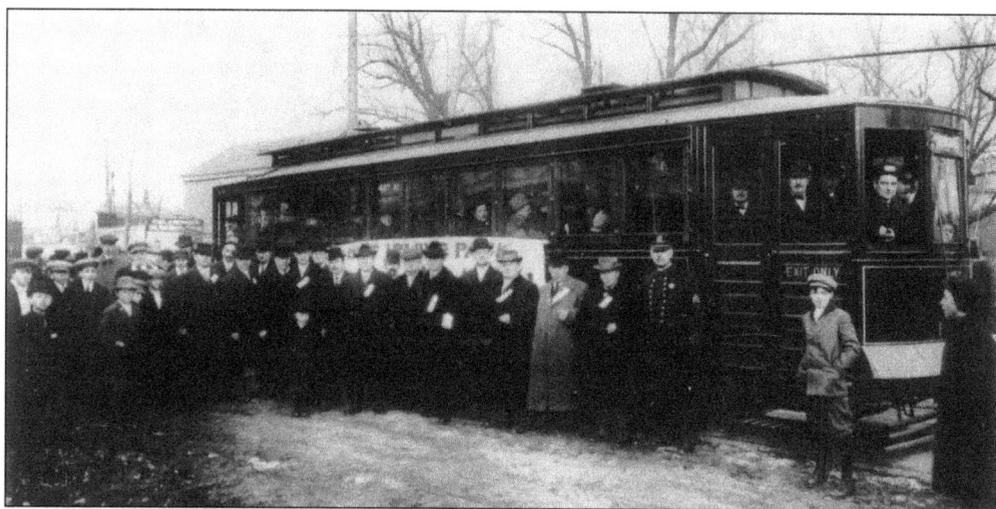

A crowd celebrates the 1913 inauguration of public streetcar service on the Forty-Eighth Avenue line (later named Cicero Avenue). The trolley line traveled south from Irving Park Road to North Avenue. Residents saw public transportation as a godsend. Electric trolleys made travel affordable, accessible, and comfortable. Fares were usually a nickel. Residents could now go on family outings, shop, and visit other parts of the growing city. (Courtesy Irving Park Historical Collection, Becker-Mitchell Collection.)

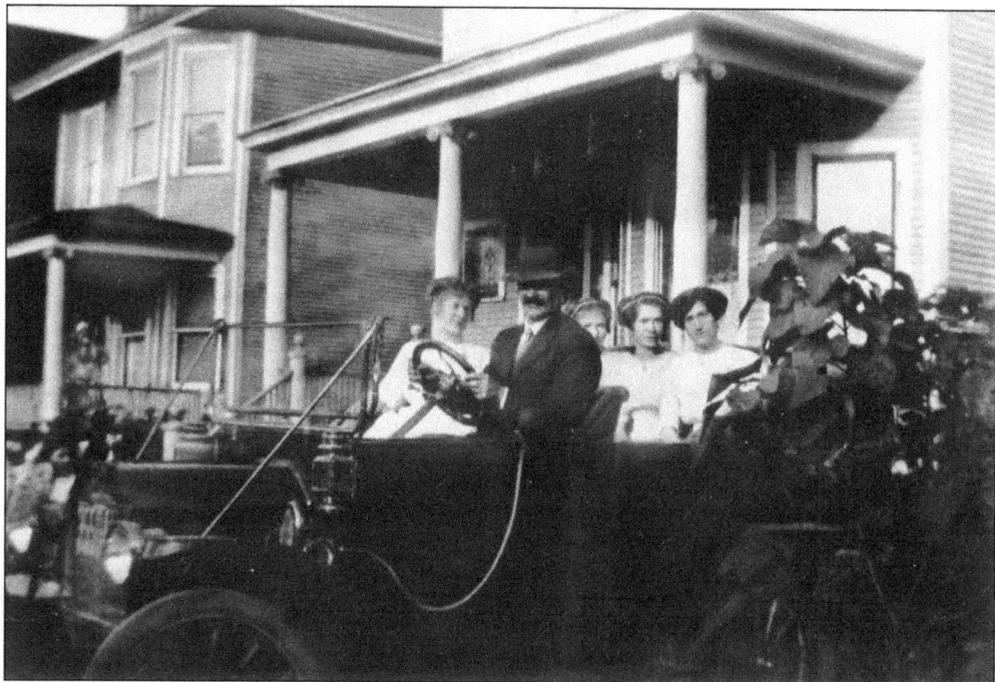

Charles H. Karlsen was a real estate agent and plastering contractor, and his brother was a carpentry contractor. They lived in Old Irving Park and together constructed numerous neighborhood houses, specifically in the 3700 block of North Lowell Avenue. The brothers built the houses at 3741 North Lowell Avenue (left) and 3737 North Lowell Avenue (behind car) in the early 1900s. Charles's brother lived in the home at 3737 North Lowell. The individuals in this 1914 photograph are unidentified. (Courtesy Irving Park Historical Society.)

Charles H. Karlsen and his brother built the house at 3733 North Lowell Avenue (right) in 1908. Charles H. Karlsen and his family lived in the home. Like this structure, most of the homes built by the brothers were in the American Foursquare style, which was very popular at the time. The individuals are not identified in this photograph from the early 1930s. (Courtesy Irving Park Historical Society.)

An unidentified young woman sits on the banister of her parents' home at 4040 North Kilbourn Avenue about 1910. The home was built in 1906 (see page 40). It is believed that this family was among the few in the neighborhood that owned a camera. Note the long, wide front porches. Families spent summer evenings on their porches, socializing with friends and neighbors. (Courtesy Hiram H. Belding School.)

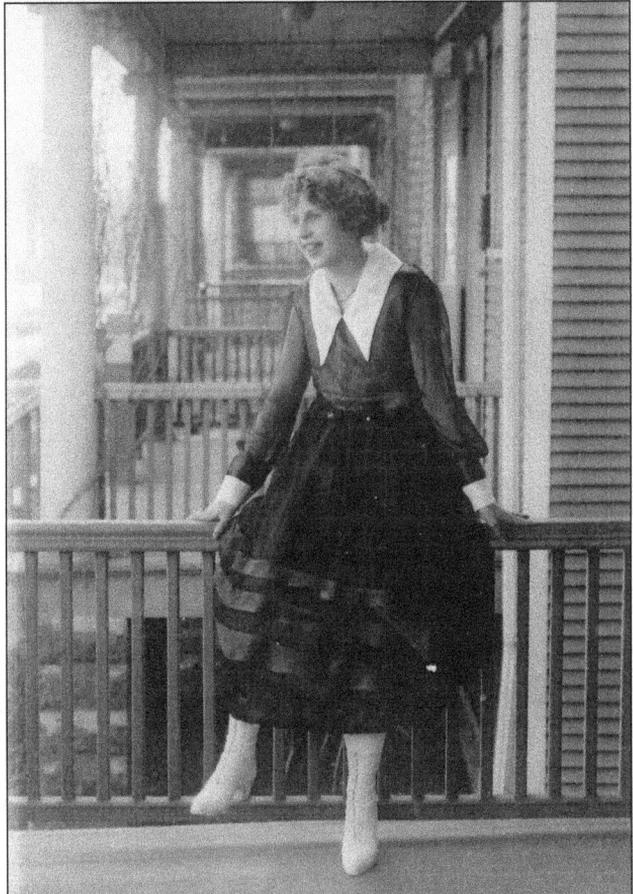

A house at 3756 North Kostner Avenue is seen here in 1909. Visible below the bay window are two women and a small dog. One woman is seated on a bench. (Courtesy Ron Ernst.)

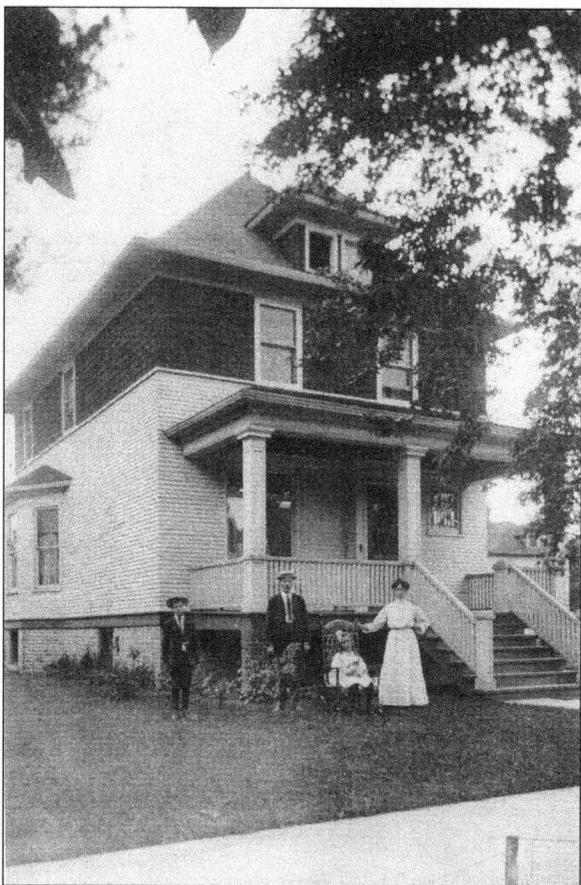

Fred Adison stands proudly with his wife, Edla, son, Francis, and daughter, Ethel, in front of their home at 3836 North Kildare Avenue around 1910. Adison built this house for his family. Some neighborhood homes were ordered from store catalogs, mainly from Sears, Roebuck and Company. Such homes were pre-cut and delivered by train, with thousands of parts labeled for assembly. From 1908 to 1940, Sears sold more than 100,000 affordable, pre-cut homes nationally. To show their prosperity in America, families mailed photographs of their homes to relatives back in the old country. (Courtesy Irving Park Historical Society.)

Dr. Clarence W. Mercereau holds identical-twin daughter Florence Frances, and his wife, Edith D. Loesner Mercereau, holds Gertrude Edith in 1910. This prominent Old Irving Park family lived for many years at 4033 North Kildare Avenue. Dr. Mercereau saw patients in his home office, and he made house calls in his new Ford Model T automobile. Their son, Clarence Mercereau, was co-owner of Compressed Steel Corporation in Schiller Park, Illinois. (Courtesy Irving Park Historical Society.)

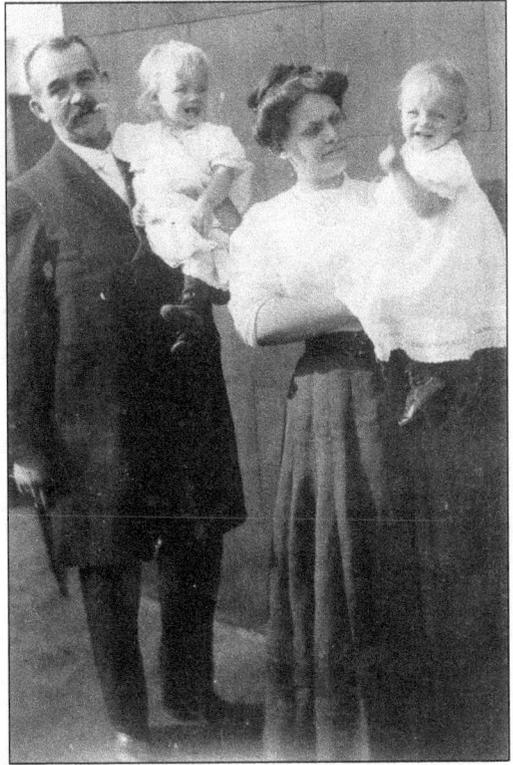

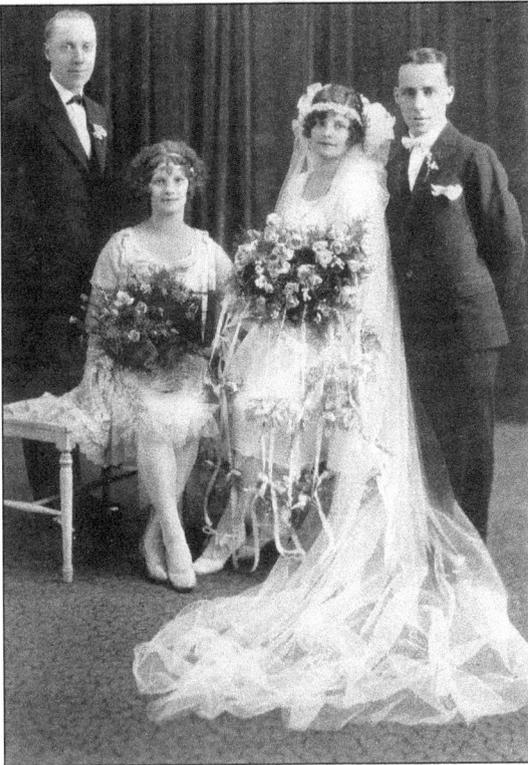

The daughters of Dr. Clarence and Edith D. Loesner Mercereau are shown here at the wedding of Florence Frances Mercereau to Harold Griffin in Chicago in the early 1930s. Identical-twin sister Gertrude Edith is seated beside Florence. The man at left is unidentified. The sisters were longtime residents of Old Irving Park. They had an older sister, Catherine Ellita, and a brother, Clarence. The entire Mercereau family were members of St. John's Episcopal Church, where they performed their sacraments. (Courtesy Irving Park Historical Society.)

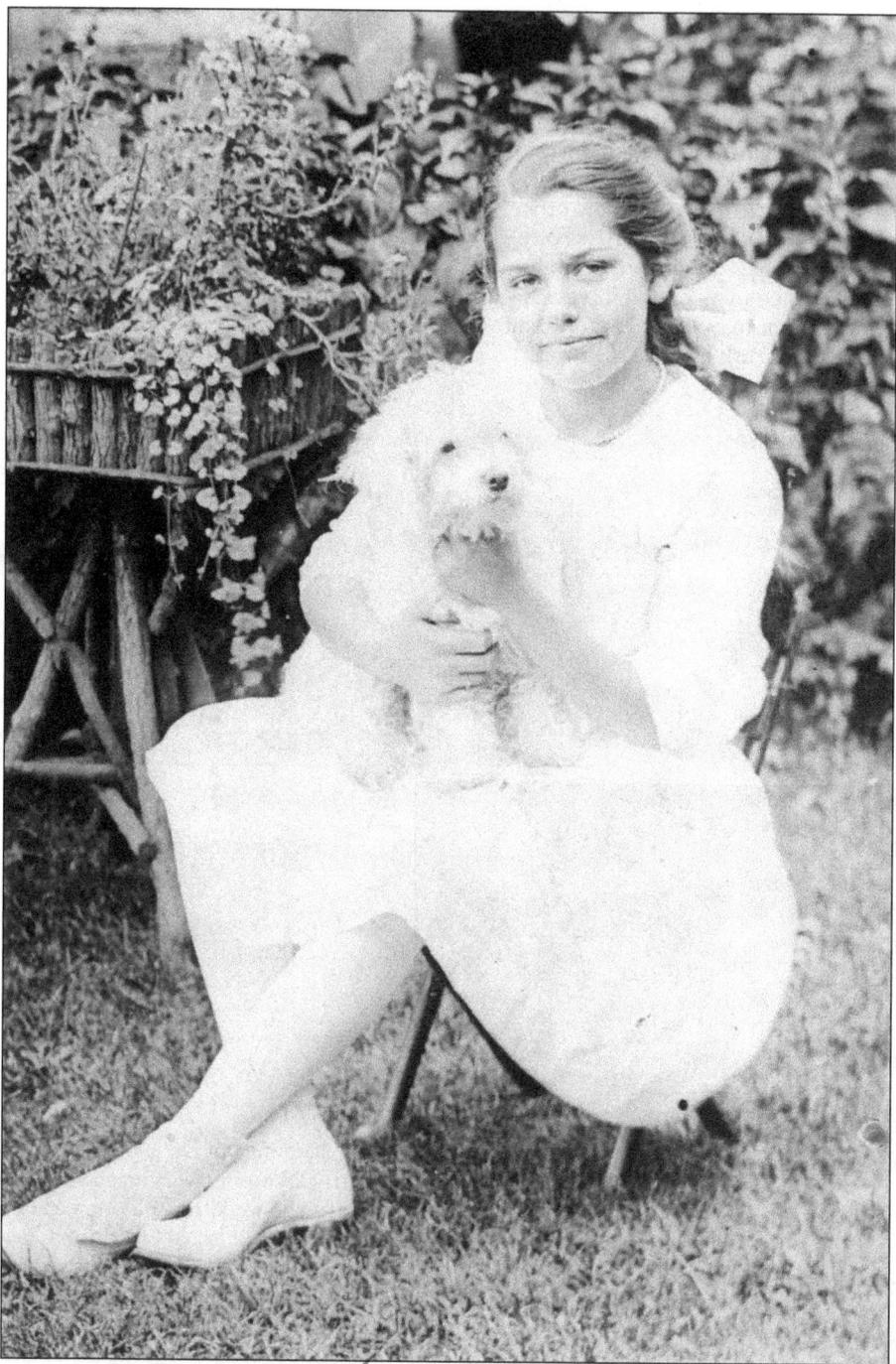

A young Grace Herhold and her dog, Trippy, are seen here about 1914. Herhold, born and raised in Old Irving Park, lived with her parents, Gustar and Anna Herhold, at 4121 North Keystone Avenue. The Herholds were active members of the Irving Park Presbyterian Church. Grace was captain of the first girls' hockey team at Carl Schurz High School. At age 85, she was featured in a 1989 *Chicago Tribune* story about Old Irving Park. (Courtesy Irving Park Historical Society, Grace Herhold Collection.)

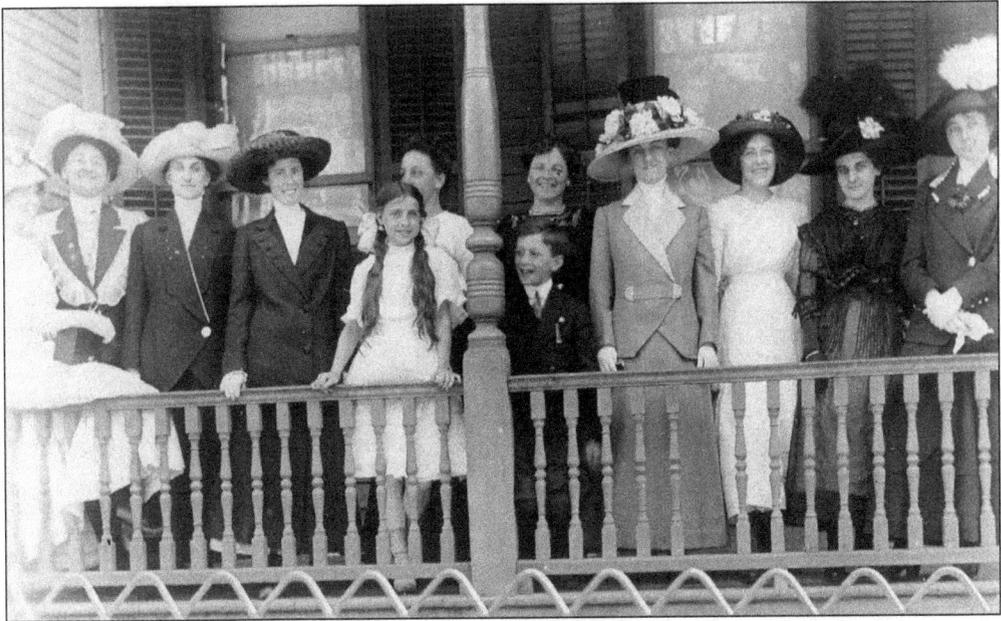

Well-dressed women and children stand on a porch in Old Irving Park in 1910. These members of the Irving Park Presbyterian Church were most likely dressed for Sunday service. (Courtesy Irving Park Historical Society, Grace Herhold Collection.)

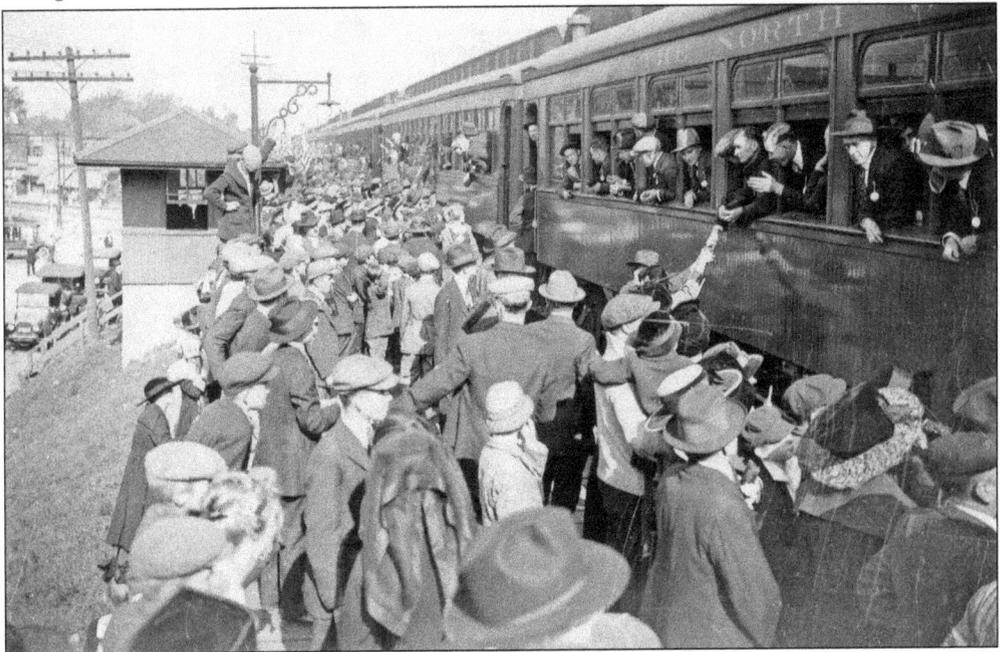

Young men drafted for military service during World War I prepare to leave from the Irving Park train station in 1917. Before the draftees boarded the trains, they participated in a patriotic procession, walking on a boardwalk between the railroad tracks. The procession was led by two drummers dressed in Colonial costumes, playing their drums, while a large crowd of family and friends, many waving American flags, cheered the men on. Automobiles are parked on the street near the elevated train station. (Courtesy Chicago History Museum.)

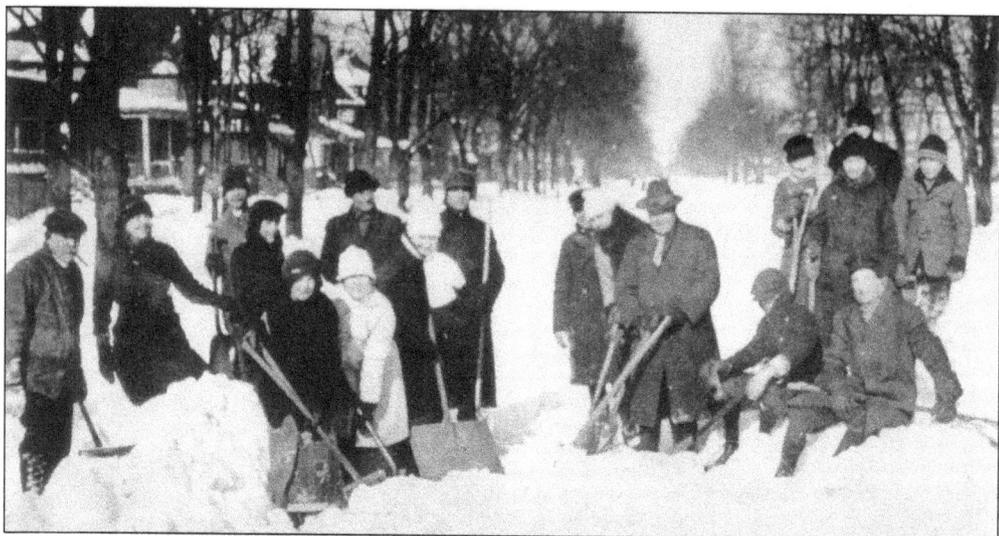

In two days in January 1918, about 15 inches of snow fell on Chicago. This snowfall added to five inches already on the ground. The blizzard paralyzed the city for days, as streetcars and suburban rail lines were put out of service. Coal could not be delivered to homes for heating. Thousands of citizens helped clear snow from streets. Here, residents dig out on the 4100 block of North Keeler Avenue. (Courtesy Irving Park Historical Society.)

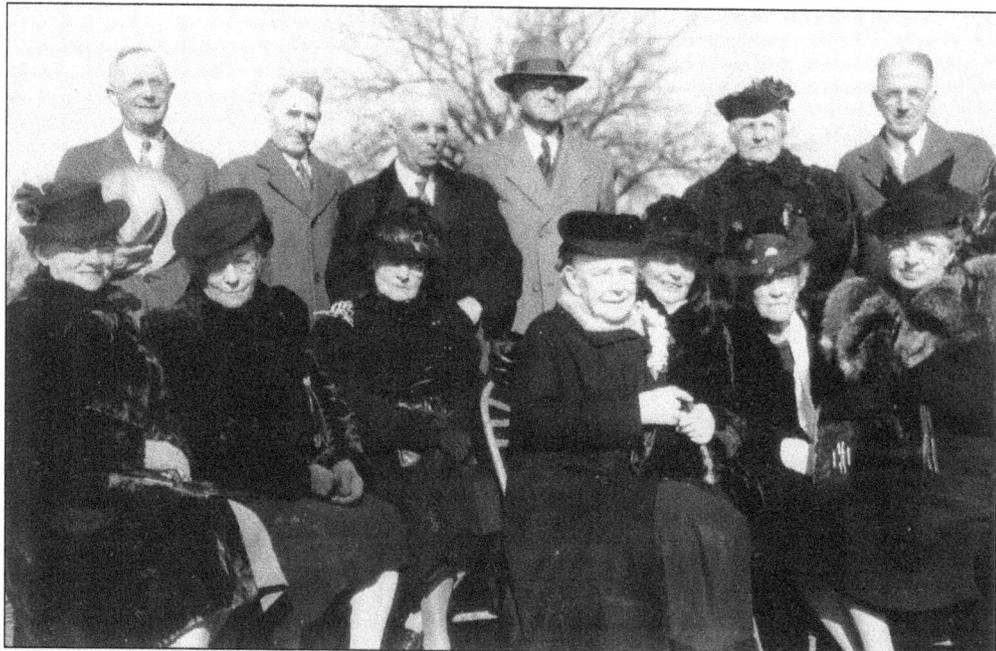

Ella LaBagh was a leader of the Irving Park Woman's Club. A prominent, longtime resident of Old Irving Park, she lived at 4222 North Kedvale Avenue. Her pioneering nature preservation efforts helped create the Cook County Forest Preserve District. Here, in 1940, the 85-year-old LaBagh (front, center) was honored in a gala ceremony complete with an honor guard. She is surrounded by friends and city and county officials. At the ceremony, a 600-acre tract of land at Cicero and Foster Avenues was named LaBagh Woods. A bronze plaque with her name was unveiled. (Courtesy Irving Park Historical Society.)

Two

RESIDENCES AND ARCHITECTURE

Old Irving Park is known for its handsomely restored older homes with their distinctive architectural features. Impressive and well-maintained homes are visible on every block. While the housing stock in some neighborhoods is homogeneous, Old Irving Park boasts a wide range of styles and periods. Vintage homes include a mixture of Victorian, Queen Anne, Italianate, Prairie School, Colonial Revival, American Foursquare, Ranch, and elegant bungalows and farmhouses. Many small and large homes have unique architectural details, like wraparound front porches, columns, cupolas, latticework, turrets, gables, and stained-glass windows.

The origins of some homes coincide with important periods in Chicago and American history. A few homes were built before and during the American Civil War. From their home cupolas, some early residents watched in amazement as the Great Chicago Fire of 1871 devoured a city just seven miles away.

Many homes from the 1870s and 1880s remain in remarkable states of preservation. A survey by the Irving Park Historical Society in 1985 estimated that several hundred homes in Old Irving Park predate 1894. Today, the society estimates that about 800 homes are over a century old. The Commission on Chicago Landmarks recognized the architectural and historical significance of several neighborhood homes, declaring them city landmarks. The commission has named 43 other residences as potential landmarks.

Several historic residences fell into disrepair and came close to being demolished. Instead, they were lovingly restored by new owners. In the process of restoration, some owners discovered hidden qualities, like preserved clapboard siding, fancy cut shingles, and stained-glass windows. A few owners also found secret trapdoors and rooms. Consequently, it is believed that the Ropp-Grabill, Charles N. Loucks, and John Gray residences—so named for their former owners—may have been part of the Underground Railroad, serving as temporary shelters for runaway slaves. Two historically significant residences are listed in the National Register of Historic Places.

Many visitors come to view the restored and well-kept residences of Old Irving Park. During the popular biannual housewalks, sponsored by the Irving Park Historical Society (IPHS), hundreds of visitors get a chance to see unique homes. Docents explain the important historical and architectural features of the homes. The IPHS also created, in 2010, a "century house project" to recognize homes within Old Irving Park that are a century or more old. Each year, the IPHS awards homeowners a bronze "century plaque" to display on the front of their homes.

Besides older homes, since the mid-1990s, the neighborhood has seen a steady increase in new construction. The new housing includes mainly single-family homes, townhouses, and condominiums.

Many homeowners take pride in their immaculate lawns and creative gardens. The Irving Park Garden Club, formed in 1990, actively encourages gardening and beautifying the neighborhood. At the northeast corner of Irving Park Road and Tripp Avenue, club members planted and maintain an eye-catching garden of various plants and flowers. They maintain roadside planters and other small gardens throughout the community.

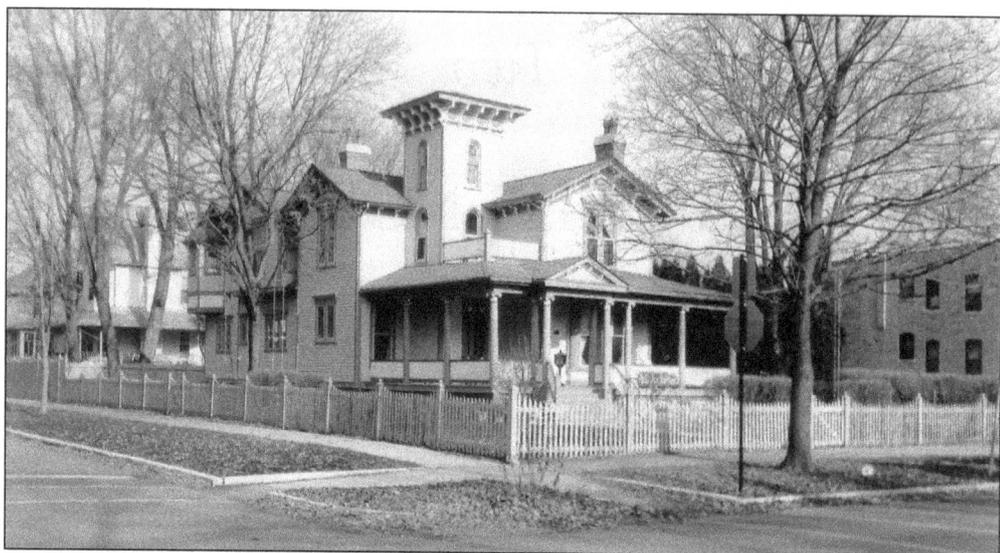

The John Gray Farmhouse, 4362 West Grace Street, was built about 1856. It is the oldest surviving home in Old Irving Park. An 80-acre farm originally surrounded the house, which predates the Civil War. The house belonged to John Gray, an early founder of Jefferson Township. The home, designed in the Italianate style, has been extensively renovated. It features a bracketed cornice, rounded windows, a cupola, and a large wraparound porch. (Photograph by Wilfredo Cruz.)

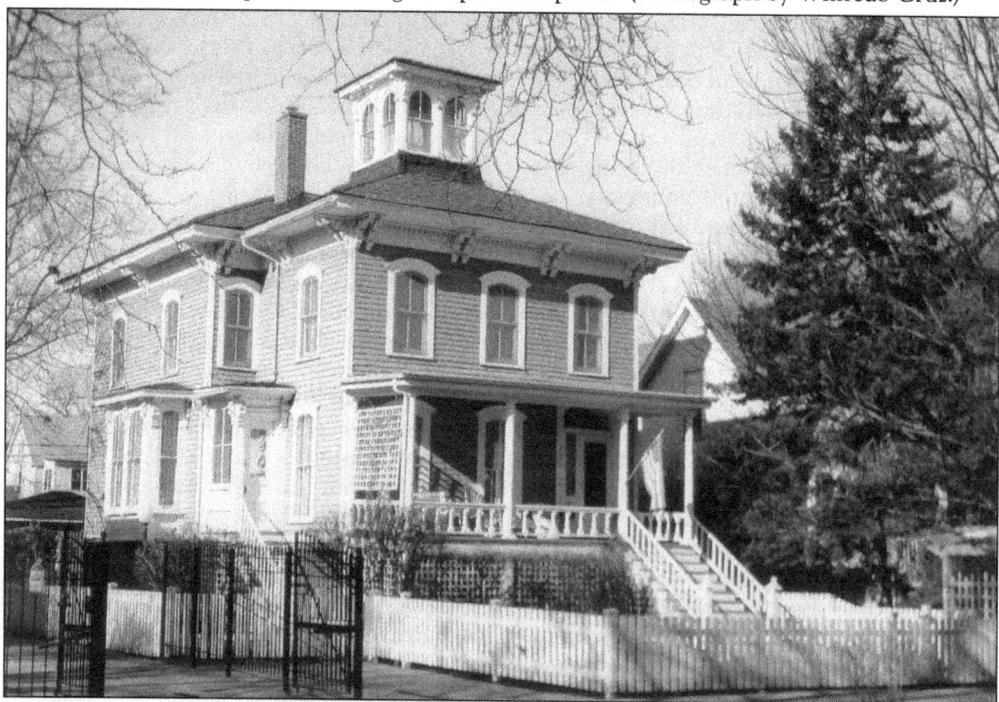

The Ropp-Grabill House, 4132 North Keeler Avenue, is a significant historical and architectural residence. Built in the early 1860s, it predates the founding of Irving Park in 1869. The home is an excellent example of the Italianate style of architecture. Its elaborate features include a bracketed cornice, arched windows, and a tall cupola. In 1985, it was listed in the National Register of Historic Places. (Photograph by Wilfredo Cruz.)

This quaint, Victorian-style house stands on the corner at 3804 North Keeler Avenue. It was built in 1866, one year after the Civil War ended. It has interesting features like clapboard siding, a multilayered, wood-shingled roof, intricate bay windows, gables on all sides, a combination of paint colors, and a cupola. (Photograph by Wilfredo Cruz.)

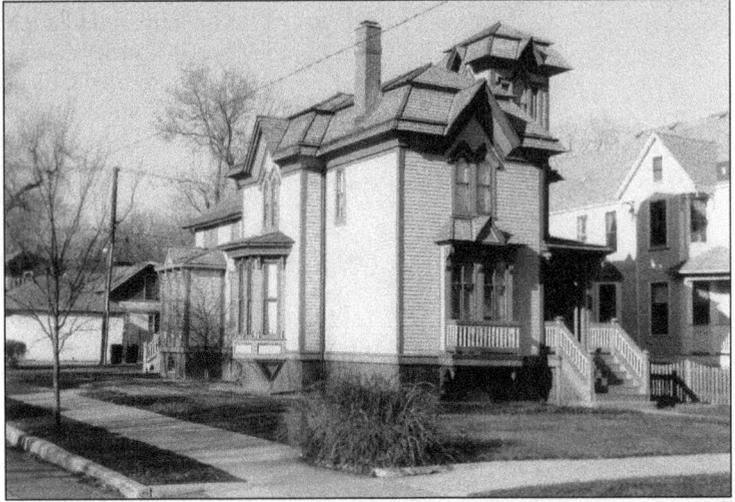

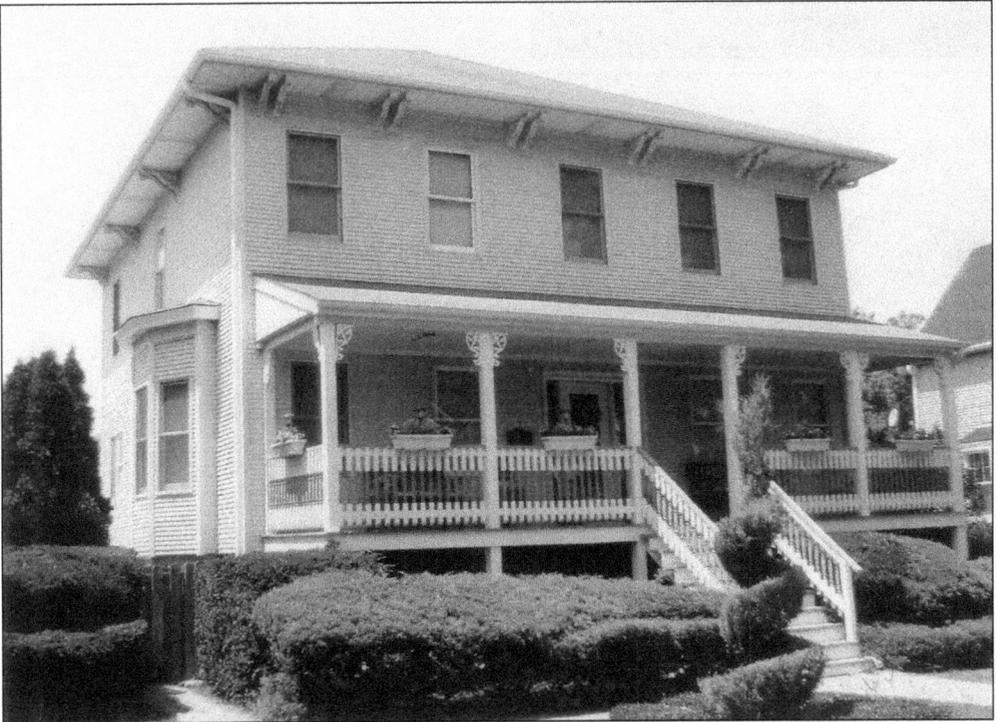

The Erastus Brown House, 3812 North Pulaski Road, was built in 1869. Erastus Brown was the father of John S. Brown and Adelbert E. Brown. The brothers were founders of Irving Park and early partners in the Irving Park Land Development Company. The house is a frame Italianate structure, but its exterior has been significantly changed. It once had large rounded windows and a tall cupola in the roof's center. At one time, the home was surrounded by large grounds of manicured lawns and shrubs. (Photograph by Wilfredo Cruz.)

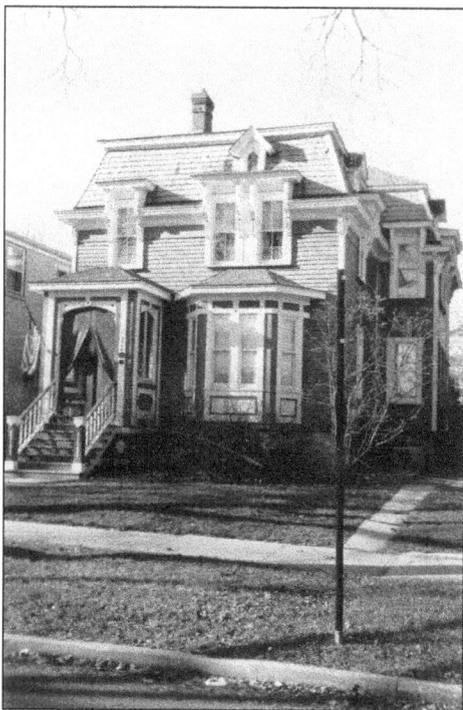

The John and Clara Merchant House, 3854 North Kostner Avenue, was built about 1872. It was awarded Chicago Landmark status by the Commission on Chicago Landmarks in 2008. The house, the commission wrote, "Is a handsome Second Empire–style building . . . noteworthy for its high-profile mansard roof and original detailing, including its oversized window hoods, finely-carved cornice and window brackets . . . the Merchant House represents the Irving Park's neighborhood's development as an early 'railroad suburb' of Chicago." (Photograph by Wilfredo Cruz.)

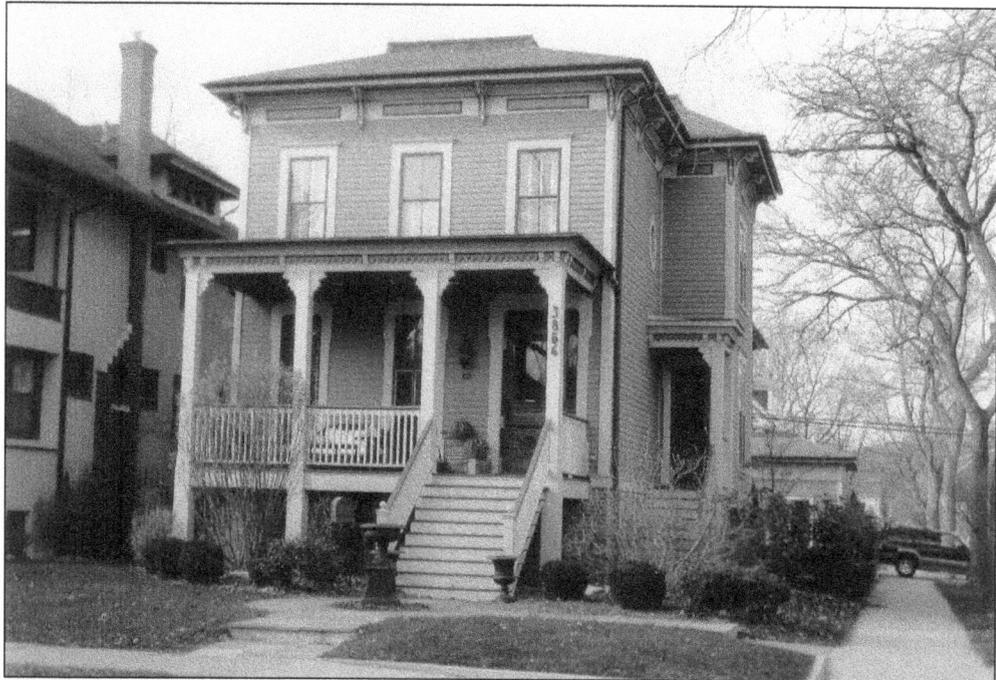

The Wheeler-Osborn House, 3856 North Kildare Avenue, is an Italianate home built about 1872. It was owned by John Wheeler, one of the original four founders of Irving Park. Wheeler was related through marriage to the Charles T. Race family. It is believed that architect Henry Rehwoldt designed the house. James Natoli and his wife, Kate Meints, currently own the house. Natoli is president of the Irving Park Historical Society. (Photograph by Wilfredo Cruz.)

The Stephen A. Race House, 3945 North Tripp Avenue, is a restored brick Italianate mansion built about 1873. Stephen A. Race was the brother of Charles T. Race. It is the last surviving home of Irving Park's founding family. The house, which originally fronted Irving Park Road, was turned 90 degrees and now fronts Tripp Avenue. It features an ornately bracketed roofline, tall arched windows, and an intricate bay window. In 1988, it was designated a Chicago Landmark by the Commission on Chicago Landmarks. (Photograph by Wilfredo Cruz.)

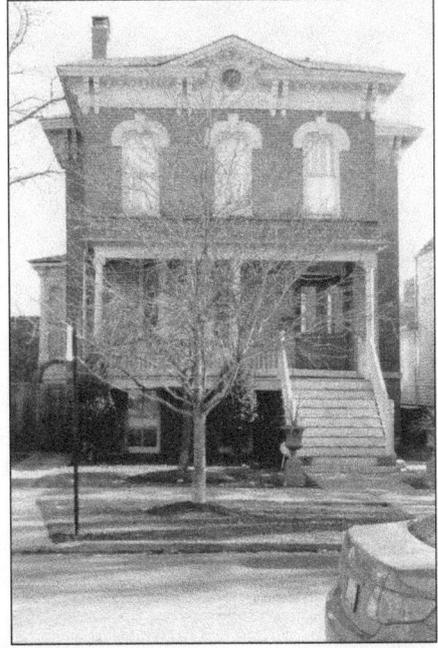

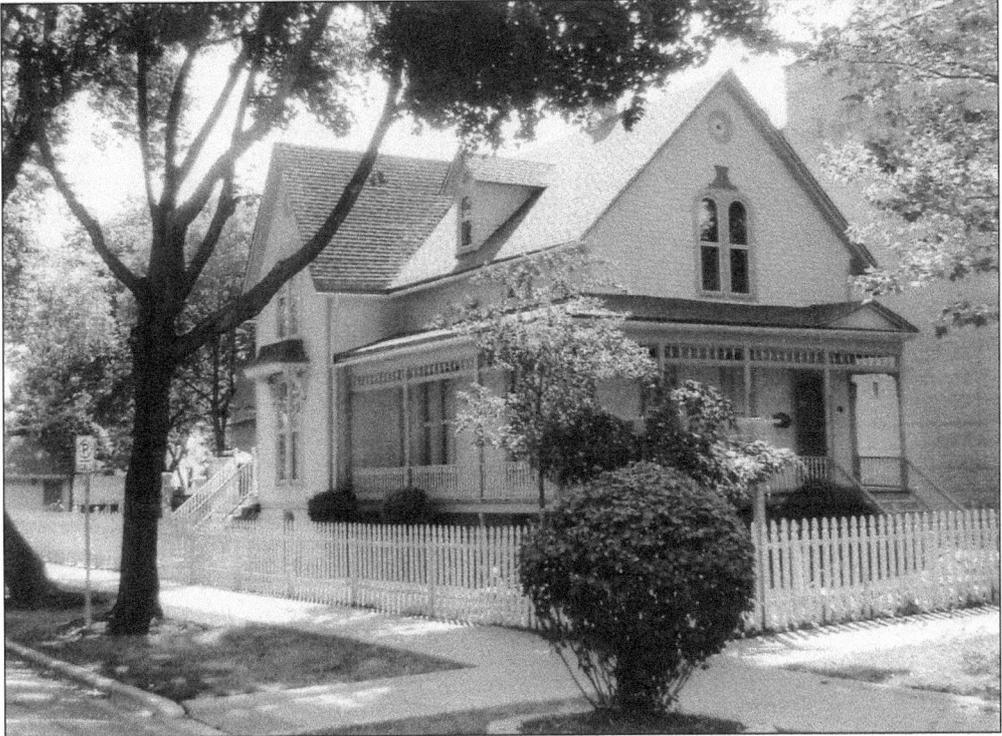

This Victorian-style house at 3857 North Kedvale Avenue was built about 1873. For a number of years, it stood vacant and in total disrepair. It appeared headed for the wrecking ball, but the current owners carefully restored it. The house features clapboard siding, gables, rounded windows, and a wraparound porch. A small wood sign over the stairs reads "circa 1873." (Photograph by Wilfredo Cruz.)

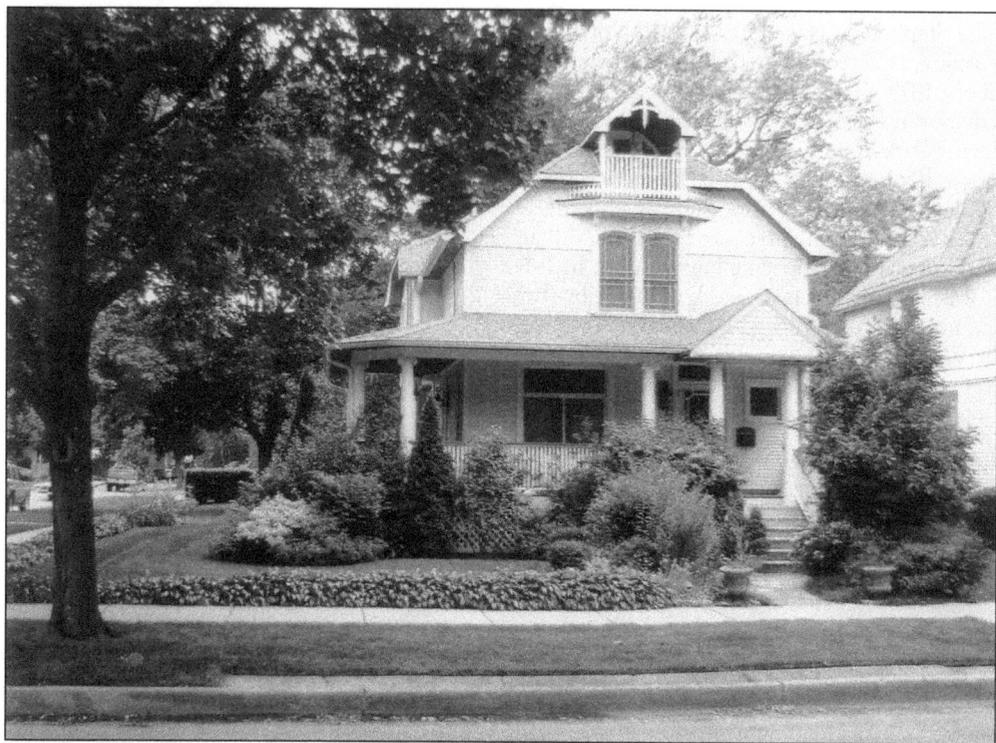

This Victorian-style house at 3800 North Lowell Avenue was built about 1878. It has a unique small porch near its roofline, fish-scale siding, columns, and a wraparound front porch. The front, side, and back of the house feature impressive landscaping and creative gardens. (Photograph by Wilfredo Cruz.)

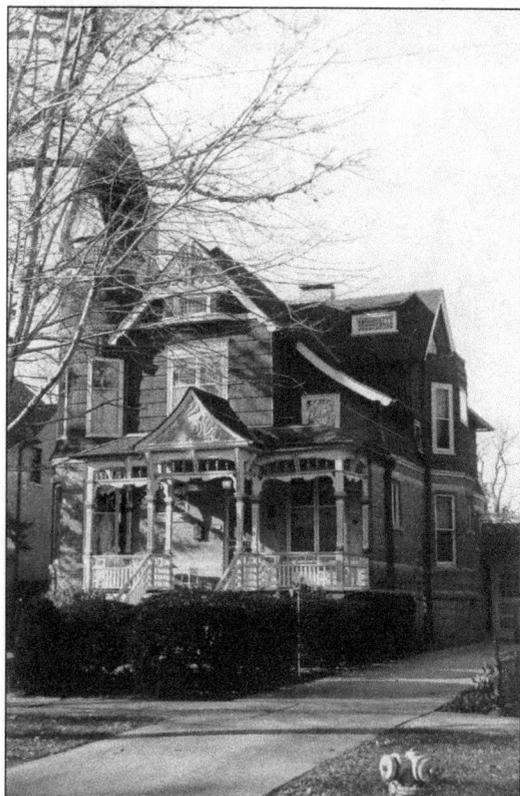

The Charles N. Loucks House, 3926 North Keeler Avenue, was built in 1889. It was designed by architect Clarence N. Tabor. This Queen Anne Victorian home features various surface materials and ornate details. Pressed tin ornamentation is used over the front porch, roof peak, and turret windows. It has a unique turret and asymmetrical stained-glass windows. In 1971, the house was almost sold to a builder who was going to demolish it and replace it with an apartment building. In 1984, it was added to the National Register of Historic Places. In 2008, it earned Chicago Landmark status from the Commission on Chicago Landmarks. (Photograph by Wilfredo Cruz.)

Built in 1887, this house at 4159 North Tripp Avenue is considered a Tri-Gable Ell, a variation of a simple farmhouse. This style of home has two stories, a rectangular plan, and two intersecting rectangles forming an ell. The roof has three gables, hence the name. The home features original interior woodwork and stained-glass windows. (Photograph by Wilfredo Cruz.)

This house at 4142 North Kedvale Avenue was built about 1887. It is a classic frame Victorian. The first owners, Arthur and Rachel Berry, owned the house for 12 years. He was president of A.V. Berry and Company, an iron contractor and manufacturer of street lamps. The second owners, Arthur and Margaret Walmsley, remained in the house for 52 years. (Photograph by Wilfredo Cruz.)

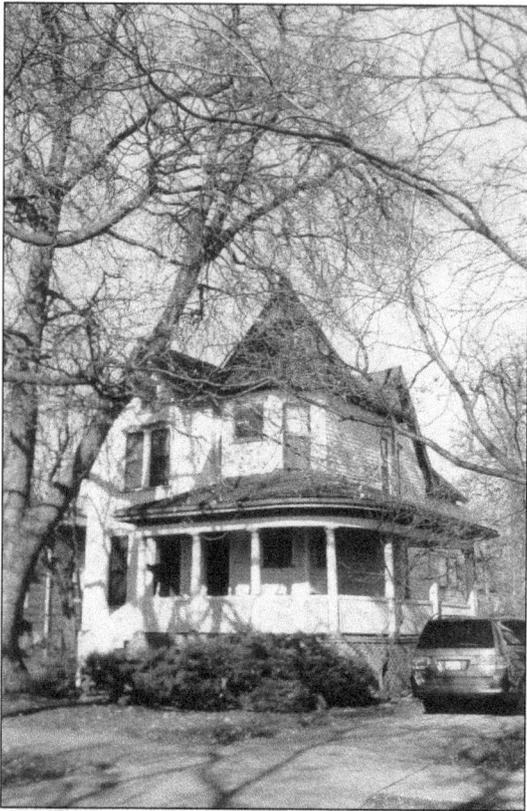

This Princess Anne Victorian house, 4016 West Belle Plaine Avenue, was built in 1889 for John Monk and his wife. The house features unique windows, a turret, and a wraparound porch. Monk was a noted lawyer from Onawa, Iowa, who successfully defended Iowa farmers against the railroads cutting through their farms. His daughter, Alice, became a missionary to Japan. She founded a girls' school in Sapporo, Japan. (Photograph by Wilfredo Cruz.)

Interior photographs of older homes are hard to come by. This is the dining area of a home in Jefferson Park, a neighborhood a little north of Old Irving Park. The photograph is illustrative of the decor and furnishings of some late-19th-century homes. While some residences were pretentiously furnished and decorated, others, like this one, were less decorated and more functional. A piano is just visible on the right. (Courtesy Northwest Chicago Historical Society.)

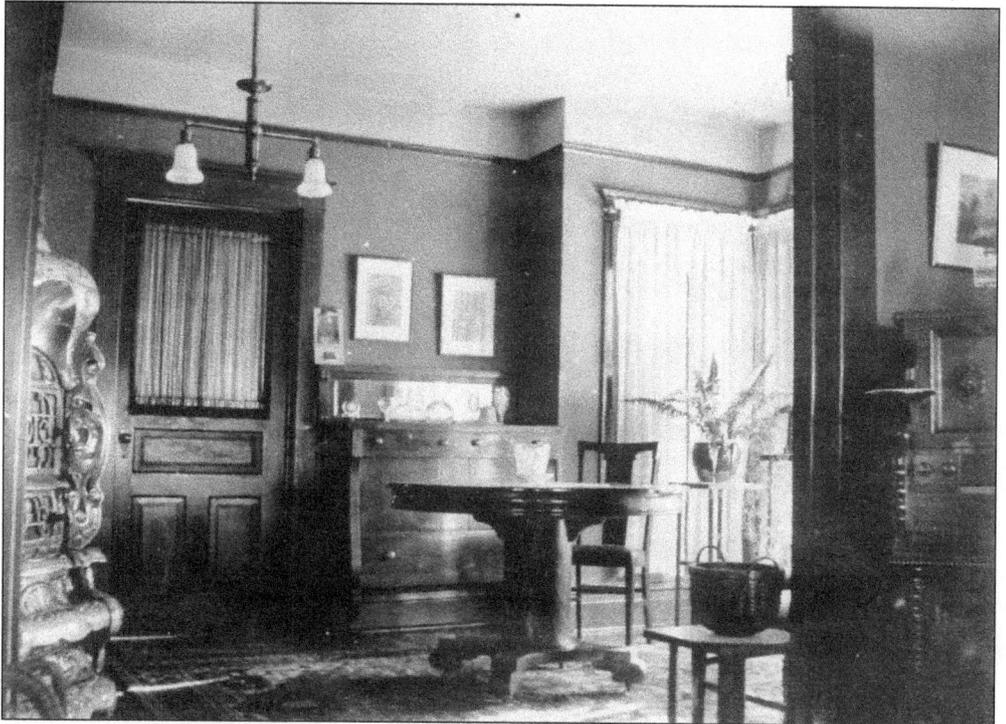

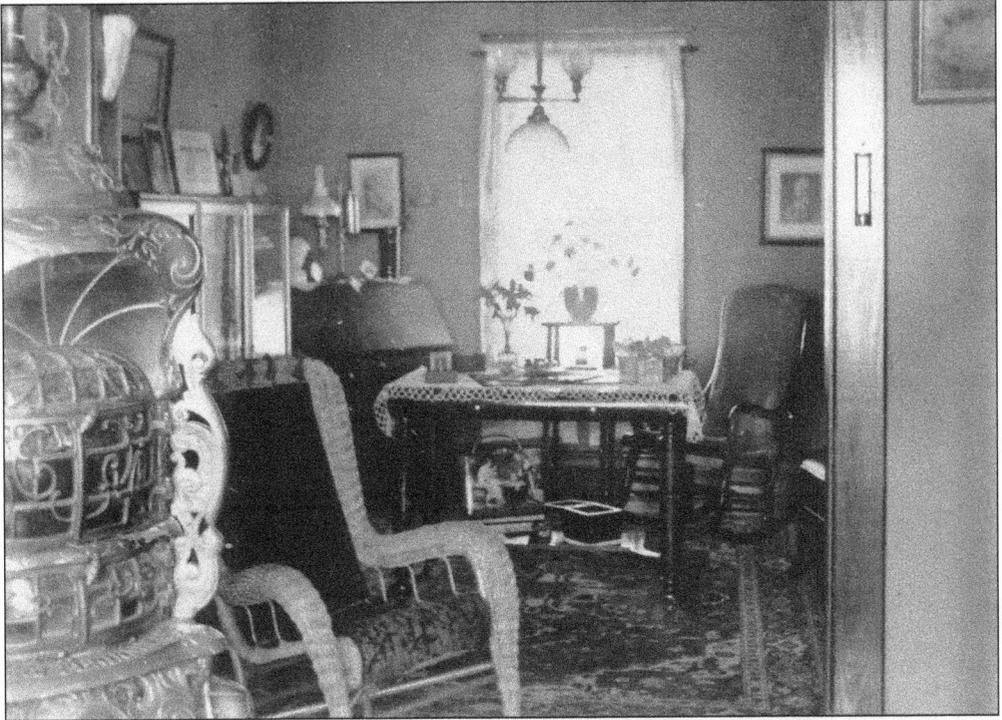

This is a small room in the same Jefferson Park house. The wood- or coal-burning heater (left) was made by the Peninsular Company. A cast-iron heater was an expensive purchase but provided essential heat to families during frigid Chicago winters. An old-fashioned desk is in the corner, and framed family photographs are on the wall. A thermometer (right) is mounted on the wood trim. (Courtesy Northwest Chicago Historical Society.)

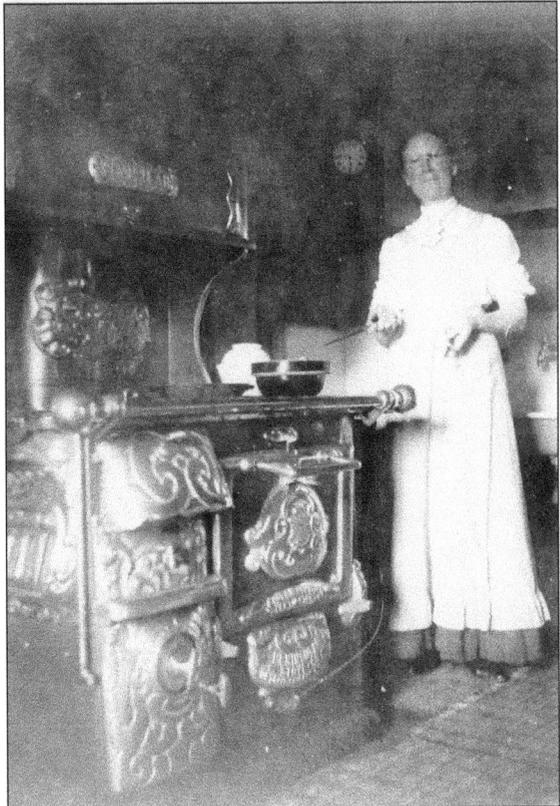

This woman, named Anna, owned the late-1800s Jefferson Park house seen in the previous two photographs. She is shown here in her kitchen standing at her cooking stove, which was made by the Peninsular Company. A wall clock and sink are visible. The refrigerator was a wooden icebox that used large blocks of ice to cool food. The floors have area rugs, probably for added warmth. (Courtesy Northwest Chicago Historical Society.)

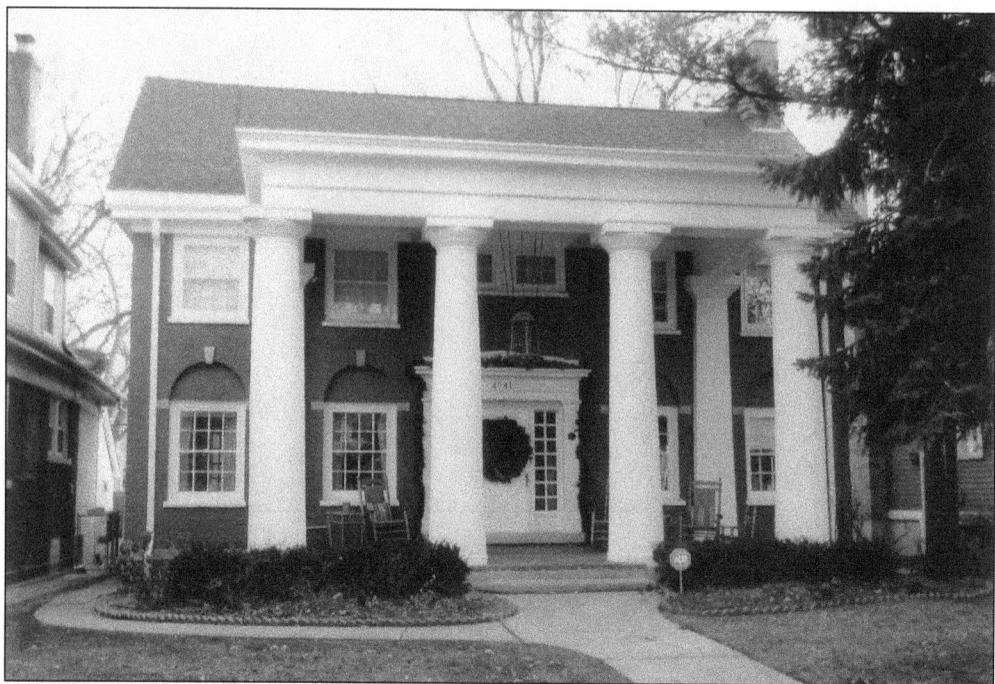

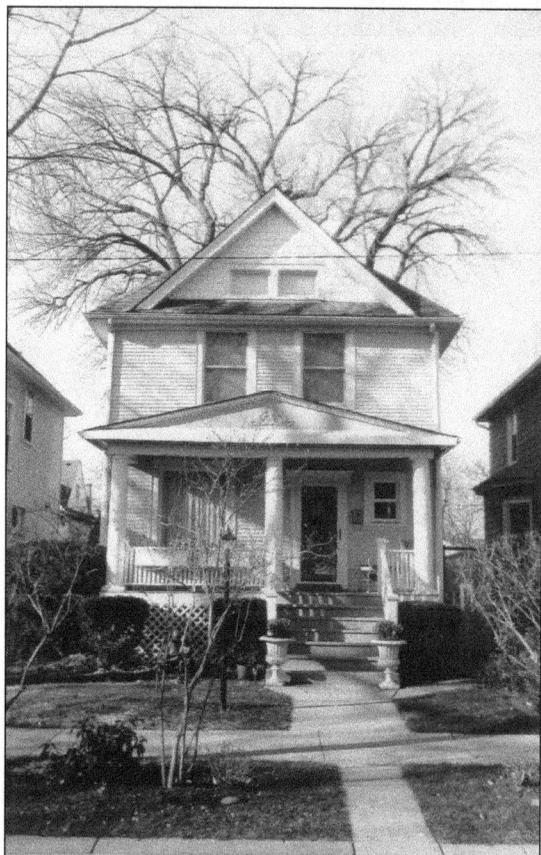

The Elmer C. Jensen home, 4041 North Lowell Avenue, was built in 1905. Jensen, a noted architect, designed the home as his personal residence. The two-story, redbrick residence is a striking example of the Colonial Revival architectural style. It features 18-foot brick columns flanking the traditional doorway. Inside are several fireplaces. Among Jensen's other notable works are the Union League Club, Kraft Foods Building, and Sears's State Street store. Jensen also designed a church and various homes in Old Irving Park. (Photograph by Wilfredo Cruz.)

The house at 4040 North Kilbourn Avenue was built in 1906. It is an American Foursquare, a style of architecture popular from the mid-1890s to the 1930s. The American Foursquare home is usually two-and-one-half stories high, squarely built, with large windows, prominent, overhanging eves, a dormer in the middle, and a front porch extending across the frame. This home has a massive ash tree in the backyard that is over 200 years old. (Photograph by Wilfredo Cruz.)

The house shown here, 3901 North Kildare Avenue, belongs to the Prairie School style of architecture. It has a stucco exterior, prominent, overhanging eves, stained-glass windows, and large gables. The house, built in 1911, has had over 10 different owners, including some who rented parts of the house to tenants. In 2012, the entire house was extensively renovated, and an addition and new stucco were added. (Photograph by Wilfredo Cruz.)

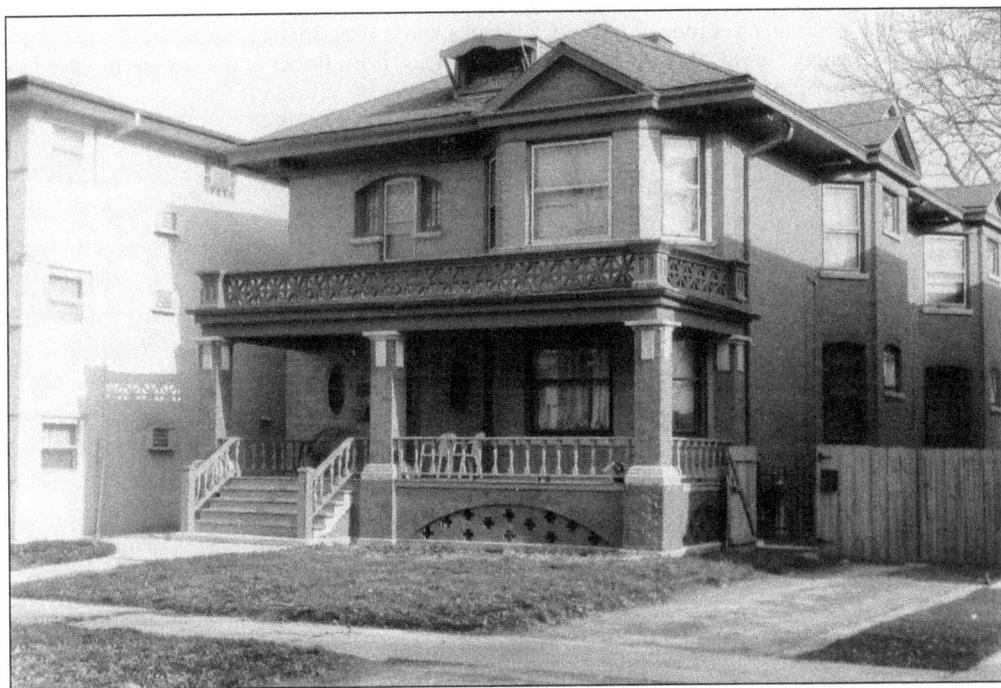

This two-flat apartment building at 4221 North Kedvale Avenue was built about 1910. The Prairie School home was designed by John S. Van Bergen, who was born in Oak Park and was employed, in 1909, by Frank Lloyd Wright. Later, Van Bergen designed homes in the Prairie School style in Chicago and the suburbs. A few suburban homes he designed are listed in the National Register of Historic Places. (Photograph by Wilfredo Cruz.)

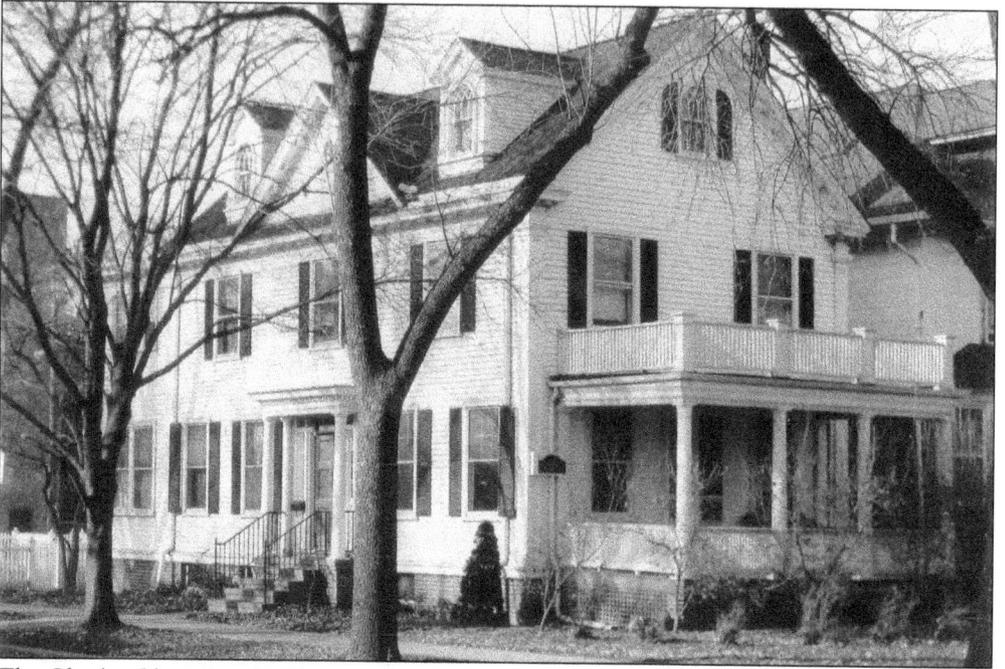

The Charles Olney Loucks House, 3900 North Keeler Avenue, was built in 1913. The Colonial Revival home features columns, shutters, dormers, a grand-entry door, a maid's room, a servants' staircase, and a summer veranda. Charles O. Loucks was a prominent lawyer with an office in downtown Chicago. He was the son of Charles N. Loucks. Both father and son were involved in various civic organizations in Old Irving Park. (Photograph by Wilfredo Cruz.)

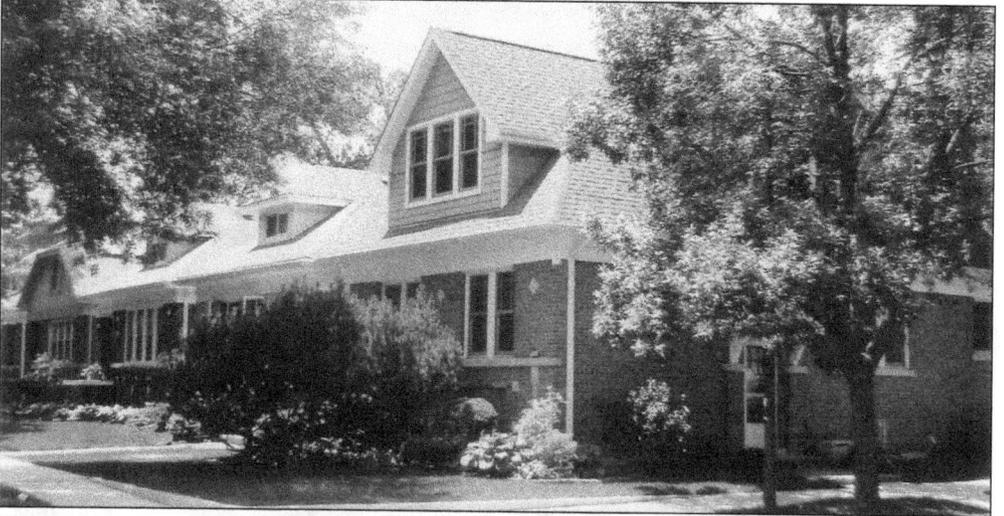

Shown here is a row of well-maintained Chicago-style bungalows in the 3700 block of North Kedvale Avenue. Bungalows emerged in Chicago between World War I and the Great Depression. The sturdy, single-family bungalow is one of Chicago's very popular architectural styles. Their affordability made home ownership a reality for thousands of Chicagoans. Many bungalows feature leaded-glass windows, front bays, clay-tile roofs, and intricate stone detailing. Some homeowners create more living space by building dormers and additions atop of their bungalows. (Photograph by Wilfredo Cruz.)

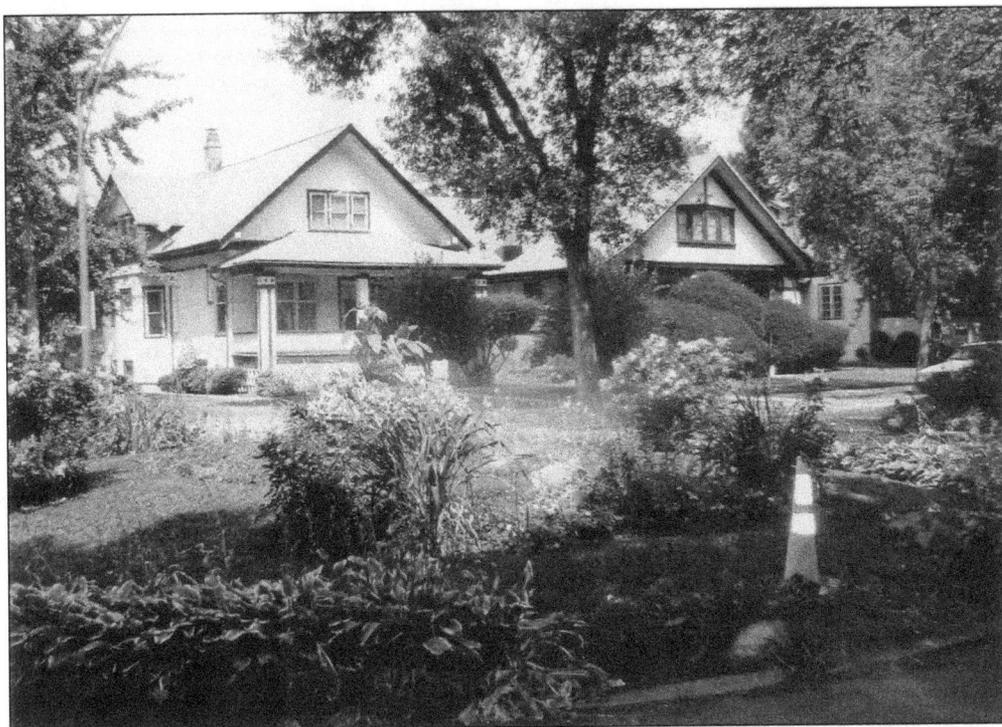

The Villa is a historic neighborhood to the east of Old Irving Park. The area, roughly seven square blocks, contains over 100 homes, mostly Chicago- and California-style bungalows, like these in the 3700 block of North Harding Avenue. Homes were built in the Prairie and Craftsman styles between 1907 and 1928. About 20 homes were designed by architects Clarence Hatzfeld and Arthur Knox. In 1979, the neighborhood was listed in the National Register of Historic Places. In 1983, it was designated a Chicago Landmark District by the Commission on Chicago Landmarks. (Photograph by Wilfredo Cruz.)

This home, 4112 North Keeler Avenue, was built in 1923 for Gerald R. Scott. He was a clerk with the Continental and Commercial Trust and Savings Bank. It is a good example of the Dutch Colonial style, typified by the hipped roof. The house has a side entrance. The interior features a fireplace, original staircase, china hutches in the dining room, and cove moldings. (Photograph by Wilfredo Cruz.)

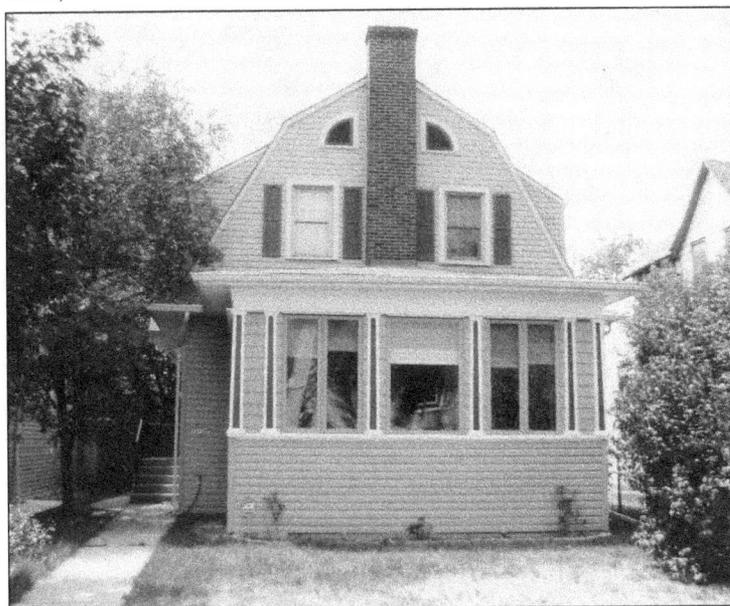

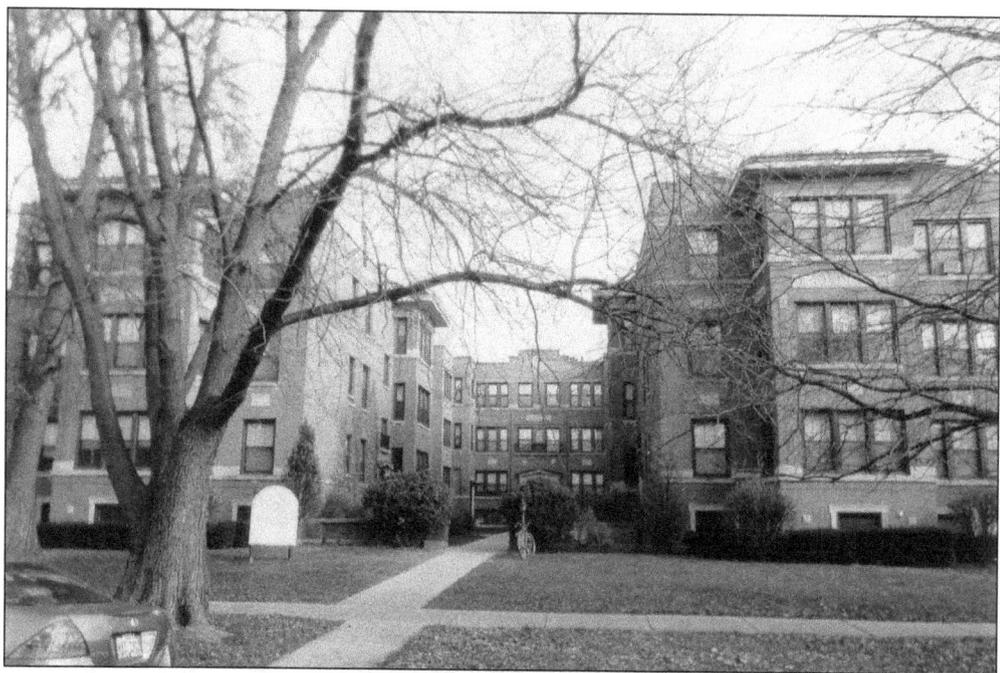

Keeler Court is a large, well-kept apartment building in the 3900 block of North Keeler Avenue. The building was likely constructed during the early 1900s, along with other neighborhood apartment buildings. Most Old Irving Park residents are homeowners, but some are tenants. Renters are attracted to the neighborhood's residential nature, affordability, and easy access to public transportation. (Photograph by Wilfredo Cruz.)

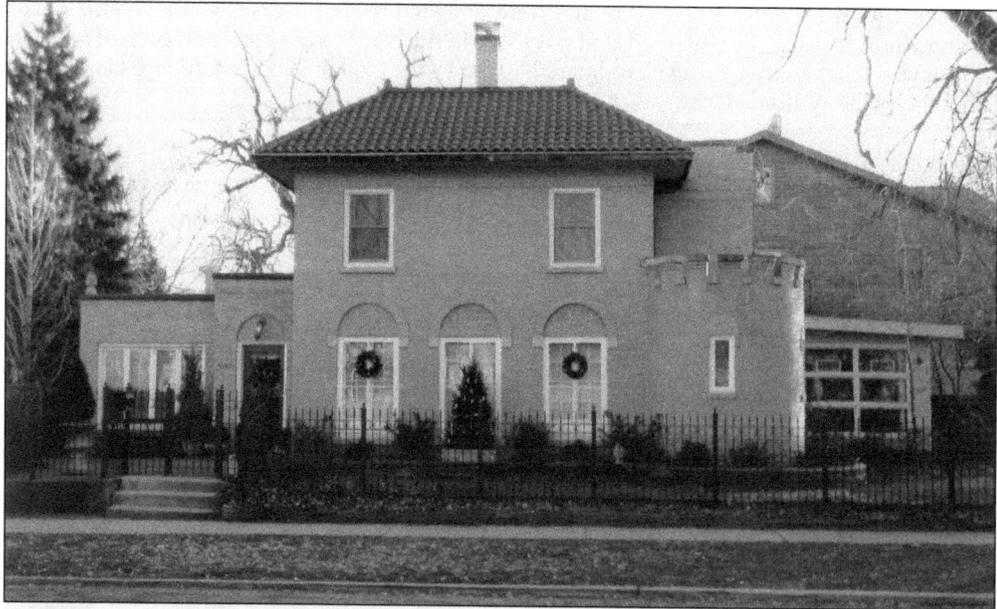

The Warnesson-Dressler House, 4165 West Berteau Avenue, was built in 1927. Jules Warnesson and his wife had this house built for their daughter Edith after her marriage to a Mr. Dressler. The home, built in the Spanish Colonial style, features beige-colored brick, tall arched windows, a clay-tile roof, and leaded-glass windows. (Photograph by Wilfredo Cruz.)

44

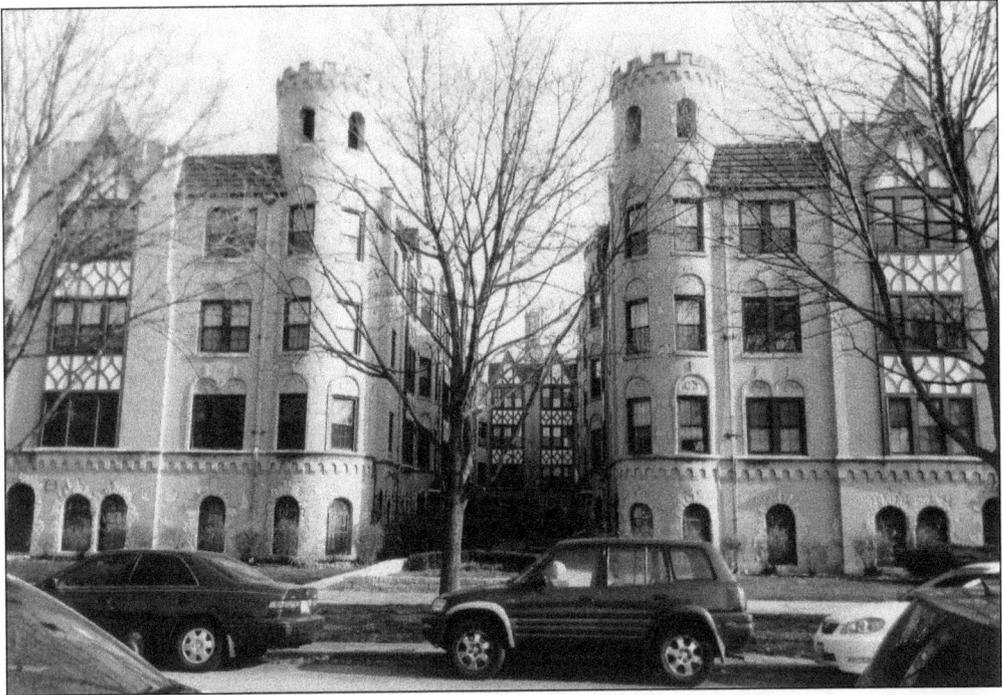

This castle-like courtyard apartment building at 4205 North Kedvale Avenue was constructed in 1929 by brothers from Bavaria, Germany. It resembles the castles of Germany, complete with turrets, striking stone detailing, and gargoyles. Lobby areas feature intricate floors, artificial fireplaces, heavy arched doors, and leaded-glass windows. (Photograph by Wilfredo Cruz.)

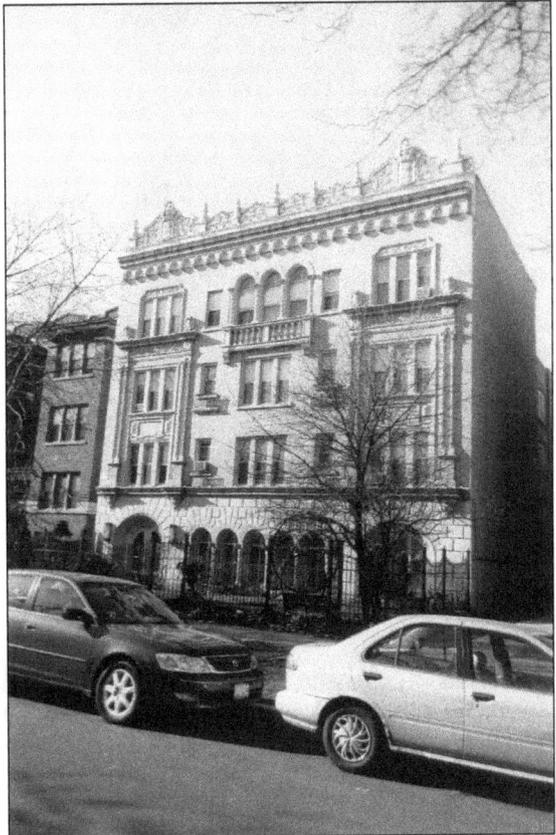

The Seville, 4142 North Keystone Avenue, is a 1930 Moorish-style apartment building. It was constructed as an upscale hotel for single women working in Chicago's downtown. The women had easy access to downtown via the nearby Chicago & North Western Railway. The building's facade features intricate terra-cotta detailing, particularly along its roofline. (Photograph by Wilfredo Cruz.)

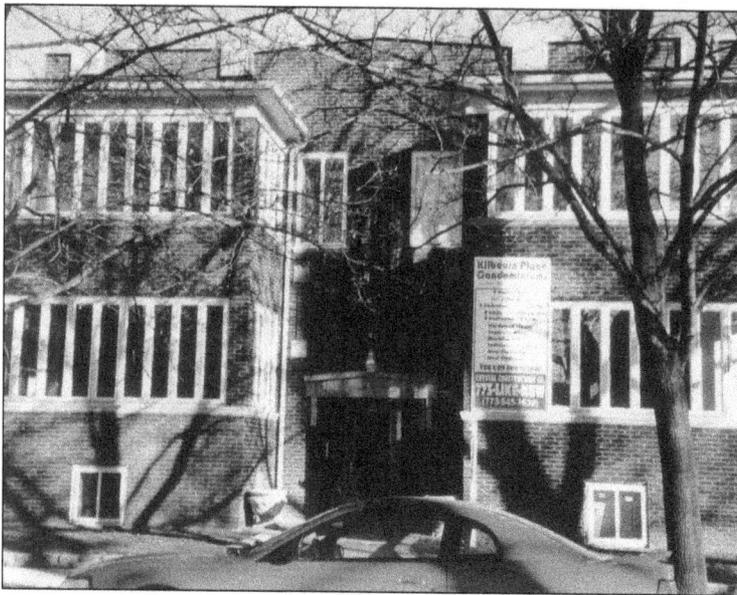

This apartment building in the 4000 block of North Kilbourn Avenue went on the market in the mid-1990s. It was immediately purchased and converted into four condominiums. The two lower units are duplexes, with added living quarters in the former basement. The units were quickly sold to young professional couples with children. (Courtesy Irving Park Historical Society.)

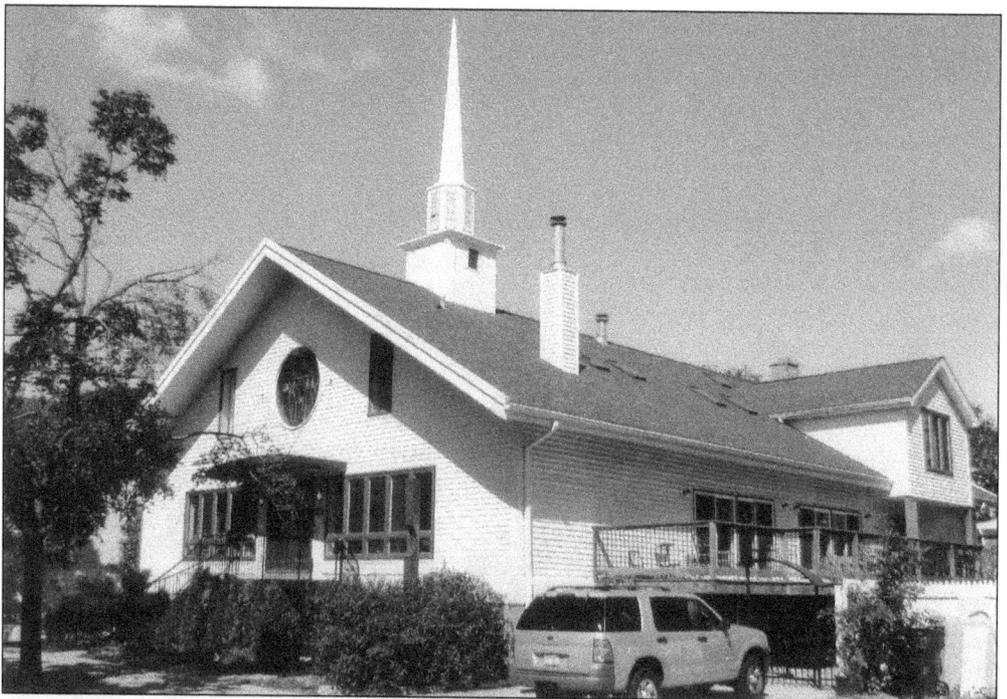

Completed in 1989, this building served as the Sacred Heart of Jesus Old Roman Catholic Church. "Old Catholicism" is a little-known brand of Catholicism that differs greatly from traditional Catholic beliefs. In the late 1990s, the building at 4154 West Berteau Avenue was sold, rehabbed, and converted into two condominiums. The stained-glass windows were removed, but the steeple of the former church remained. (Photograph by Wilfredo Cruz.)

46

These single-family homes in the 4400 and 4500 blocks of West Berteau Avenue are part of Terraces of Old Irving Park, a housing development of 89 single-family homes built on an 11-acre site. The homes were constructed in 1995 by C.A. Development and designed with Victorian detailing. This site was formerly a beer distribution warehouse. Palumbo Brothers construction firm wanted to use this site for dumping construction concrete and debris. Residents opposed, and homes were built instead. (Photograph by Wilfredo Cruz.)

These townhouses, along the 4500 block of West Irving Park Road, are part of Residences of Old Irving Park, a housing development of 55 single-family homes. C.A. Development built this block in 2006. Other homes were built as well, in various styles, with small front yards, backyards, or porches. This location was formerly occupied by a used car dealership and, later, a television cable company. (Photograph by Wilfredo Cruz.)

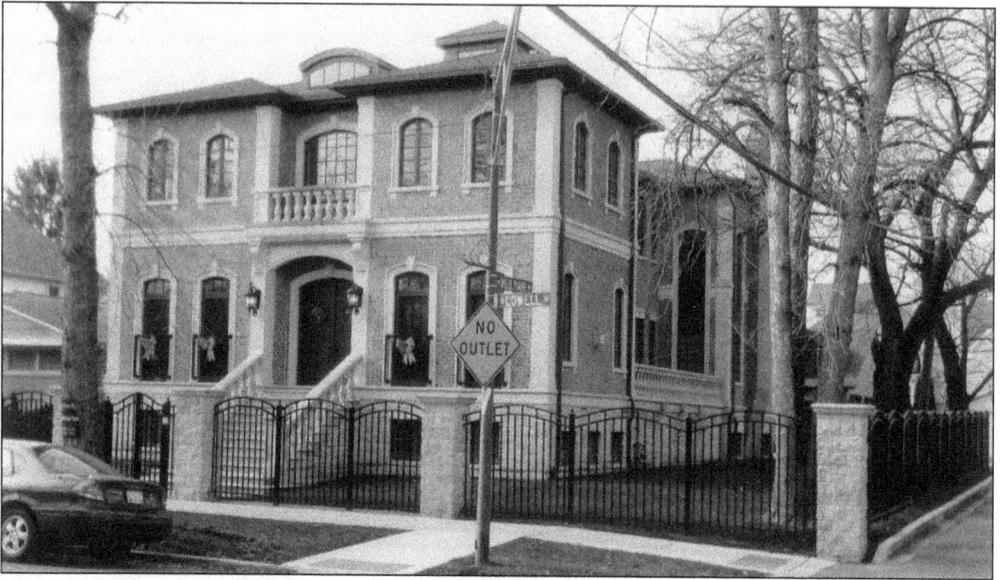

This is a newer brick house in the 3900 block of North Lowell Avenue. The home has a grand entrance with large front steps, arched doorway, and massive double-entry doors. It has arched windows, stylish concrete balusters, and a glass-enclosed section in the back and, outside, a big wrought-iron fence. (Photograph by Wilfredo Cruz.)

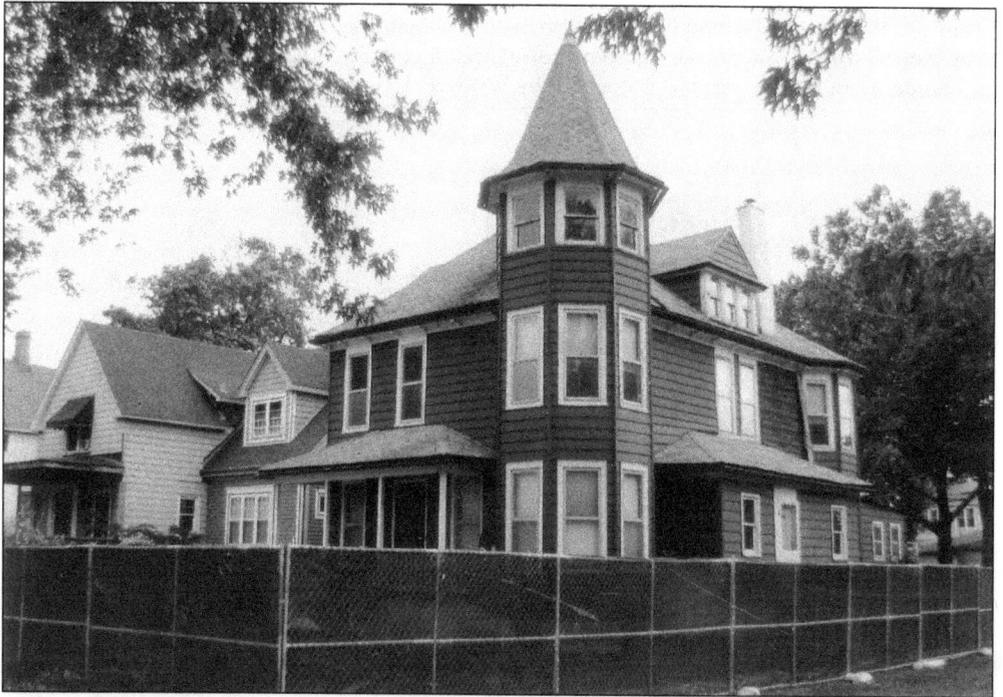

Some residents care about preserving older homes. But other homeowners believe it is more cost-effective to raze these structures than restore them. This large frame house in the 3800 block of North Keeler Avenue, more than a century old, met the wrecking ball in 2012. Before demolition, its large oak staircase was removed intact. Then, in two days, the home was reduced to rubble and hauled away. A modern brick single-family house replaced it. (Photograph by Wilfredo Cruz.)

Three

RELIGION

Historically, the church was a crucial institution for immigrants. Upon arriving in a new place, immigrants quickly embarked on building their own ethnic church, which served as a sanctuary, helping to ease their struggles and validate their lives. It also helped newcomers assimilate in a new culture and become full Americans.

Early arrivals to Old Irving Park placed great importance on building churches. It is a community steeped in religion, with a vibrant tapestry of different faiths. There are nearly a dozen churches in close proximity. Some churches had humble beginnings, with residents coming together in a member's home or in a modest storefront church. Later, members pooled their money and ingenuity to built elegant churches.

The first settlers were mainly Protestant. The Dutch Reformed Church was the first church built, in 1872. The building, a large wooden Gothic structure, was completed at a cost of $9,000 on land donated by Charles T. Race. The architect was Henry Rehwoldt, an Irving Park resident who designed many neighborhood homes. The early congregation consisted of various denominations, and later, some members broke away and formed their own Protestant churches.

The charming St. John's Episcopal Church is Old Irving Park's second-oldest church structure. The building was completed in 1888 at a cost of $3,500. The white stucco exterior and main entranceway were added in the 1920s. Architect Clarence Jensen renovated the structure to its current form in 1924. On its golden anniversary in 1938, St. John's received congratulations from Pres. Franklin D. Roosevelt, who wrote, "In the hope that St. John's, which has now completed fifty years of spiritual service, may long continue to bear witness to the eternal truths of religion. I send hearty felicitations and warmest personal greetings."

Impressive churches were subsequently built for various denominations, including Catholic, Baptist, Lutheran, Christian, Methodist, Christian Science, Masonic Temple, and Salvation Army. It was in these churches that families came together to socialize, sing, and worship. Religion gave families hope for a brighter future. Families were joined in marriages and performed sacraments of confirmation, communion, baptism, and burial.

Over the years, church leaders have worked to improve the neighborhood. Besides religious services, churches provide social services like day care, after-school sessions, and summer camps. Due to the Great Recession, which began in late 2007, churches are now seeing more dependent people. Some churches sponsor food, clothing, and toy drives for needy residents.

Other demographic and ethnic changes have impacted churches. Some have seen their congregants age or move to the suburbs. Some churches have become nondenominational to attract new members. A few churches have changed ownership and have become Korean Presbyterian, Greek Orthodox, and Spanish Pentecostal. A new Christian church and Muslim mosque have been formed. In years past, the languages heard in the churches were English, German, Swedish, and Scandinavian. Now, one hears English and Spanish, Greek, Korean, and Arabic.

But some things have not changed. Like days of old, on Sundays, the churches are filled with worshippers. And soothing church bells can still be heard ringing throughout the neighborhood.

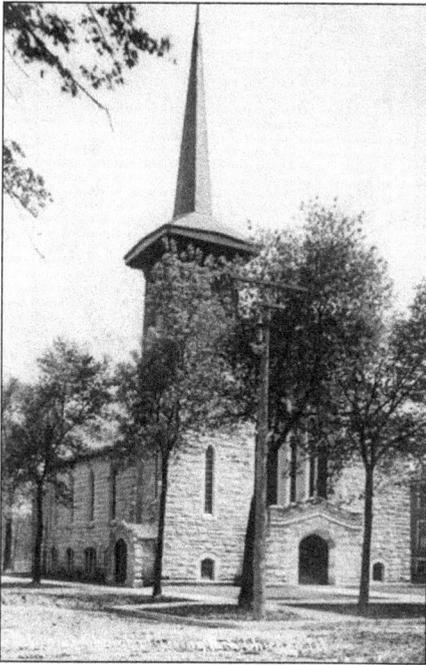

The Dutch Reformed Church of Irving Park, 4047 North Keeler Avenue, was built in 1872. Designed by architect Henry Rehwoldt, this was the first church built in Irving Park. In 1908, architect Elmer C. Jensen designed the larger, Bedford stone-clad structure that stands today. It is seen in this c. 1909 postcard. In 1913, the church severed ties with the Dutch Reformed faith and became the Irving Park Presbyterian Church. Today, it is the Fullness Korean Presbyterian Church. (Courtesy Frank Suerth.)

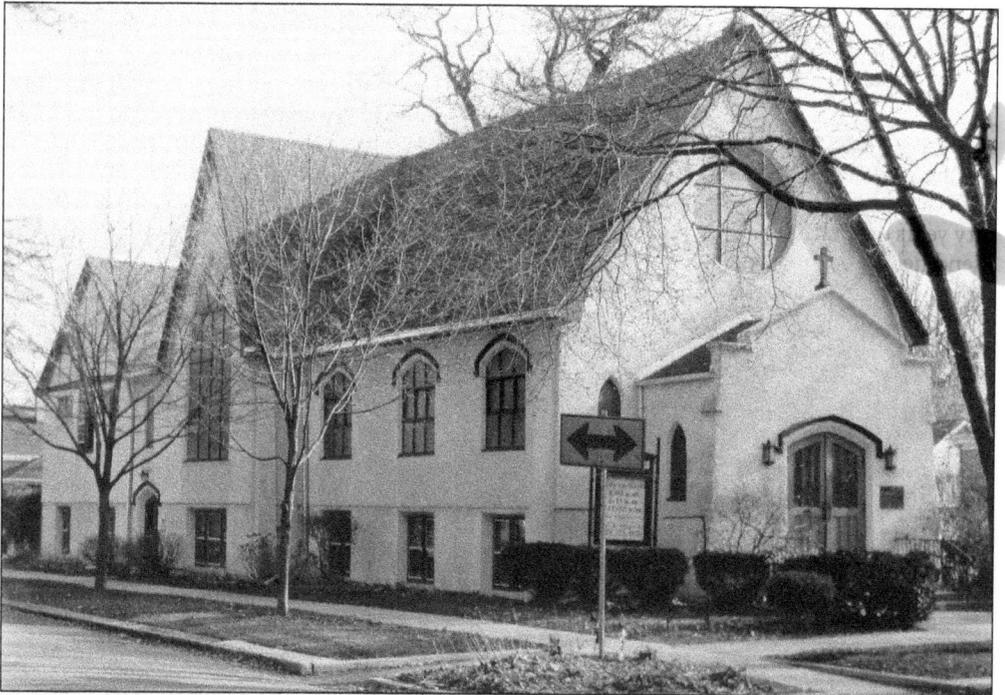

St. John's Episcopal Church, 3857 North Kostner Avenue, is the second-oldest church in Irving Park. The church was constructed in 1888 on land donated by John Gray, an early developer of Grayland. The white stucco exterior and main entranceway were added in the 1920s. Architect Clarence Jensen renovated the church to its current form. Among its features are Irving Park's oldest stained-glass window, a pipe organ, original wood beams, and wainscoting. (Photograph by Wilfredo Cruz.)

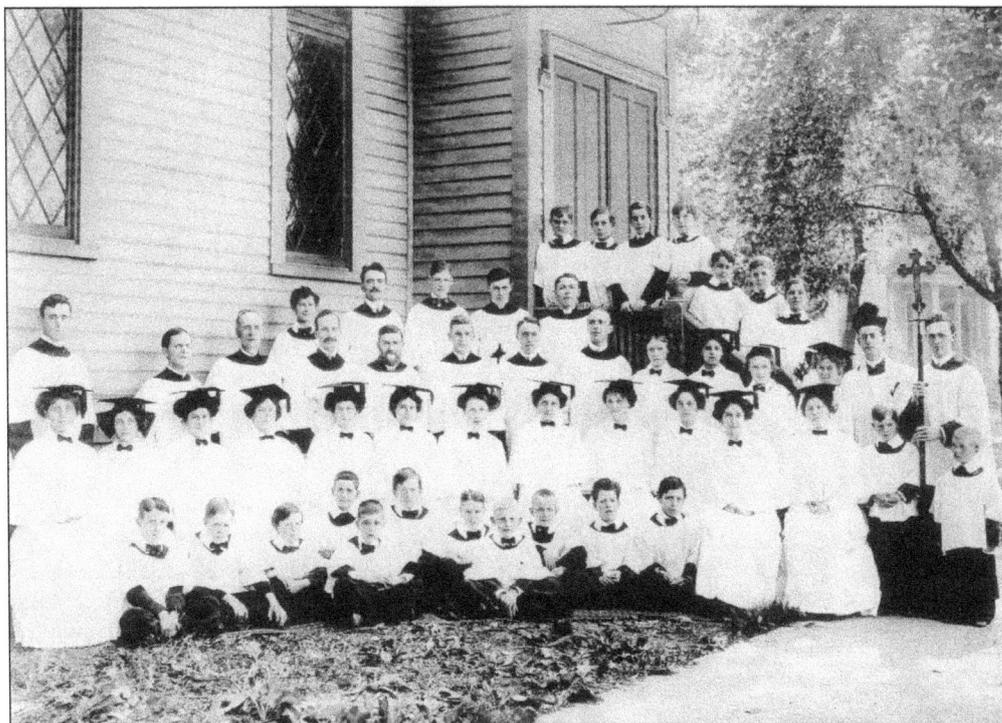

The senior and junior choir of St. John's Episcopal Church is seen here around 1908. The members are gathered in front of the original church before it was renovated. Rector Howard E. Ganster, with cap, is standing second from the right. (Courtesy St. John's Episcopal Church.)

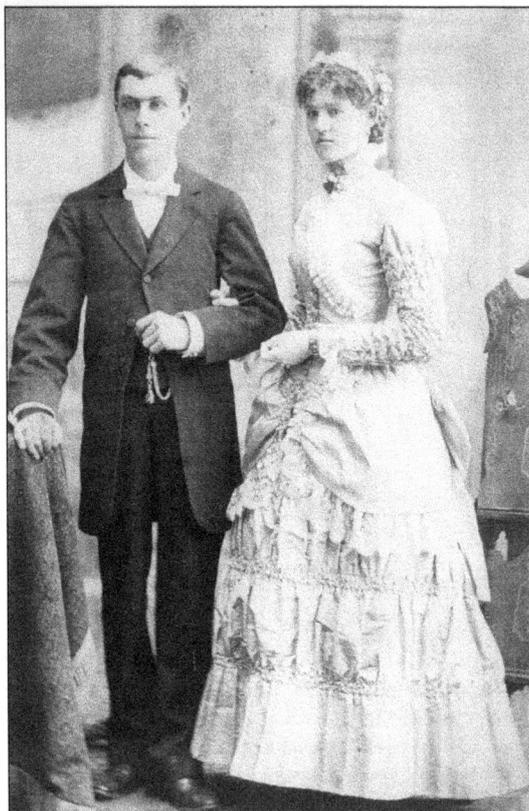

This is the wedding of William B. Anderson and Emma Louise Harrison in Chicago in 1883. The couple lived at 4212 North Harding Avenue. The home is still standing. The couple were active, longtime parishioners at St. John's Episcopal Church. Their three daughters were baptized, confirmed, and married at the church. (Courtesy St. John's Episcopal Church.)

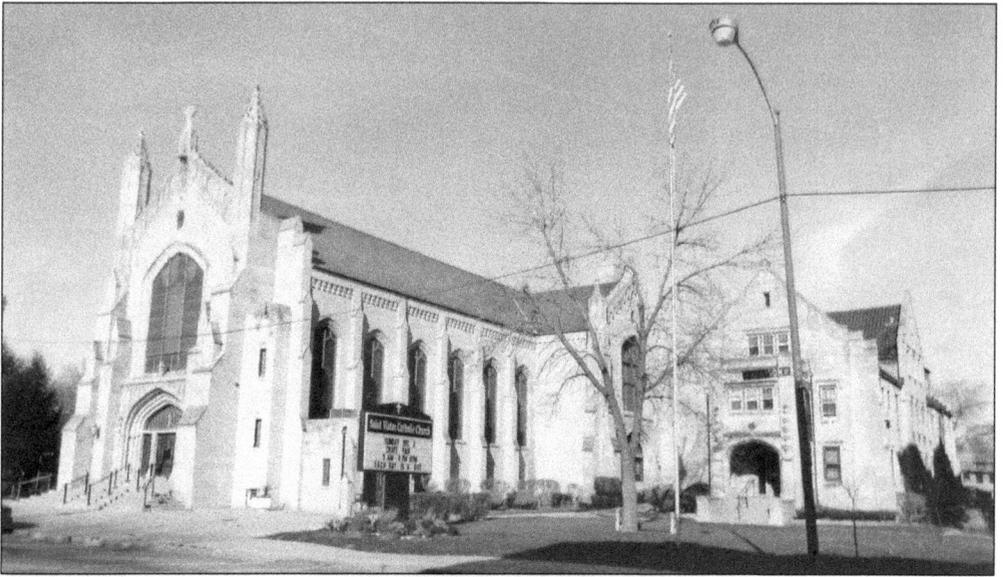

The Victorian Fathers established St. Viator Catholic Church at Belmont Avenue and Pulaski Road in 1888. In 1910, the church moved to 4140 West Addison Street, using its school building as both parish and school. In 1928, the Gothic Revival church shown here was built next to the school at 4170 West Addison Street. The church rectory is on the right in the photograph. The architect was Charles L. Wallace. The church underwent interior renovations prior to its centennial celebration in 1988. (Photograph by Wilfredo Cruz.)

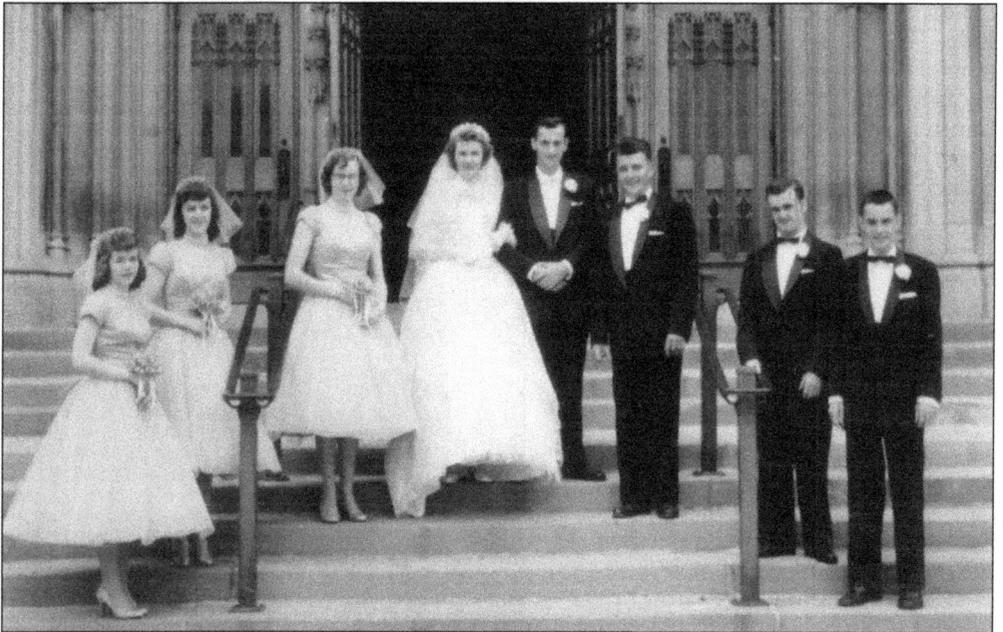

Edward and Cecelia Philbin were married at St. Viator Church in September 1957. The couple had three children and lived many years at 3913 North Kenneth Avenue. Edward Philbin worked for over 30 years as a unionized laborer for the City of Chicago, and Cecelia was employed at a local factory and later became a homemaker. Their names are engraved on a neighborhood memorial (see page 122). (Courtesy Jason and Maureen Lontoc.)

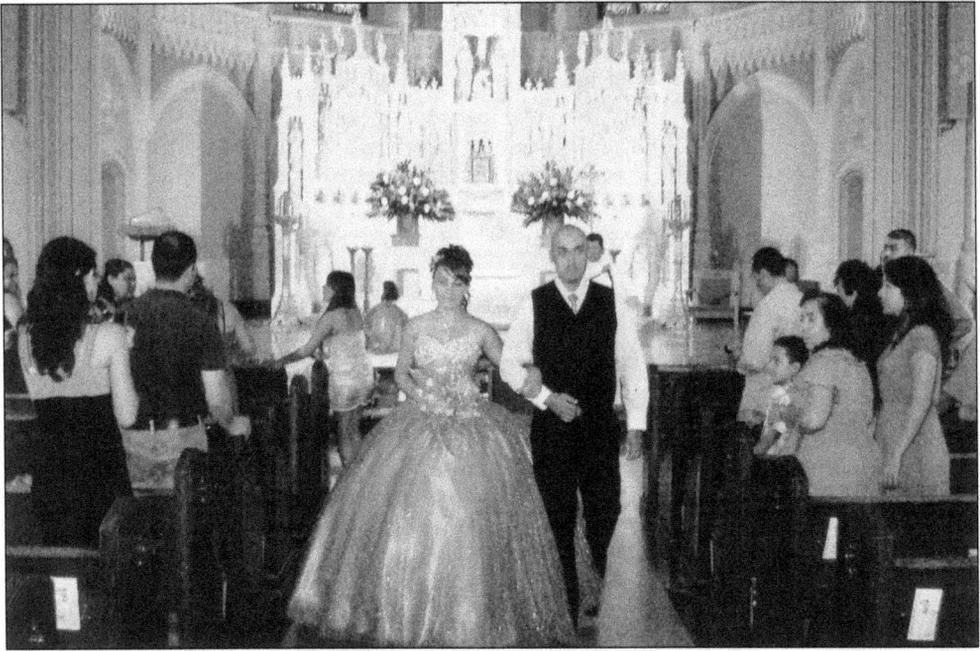

Some Latino families host an elegant *quinceañera* to celebrate a girl's 15th birthday. The event is the social debut of a young girl and has both cultural and religious significance. Here, Alexandra Fernandez and her unidentified escort celebrate her quinceañera at St. Viator Church in August 2012. They are surrounded by family and friends. A good number of Latino families regularly attend St. Viator Church. (Photograph by Wilfredo Cruz.)

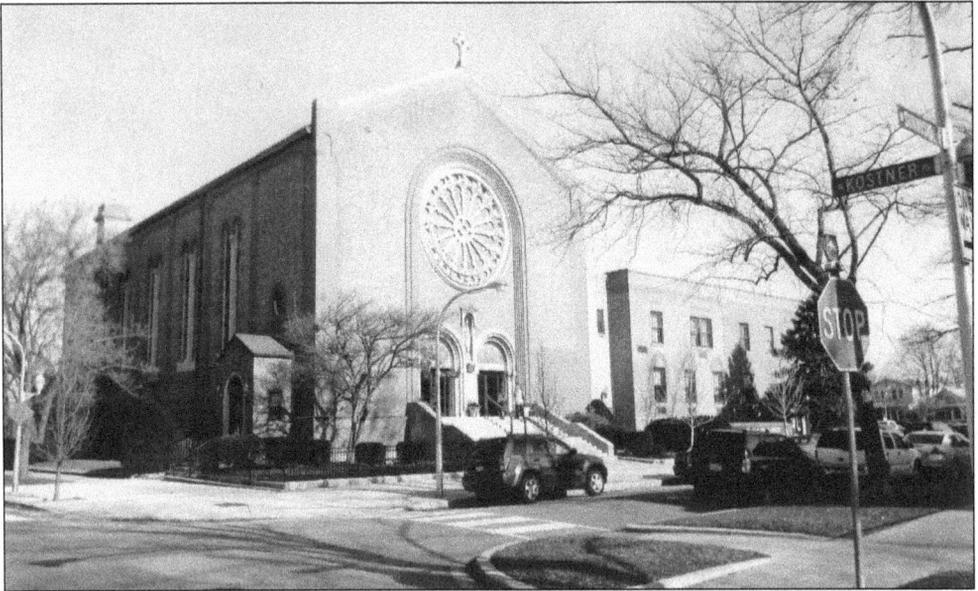

St. Edward Catholic Church was established in 1889, and its first building, a frame structure, was dedicated in 1899. The building shown here at 4350 West Sunnyside Avenue was dedicated in 1940. The parish is located one block north of Montrose Avenue, outside of the Old Irving Park boundary. However, many Old Irving Park families attend the parish and enroll their children in its elementary school. (Photograph by Wilfredo Cruz.)

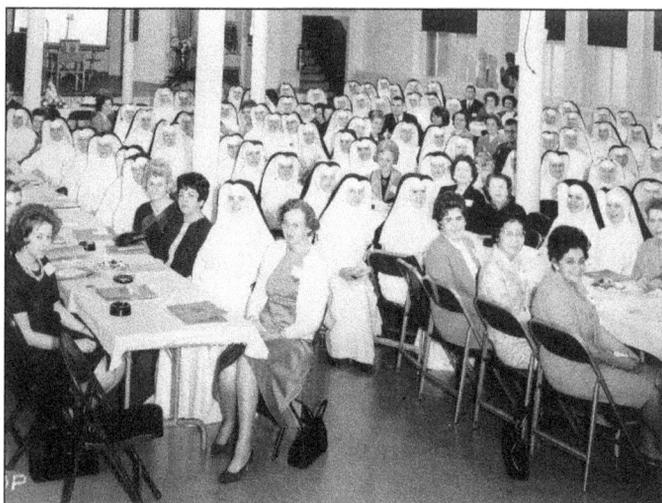

Since 1910, the Dominican Sisters, a Catholic order from Springfield, Illinois, were very involved in St. Edward Church. The nuns also taught at St. Edward School for many years. Here, Dominican Sisters from St. Edward Church and other city parishes attend an educational conference. They are meeting in the basement of Our Lady of Grace Church in 1966. (Courtesy St. Edward Church.)

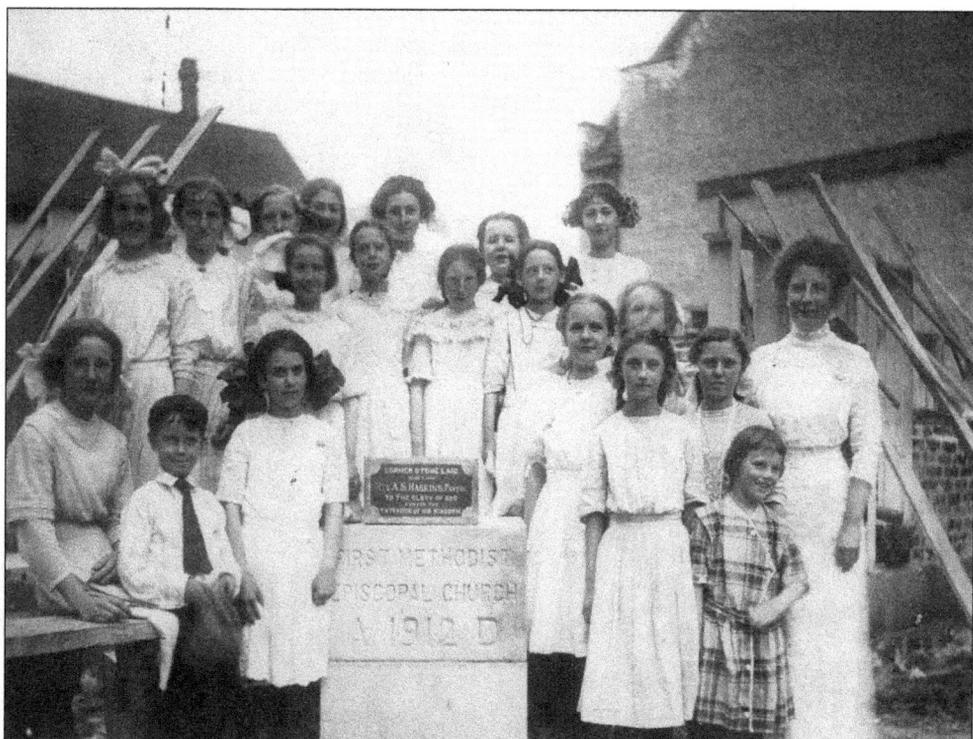

The First Methodist Episcopal Church was organized in 1888, and a white frame church was built in 1891. In this 1912 photograph, members lay the cornerstone for a new church at 3801 North Keeler Avenue. Elizabeth M. Haskins (far right), the pastor's wife, was in charge of the church's primary school. The church later became the Irving Park United Methodist Church. (Courtesy Irving Park United Methodist Church.)

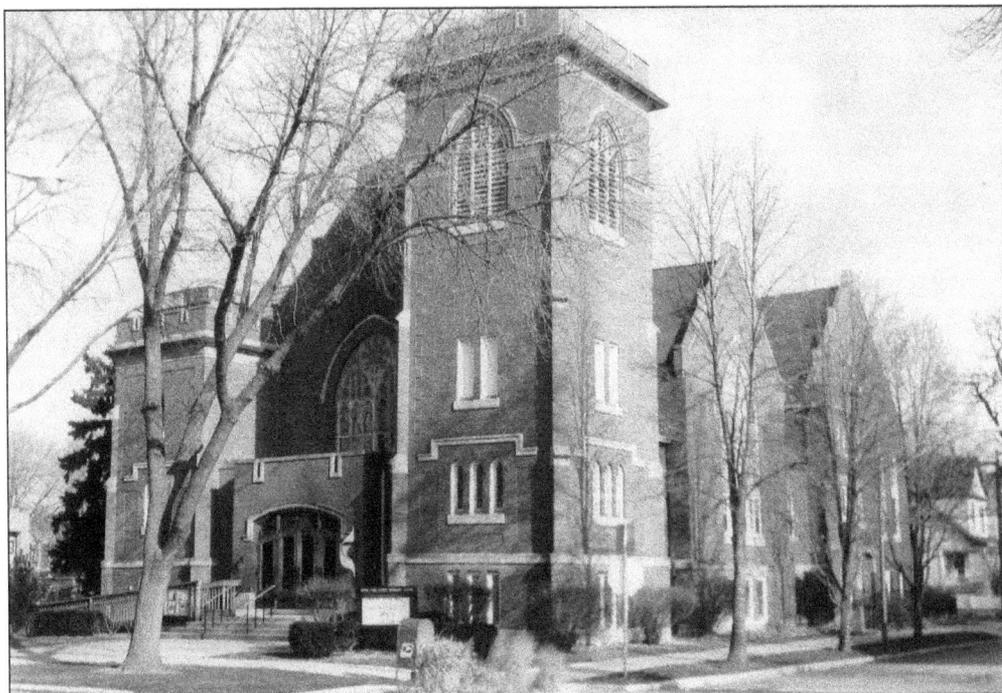

This is the current Irving Park United Methodist Church, at 3801 North Keeler Avenue. In 1963, the sanctuary was completely renovated, and the chapel area was restored in the mid-1990s. The church has weekly worship services, Bible study, Sunday school, a youth program, and a choir. Various religious and nonprofit groups rent space in the church to carry out their activities. (Photograph by Wilfredo Cruz.)

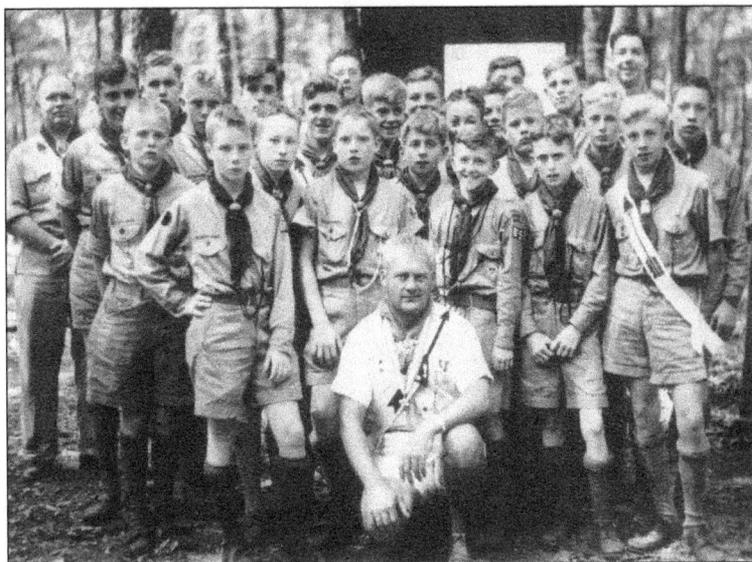

Since 1924, the Irving Park United Methodist Church has sponsored Troop 875 of the Boy Scouts of America. The Boy Scouts stress sociability, patriotism, and citizenship. Troop 875 is seen here in the early 1940s camping in Michigan. The Scoutmaster was Carl Hallen (front, center). (Courtesy Irving Park United Methodist Church.)

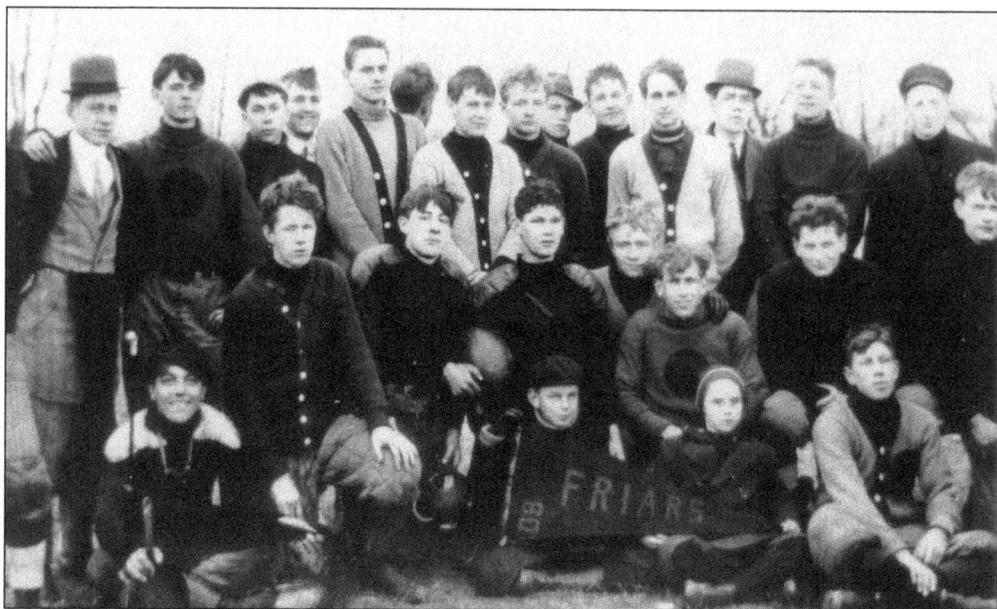

The Friars, shown here in 1908, was a social club of young men who played sports, including football and baseball. The Friars competed against clubs from other neighborhoods. The Irving Park United Methodist Church established the group in 1905 to keep young men focused on positive things, such as sports, family, and religion. Many members remained longtime friends. In 1935, members gathered for a 30th-anniversary photograph. (Courtesy Irving Park Historical Society.)

Rev. Martin Deppe (back row, right of center) was pastor of the Irving Park United Methodist Church. Here, he welcomes the extended Samuels family as new church parishioners in the mid-1990s. The family had recently moved into the Irving Park community. (Courtesy Irving Park United Methodist Church.)

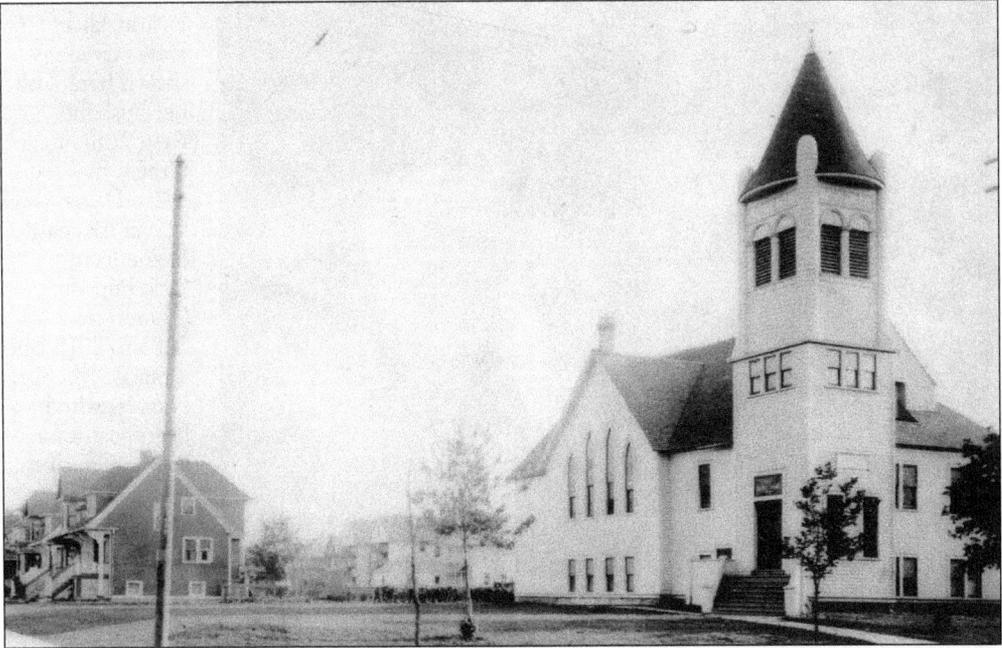

The founding of a Baptist church was discussed in 1889 at the home of John and Clara Merchant (daughter of John Gray). John Merchant agreed to find a donated lot and raise $3,000 for construction if residents raised a similar amount. The First Baptist Church of Irving Park, shown here, was dedicated in 1894. The frame structure was located a little west of Kostner Avenue in the 4400 block of West Irving Park Road. (Courtesy Irving Park Baptist Church.)

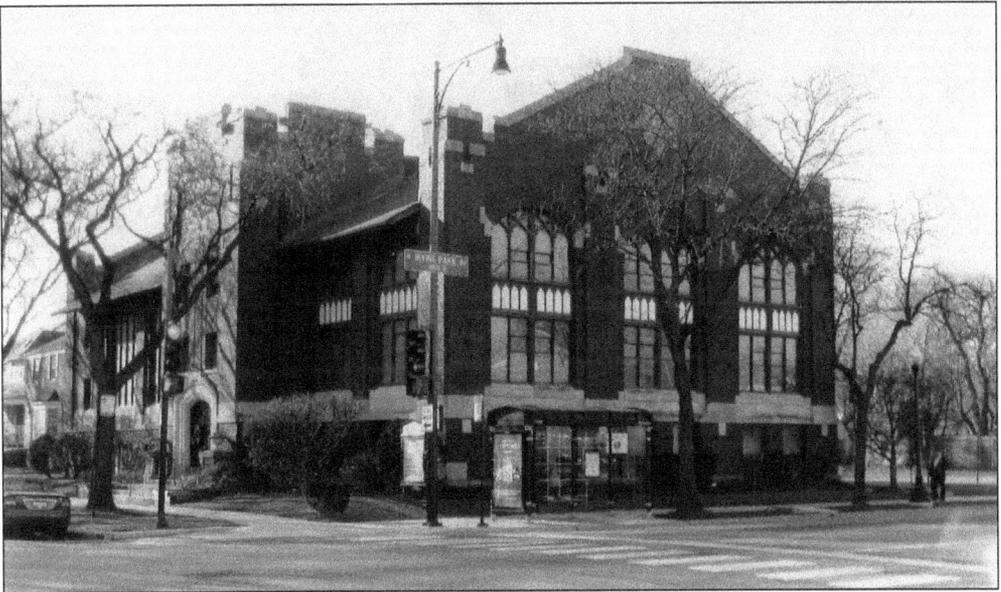

The First Baptist Church of Irving Park built this larger, brick church in 1917. The church, at 4401 West Irving Park Road, changed its name to the Irving Park Baptist Church. The interior features stained-glass windows installed in 1975 by Botti Studios of Evanston, Illinois. The church eventually installed a new pipe organ, using some pipes from the original church. (Photograph by Wilfredo Cruz.)

Pastor Alice Davis Green is shown here with her husband, Rev. William Green, in 2006. Alice Davis Green was pastor of the Irving Park Baptist Church from 2003 to 2011. She replaced Michael Harvey, who had been pastor for 24 years. (Courtesy Irving Park Baptist Church.)

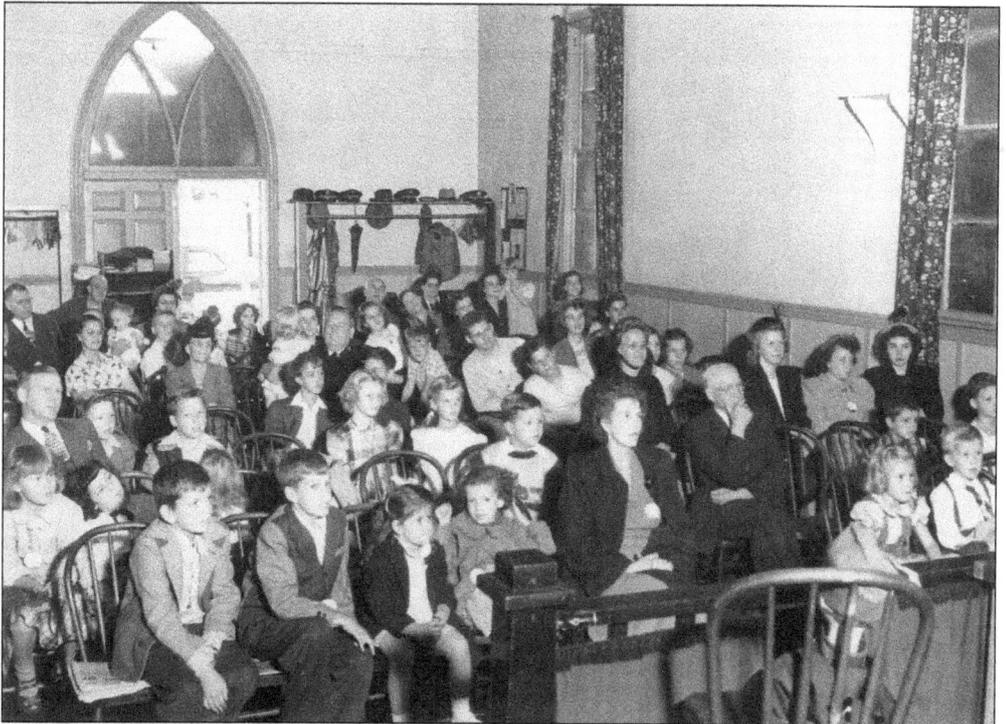

The Salvation Army Irving Park Community Center and Church was organized in 1891. Its first, modest storefront building was at 4120 West Irving Park Road. Early members were largely Swedish and Norwegian. In this 1941 photograph, parents and children attend Sunday school service. In 1950, the Salvation Army erected a building at 4056 North Pulaski Road. (Courtesy Salvation Army Irving Park Community Center and Church.)

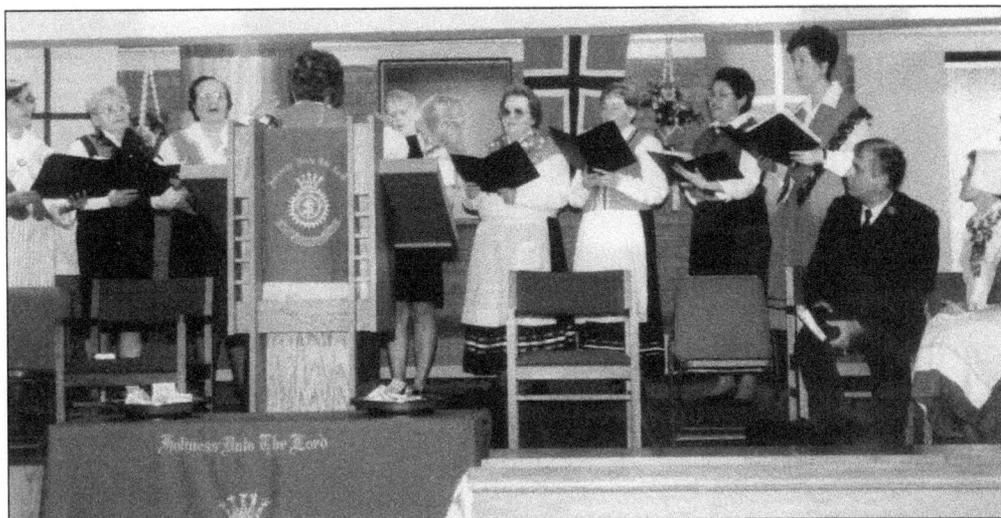

Members of the Salvation Army Irving Park Community Center and Church join together for prayers and hymns in 1991. They are gathered for the centennial celebration of the Salvation Army's service in Irving Park. The women are wearing traditional Norwegian and Swedish dresses. Some hymns were sung in the Swedish language. (Courtesy Salvation Army Irving Park Community Center and Church.)

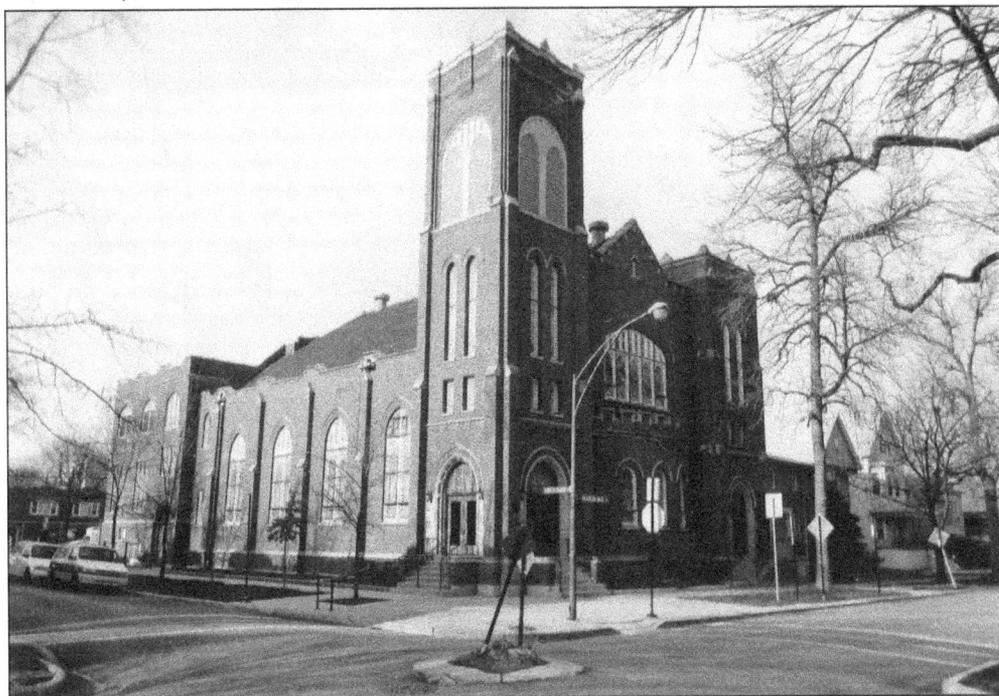

A group of Swedish residents organized the Irving Park Lutheran Church in 1903, and a small frame church was erected in 1905. Swedish was the church's official language until World War I. A larger church, seen here, was completed in 1917. This church, at 3938 West Belle Plaine Avenue, is located a half-block east of Pulaski Road, outside of Old Irving Park. But many families in Old Irving Park have been longtime members. Some church records are stored at the Chicago Swedish American Museum. (Photograph by Wilfredo Cruz.)

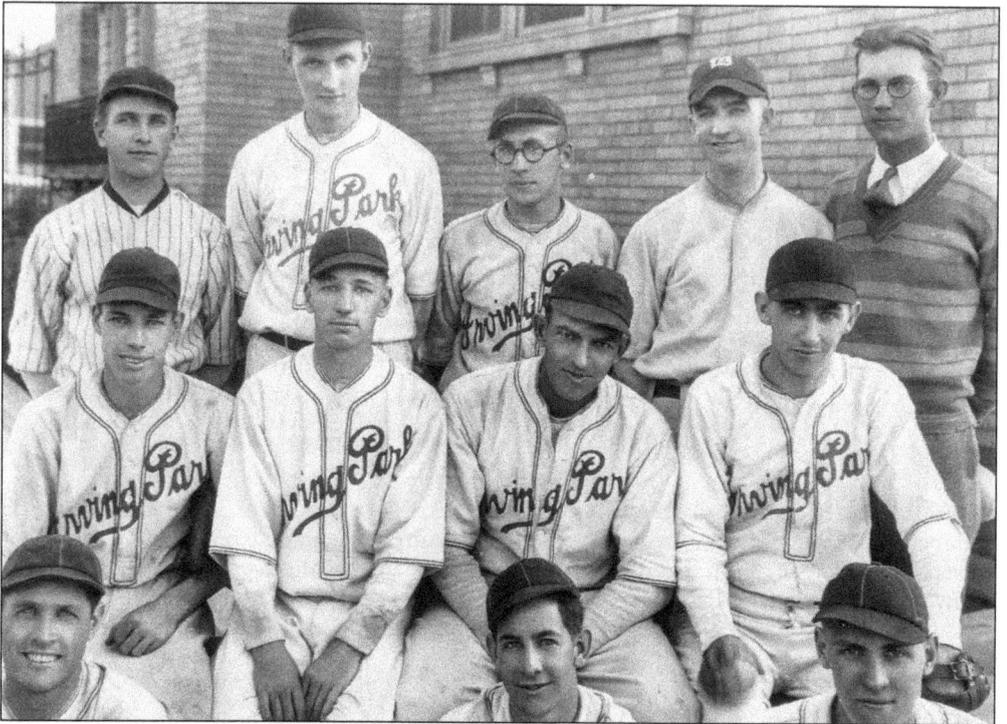

Churches traditionally sponsored sport teams as a healthy outlet for young men. The baseball team shown here was organized by the Irving Park Lutheran Church. This 1928 photograph was taken at the Chicago Park District's Athletic Field Park, 3546 West Addison Street. (Courtesy Irving Park Lutheran Church.)

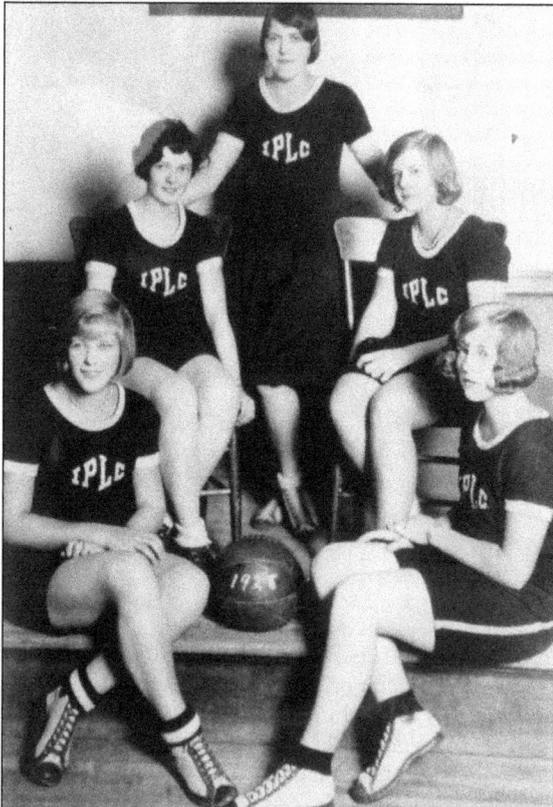

The Irving Park Lutheran Church was ahead of its time regarding women and sports. Few churches sponsored sports teams for young women, who were taught to shun sports. Yet Irving Park Lutheran sponsored this 1928 basketball team. (Courtesy Irving Park Lutheran Church.)

The Calvary Lutheran
Church, 4200 North
Keeler Avenue, was built
in 1910. Many Swedish
families attended this
church. Amazingly, 49
young men from this
small church served in
World War I. Their names
are engraved on a bronze
plaque donated to the
Irving Park Historical
Society. This church
became the Greek
Orthodox Church of Sts.
Athanasios and Ioannis in
about 1997. (Photograph
by Wilfredo Cruz.)

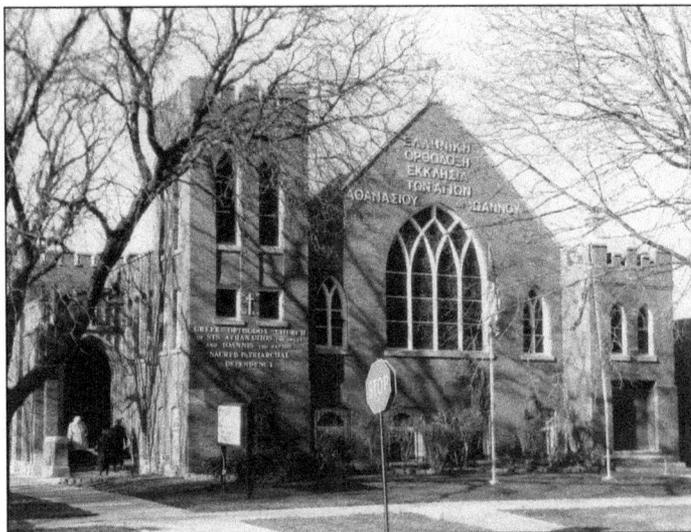

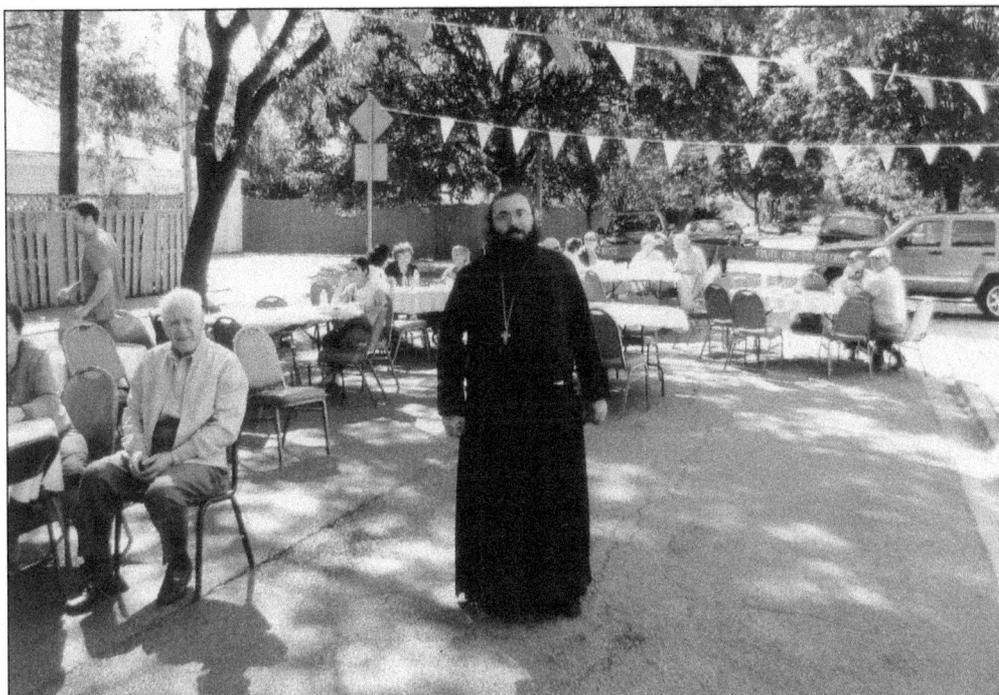

Dimitrios Panetas is pastor of the Greek Orthodox Church of Sts. Athanasios and Ioannis. Here,
he mingles with Greek families and other neighborhood residents at the church's annual Greek
Fest in August 2012. The two-day church fundraiser features live music, homemade pastries, and
tasty chicken dinners. The pastries and food are prepared by some elderly Greek women who are
church members. (Photograph by Wilfredo Cruz.)

This imposing structure was formerly the Myrtle Masonic Temple. The building at 4240 West Irving Park Road was designed by the architectural firm of Hatzfeld and Knox. In the early 1980s, it became the Korean Bethel Presbyterian Church. Many of the church's members are Asian American young adults and college students. The building, erected in 1910, is currently for sale. (Photograph by Wilfredo Cruz.)

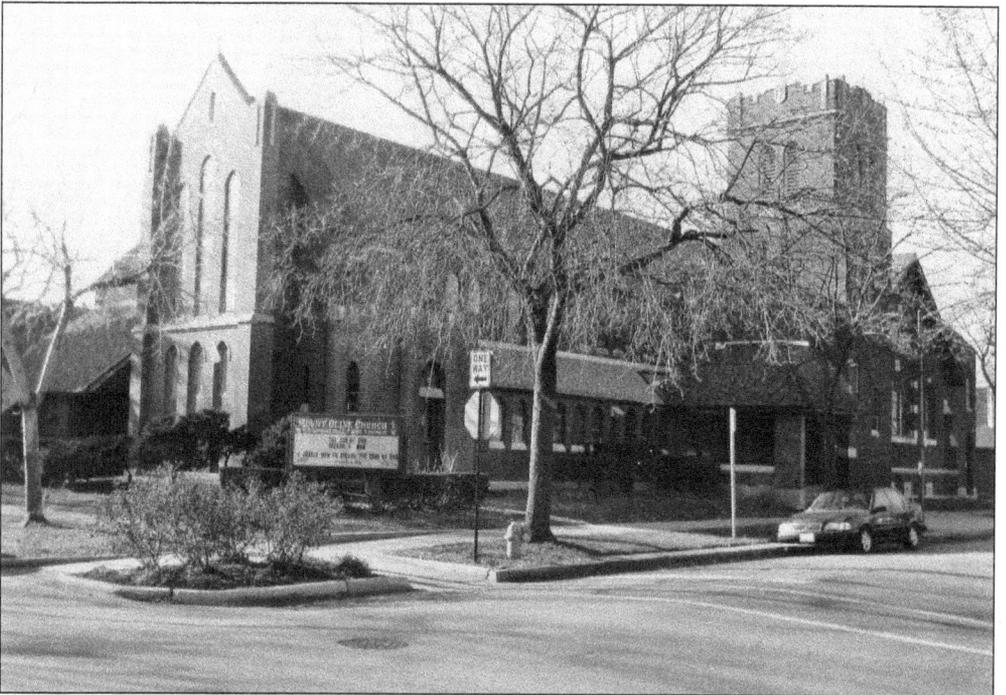

The Mount Olive Congregation, established in 1917, initially held services in a small storefront church. In 1922, it acquired a permanent site, shown here, at 3850 North Tripp Avenue. As church membership increased, an adjoining structure was completed in 1927. The church eventually dropped its Lutheran denomination and became a nondenominational church. (Photograph by Wilfredo Cruz.)

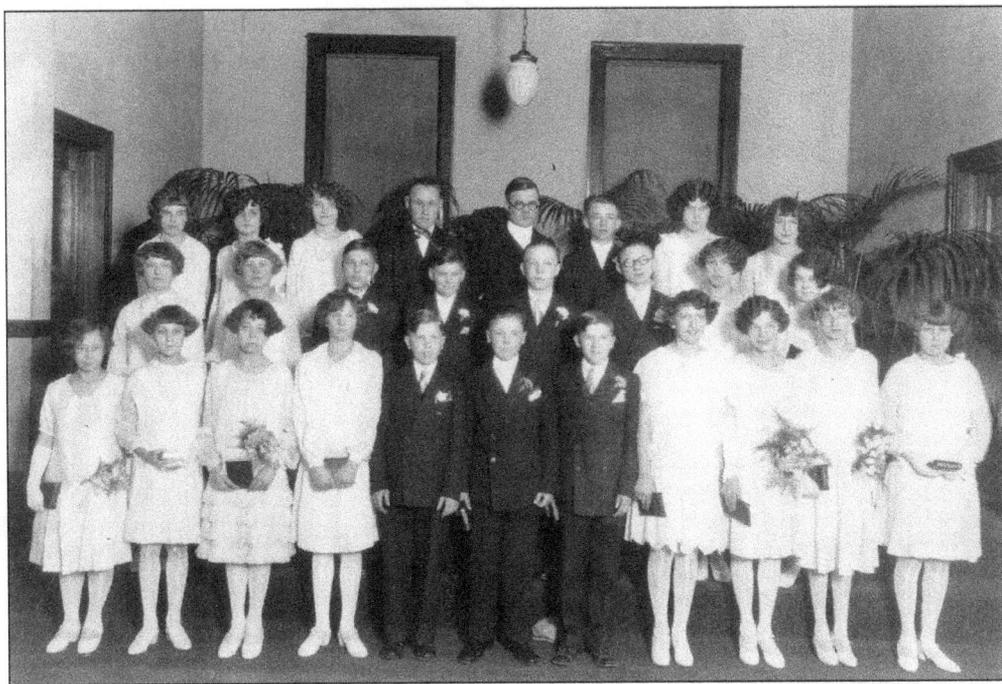

These well-dressed young boys and girls stand inside Mount Olive Church in 1927. They had completed their confirmation ceremony. (Courtesy Mount Olive Church.)

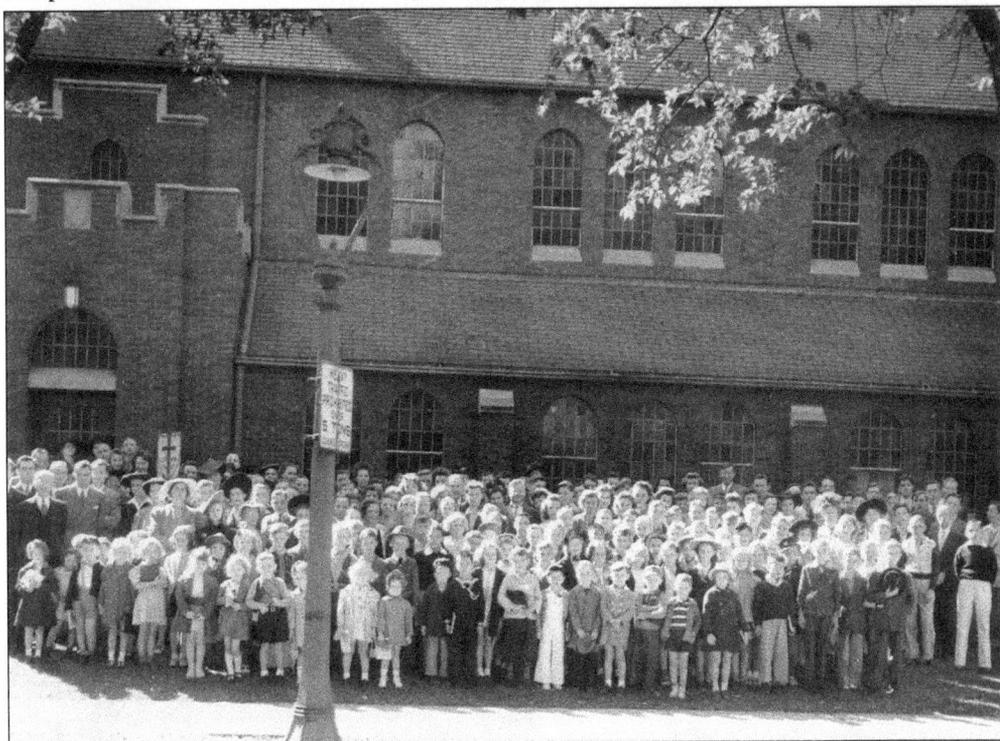

Parishioners of Mount Olive Church joined together for a group photograph outside the church in 1942. (Courtesy Mount Olive Church.)

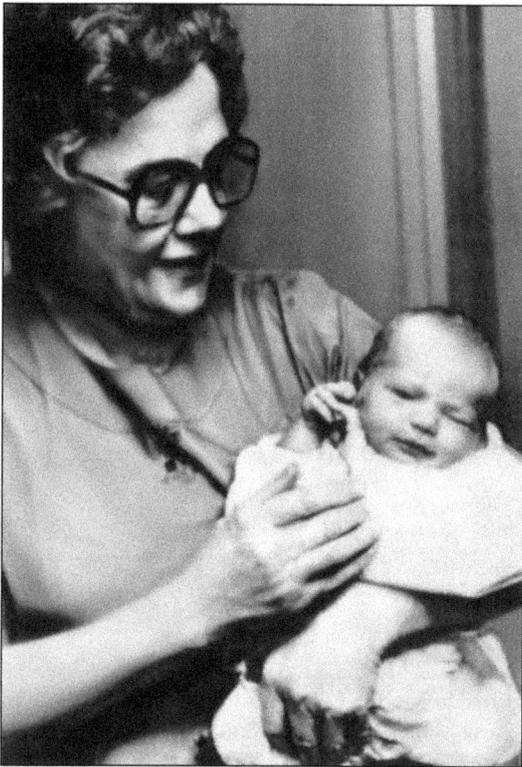

A newborn baby girl was abandoned at the door of Mount Olive Church in May 1989. Women of the church's Mary Martha Guild found the baby and named her Mary Martha after the two biblical women who are the namesakes of the club. The healthy baby was taken to Resurrection Medical Center, where she is seen here being held by nurse Catherine Gallagher. The Illinois Department of Children and Family Services took custody of Mary Martha. (Courtesy Mount Olive Church.)

This building at 4115 North Kedvale Avenue was formerly a Christian Science church. It was constructed in 1940. In the early 1990s, it became the Korean Martyrs' Catholic Church. Many of its Korean parishioners come from neighborhoods across the city. (Photograph by Wilfredo Cruz.)

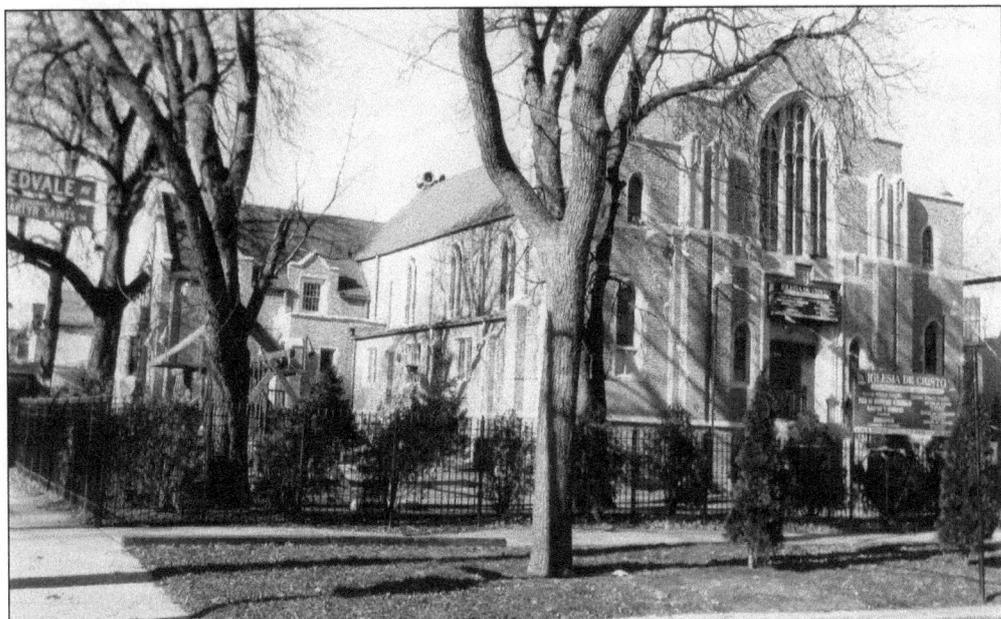

The modified English Gothic structure shown here was formerly the Irving Park Christian Church. The building, completed in 1929, stands at 4300 North Kedvale Avenue. In the early 2000s, the building was sold and became Iglesia de Cristo, a Pentecostal church. Two Sunday services are conducted in Spanish. Many of its Latino congregants come from other neighborhoods and the suburbs. (Photograph by Wilfredo Cruz.)

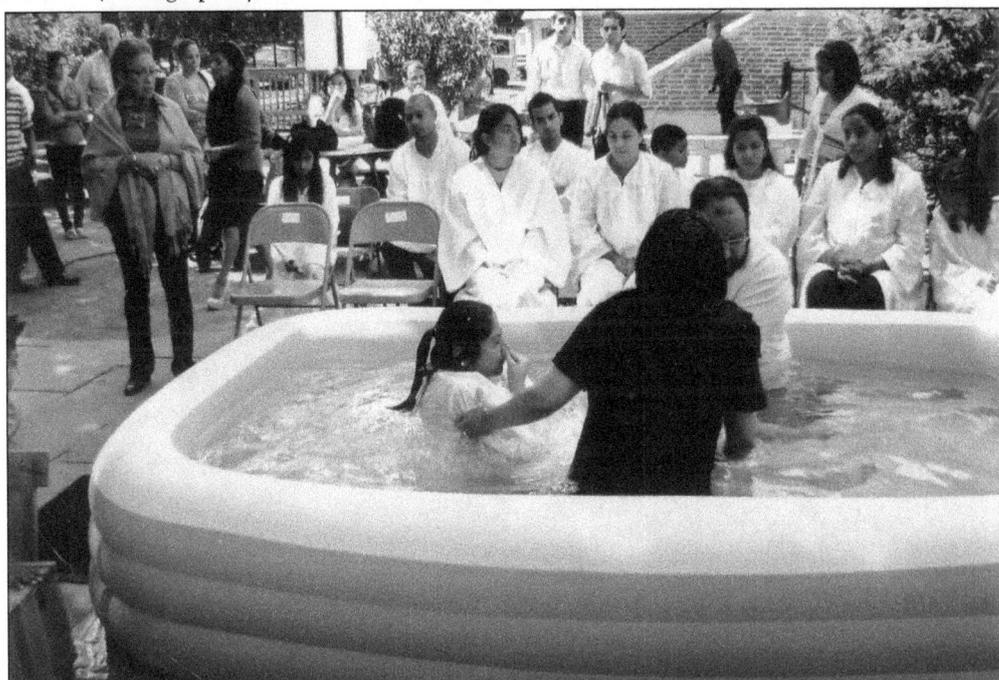

Pastors William and Brenda Gordillo baptize new members of Iglesia de Cristo. Other members, in white robes, await their baptism, which is the final step of conversion to the Pentecostal faith. This ceremony took place next to the church in August 2012. (Photograph by Wilfredo Cruz.)

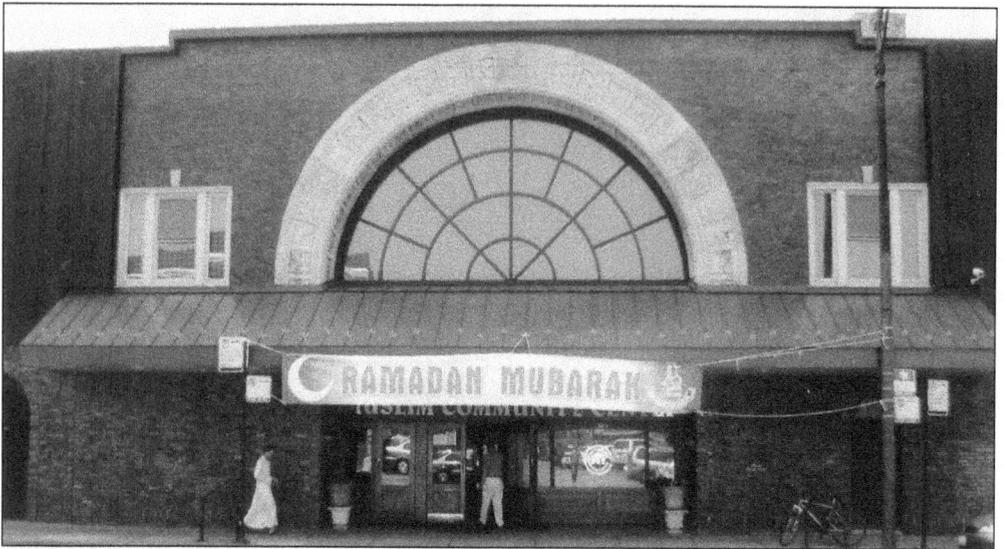

Congregants enter the Muslim Community Center, 4380 North Elston Avenue, in 2012. The sign indicates that American Muslims are celebrating the holy month of Ramadan. In 1982, Muslims purchased this building, the former Rivoli Theater, which opened in 1922 and could seat 1,500. (Photograph by Wilfredo Cruz.)

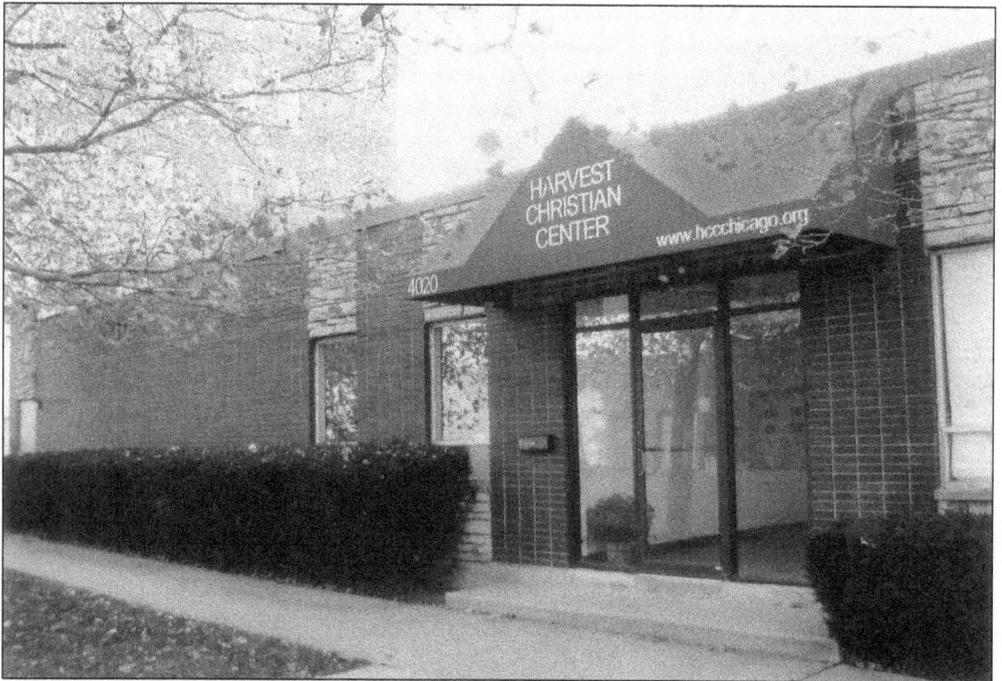

A relatively new church in Old Irving Park is the Harvest Christian Center, 4020 North Tripp Avenue. The church started in 2010 in this building, which formerly housed a furniture distribution company. Members of this predominantly African American church are currently renovating the building. (Photograph by Wilfredo Cruz.)

Four

BUSINESS

Old Irving Park is a residential neighborhood without much large-scale commercial activity. Small, family-owned stores traditionally dotted Irving Park Road. These businesses were usually of a practical nature. In the middle of the 20th century, the neighborhood had grocery stores, meat markets, drugstores, candy and clothing stores, restaurants, gas stations, ice-cream parlors, cleaners, bars, mortgage companies, coal companies, and funeral homes. There were two weekly newspapers, the *Irving Park Signal* and *Irving Park Review*.

Even today, most businesses are small mom-and-pop stores. Some residents desire more business development, but most prefer things as they are. Residents fear that building large shopping centers will adversely change the neighborhood's character, create traffic congestion, and bring large crowds. When three shopping malls were built along Addison Street near Kimball Avenue in the mid-1980s, residents complained about traffic congestion.

Many Old Irving Park families drive to nearby suburban malls to shop. Also, residents shop in the adjoining Portage Park neighborhood at Six Corners, a commercial area located at Irving Park Road, Milwaukee Avenue, and Cicero Avenue. Six Corners is anchored by a large Sears, Roebuck and Company store that opened in 1938. In the late 1990s, the Marketplace at Six Corners opened, bringing new retail, including a Jewel-Osco. And the recent $20-million redevelopment of the Klee Plaza building at Milwaukee Avenue and Cicero Avenue brought 64 condominiums and more retail stores to the area.

Old Irving Park's first established business was D.D. Mee Grocery store, built about 1870. The store was the focal point of the community. This commercial building is a city landmark located on the northwest corner of Irving Park Road and Keeler Avenue. One popular occupant of the building during the 1980s was a tavern called the Whistle Stop. The name plays on the fact that it is near the Irving Park train station.

During the 1920s, about 26 neighborhood movie theaters existed in Irving Park. Several theatres would feature three movies, vaudeville acts, and live organ music. On the southwest corner of Irving Park and Pulaski Roads was the Irving Theater, and on the northwest corner was the popular Buffalo Ice Cream Parlor. Families and dating couples would attend evening movies at the theaters and then stop at the soda fountain for delicious ice cream. Buffalo served residents for 60 years until it closed in 1978. In the mid-1980s, Buffalo Bill's, a fancy ice-cream parlor and restaurant, opened at 3944 West Irving Park Road. It imitated the old Buffalo parlor with its homemade ice cream and old-fashioned walnut counters. Unfortunately, it soon failed and shut down.

Today, along with new thriving neighborhood businesses, some longtime, family-owned establishments have shown remarkable staying power. For instance, Pert Cleaners, at 4213 West Irving Park Road, has been in business for 61 years. Owner Tony Lupo, 77, survived the wash-and-wear trend that shuttered other cleaners. He says his early customers were German, Irish, and Polish. Despite changing ethnicities and clothing styles, loyal customers have been coming to Lupo for over half a century. They appreciate the friendly, good service he offers.

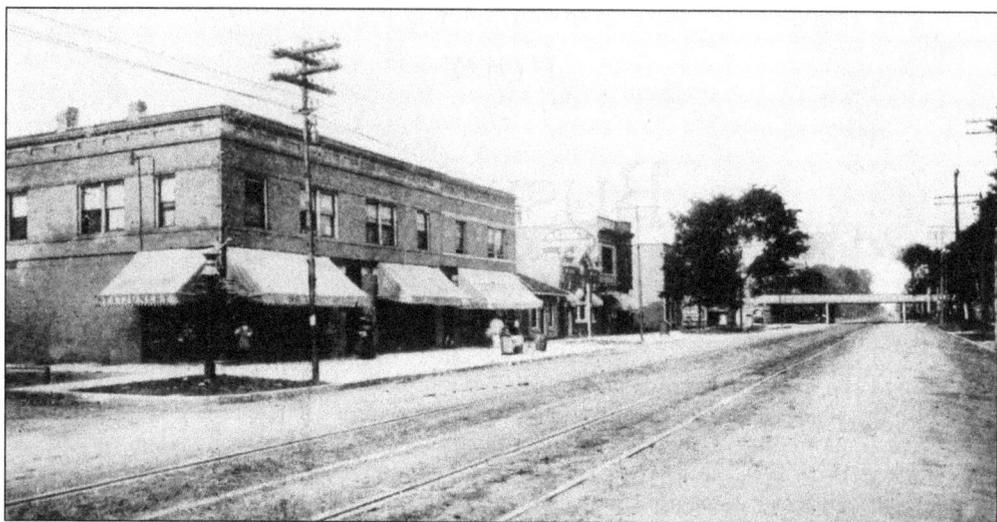

This 1902 photograph looks east on Irving Park Road near Tripp Avenue. The drugstore at left displays a mortar and pestle symbol, and the word "stationery" is visible on its awning. Individuals are seen entering stores. Also visible is the first post office building and the R.L. Tracy Hardware store. Behind the large tree right of center is Brown's Drug Store (formerly D.D. Mee Grocery). The train viaduct is in the distance. Tracks on the street accommodate electric streetcars. (Courtesy Frank Suerth.)

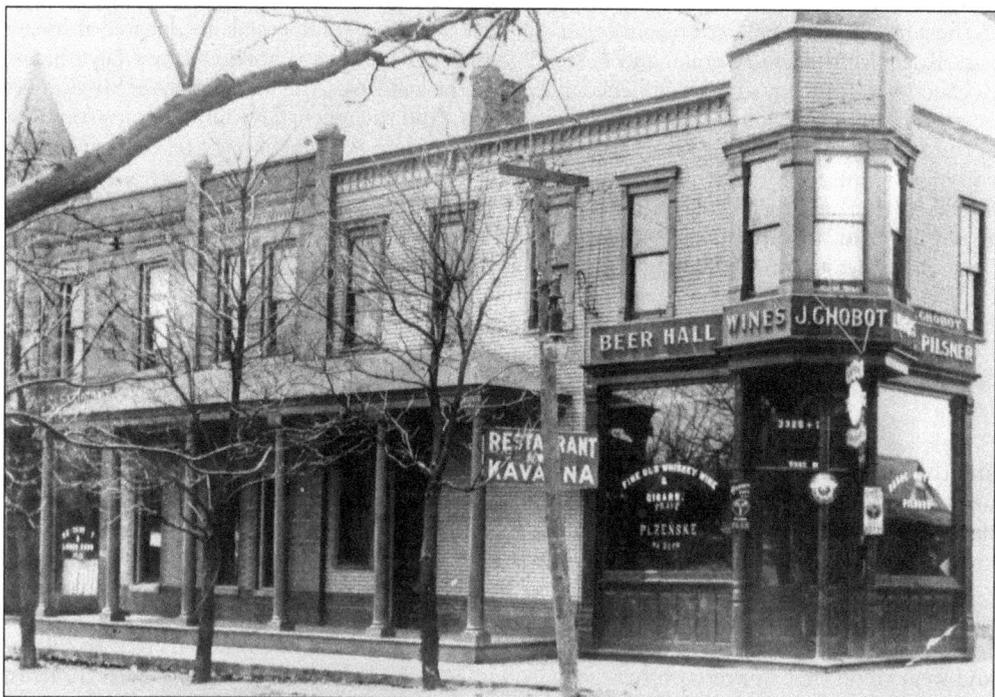

The J. Chobot Beer Hall, 3325 North Pulaski Road, is shown around 1909. The beer hall was located a few blocks outside of Old Irving Park's southern boundary of Addison Street. But men from Old Irving Park were regular patrons. Men gathered at beer halls like this to drink, socialize, and discuss worldly affairs. The building is no longer standing. (Courtesy Irving Park Historical Society.)

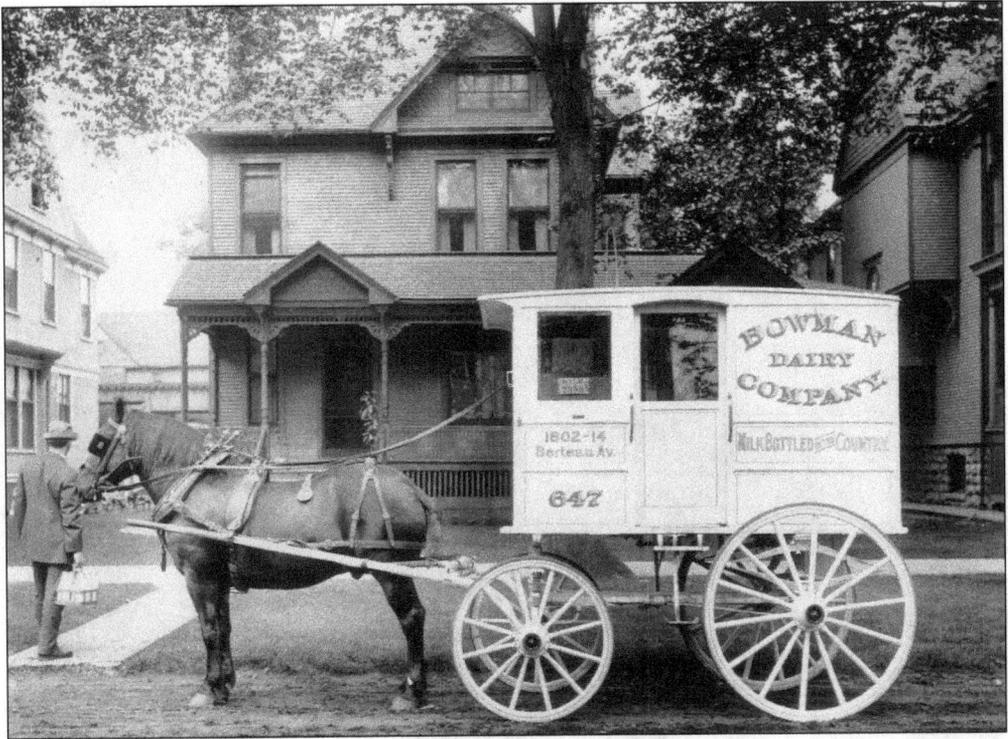

The Bowman Dairy Company was a major supplier of milk, eggs, and dairy products in Chicago during the early 1900s. Bowman had a large distribution company at 4452–4466 West Cullom Avenue. Bowman milkmen in house-drawn wagons, such as the one shown here in 1914, would deliver glass quarts of milk to homes in Old Irving Park. The street location of this photograph is unknown. Construction of the Kennedy Expressway in the late 1950s razed Bowman and other neighborhood businesses and homes. (Courtesy Chicago History Museum.)

An employee works inside the Bowman Dairy Company, 4452–4466 West Cullom Avenue, in the early 1940s. Teachers from nearby Hiram H. Belding School would walk their students to the dairy for field trips. Students learned firsthand how milk was processed, bottled, and distributed. They would also watch a film about cows. In 1966, the entire Bowman Dairy Company business was bought by Dean Foods, and it later closed. (Courtesy Jane Ohlin.)

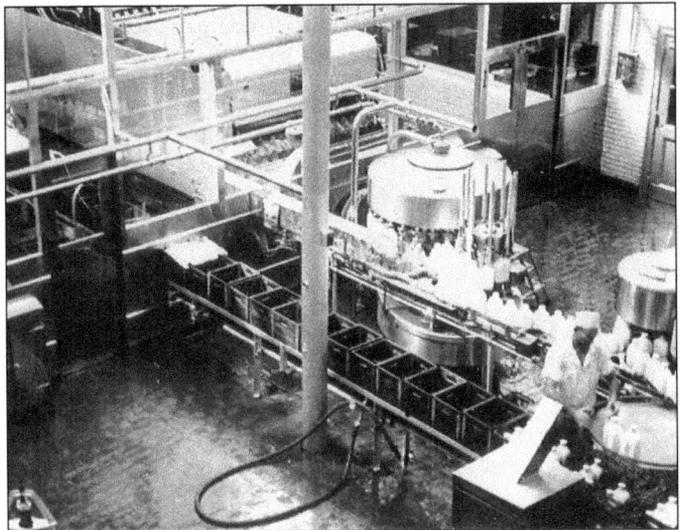

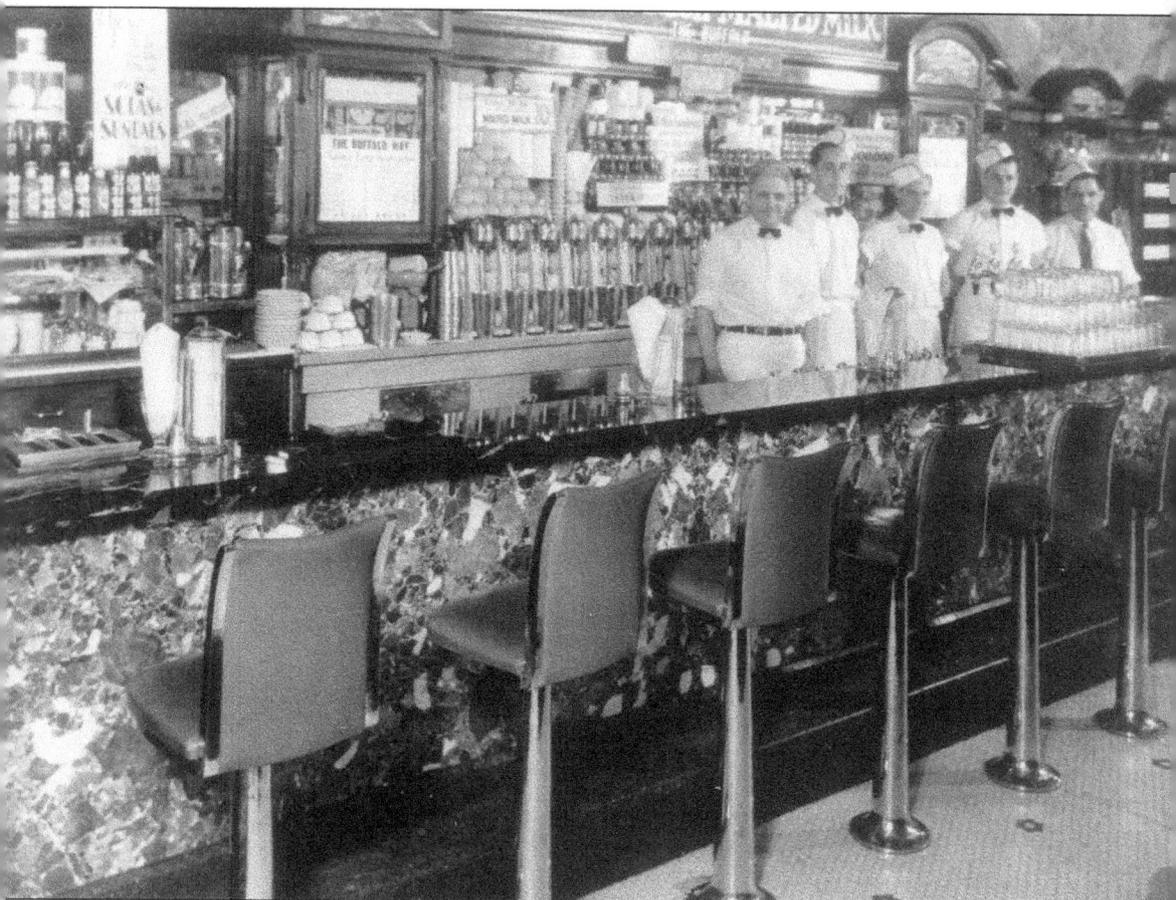

Charles Andrews, a Greek immigrant, opened the Buffalo Ice Cream Parlor at Sedgwick and Division Streets in 1902. In 1918, it moved to 4000 West Irving Park Road, where it became a neighborhood fixture. Its ice cream and whipped toppings were homemade. Among customer favorites were ice cream, banana splits, malts, and sundaes. The interior, shown here in 1952, featured stained-glass windows, marble counters, wooden booths, tile floors, and wall murals. (Courtesy Irving Park Historical Society.)

The Buffalo Ice Cream Parlor is seen in this 1952 photograph looking west on Irving Park Road. Other businesses seen here are a surgeon's office, newspaper stand, tavern, bakery, pizzeria, and cleaners. (Courtesy Irving Park Historical Society.)

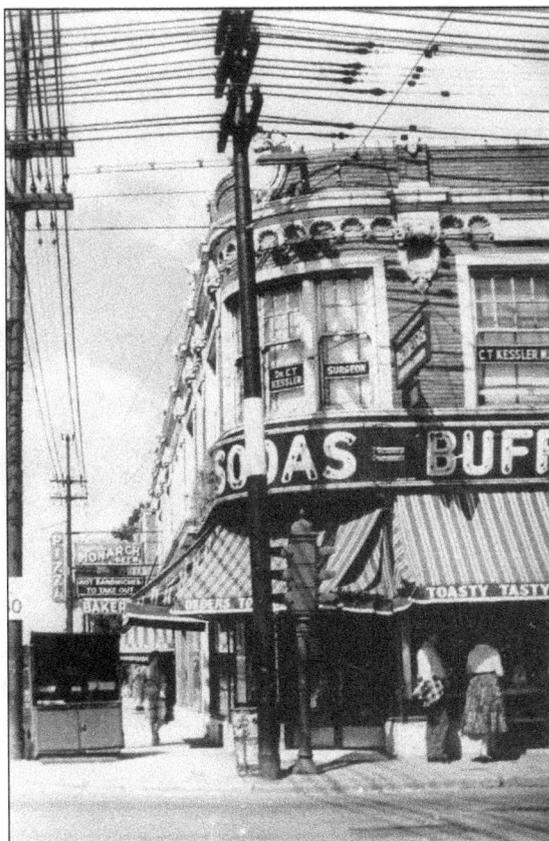

The Buffalo Ice Cream Parlor is seen here in the mid-1960s. Other establishments in the photograph include the Buffalo Pub (left) and a Standard gas station (right). The ice-cream parlor served generations of residents, but after 60 years of friendly service, it closed in 1978. The building was razed, and a Shell gas station now occupies this corner. (Courtesy Irving Park Historical Society.)

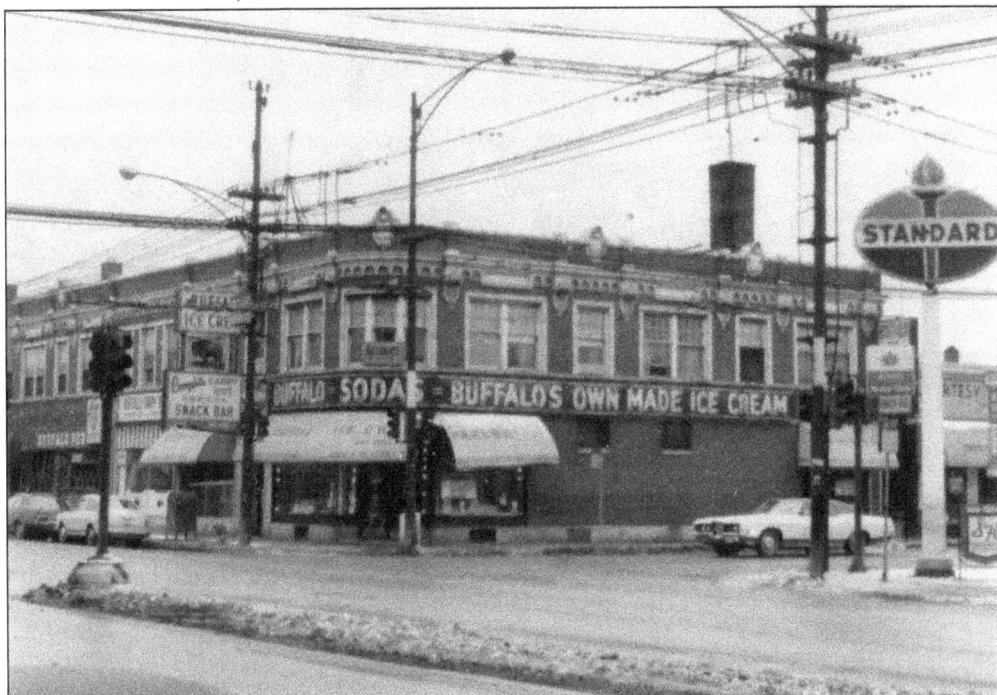

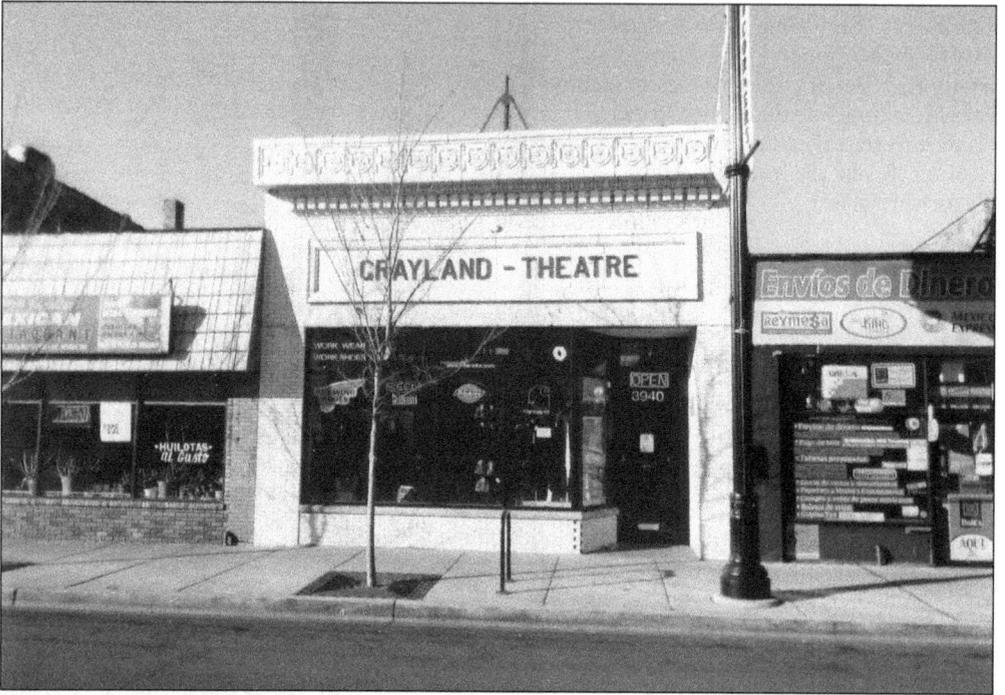

The Grayland Theatre, 3940 North Cicero Avenue, was built in 1909. It was located in the Portage Park neighborhood at Six Corners, a few blocks west of Old Irving Park. Nevertheless, families from Old Irving Park were patrons of the theater, which showed silent films and serial movies every Saturday night. Audiences returned week after week. The theater, designed by William Ohlhaber, held about 100 people. It closed in 1928. The building today houses Rasenick's clothing store. Also shown in this photograph are two Mexican-owned businesses. (Photograph by Wilfredo Cruz.)

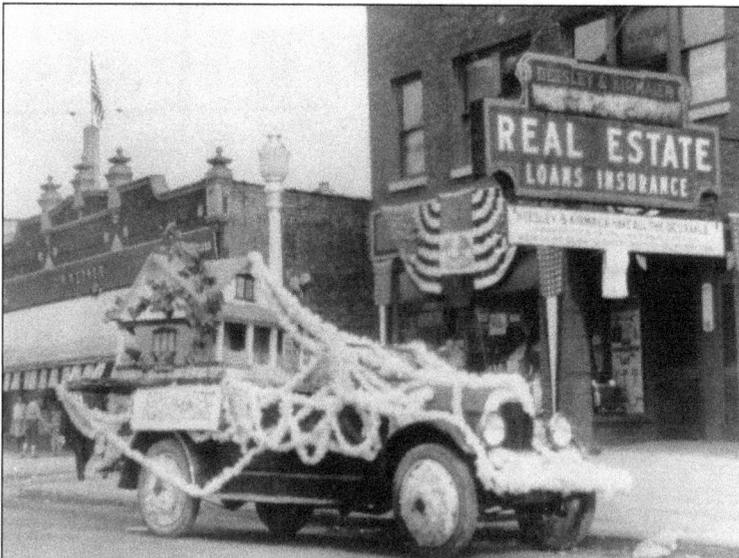

The Beesley & Kirmaier Real Estate office, 4219 West Irving Park Road, is shown here around 1920. The firm's car is decorated for a Fourth of July parade. Also visible, at left, is the C.W. Wegner store, which billed itself as "Irving Park's Leading Dry Goods Store and Men's Furnishings." (Courtesy Irving Park Historical Society.)

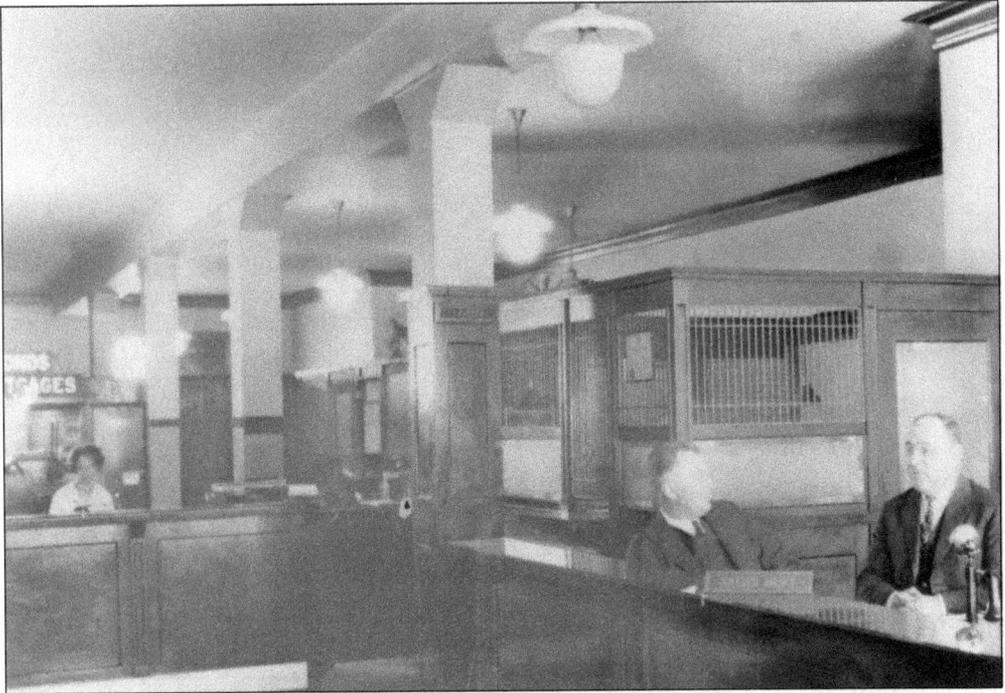

The interior of the Beesley & Kirmaier Real Estate office is seen here about 1920. In addition to selling real estate, the firm issued bonds and mortgages. (Courtesy Irving Park Historical Society.)

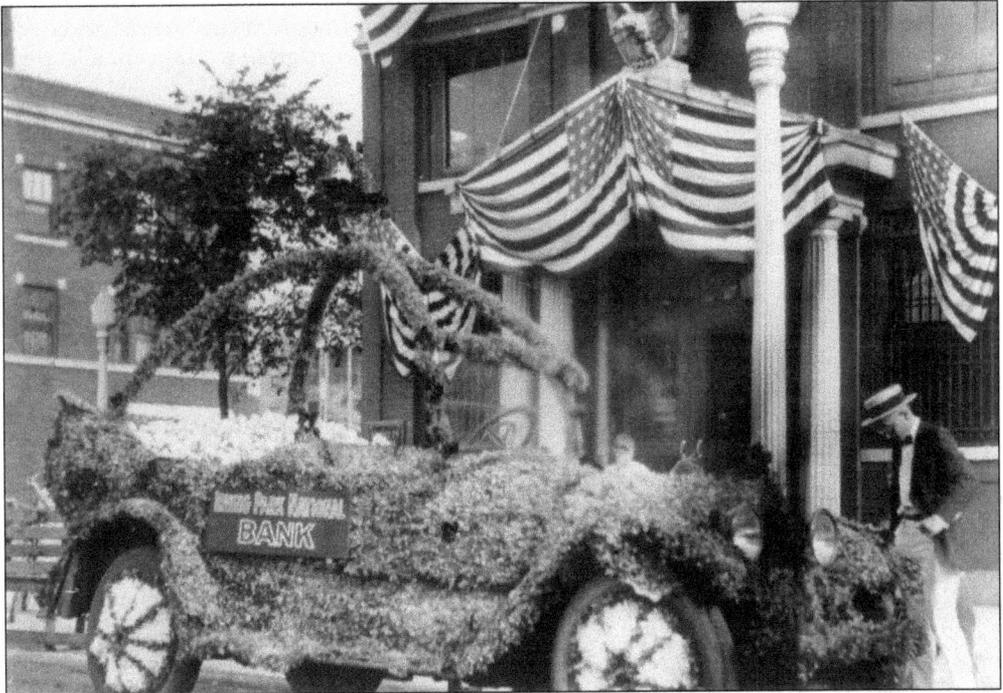

The Irving Park National Bank, 4201 West Irving Park Road, is shown here around 1920. A man and little boy gaze at the bank's car, decorated and ready for a Fourth of July parade. The exterior has been altered, but this building is still in use. (Courtesy Irving Park Historical Society.)

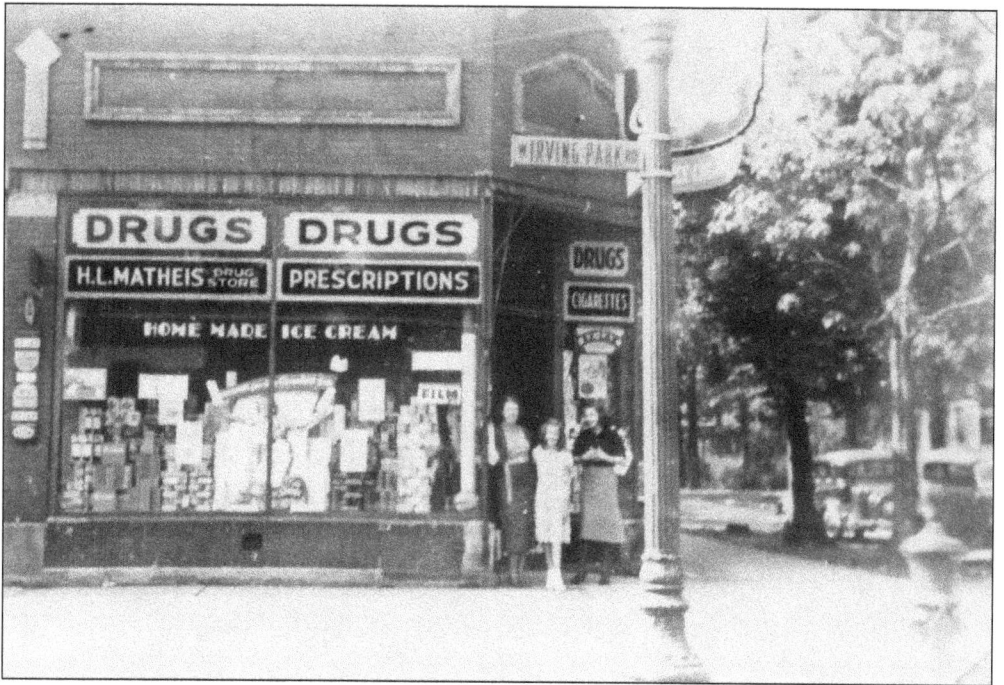

The H.L. Matheis Drug Store, 4365 West Irving Park Road, was in the neighborhood for many years and sold just about everything. The family-run business, which opened in 1933, sold medications, filled prescriptions, and offered old-fashioned remedies. The store, seen here around 1939, also sold candy, cigars, cigarettes, cosmetics, perfume, and magazines and rented out books. Whenever ice cream was made at the soda fountain, samples were given to children. (Courtesy Irving Park Historical Society.)

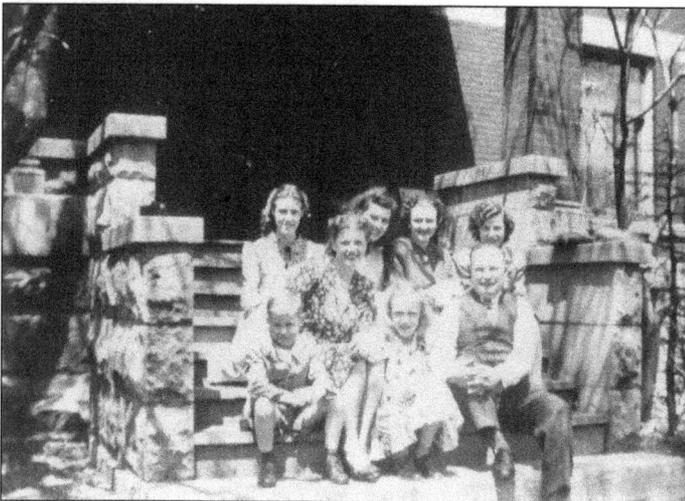

Henry L. Matheis, owner of H.L. Matheis Drug Store, and his family sit on the front steps of their home, 4402 West Irving Park Road, in the early 1940s. Most family members worked in the store, which was open from seven in the morning until midnight. Customers could purchase money orders and postage stamps and pay their water, electric, and gas bills. (Courtesy Irving Park History Society.)

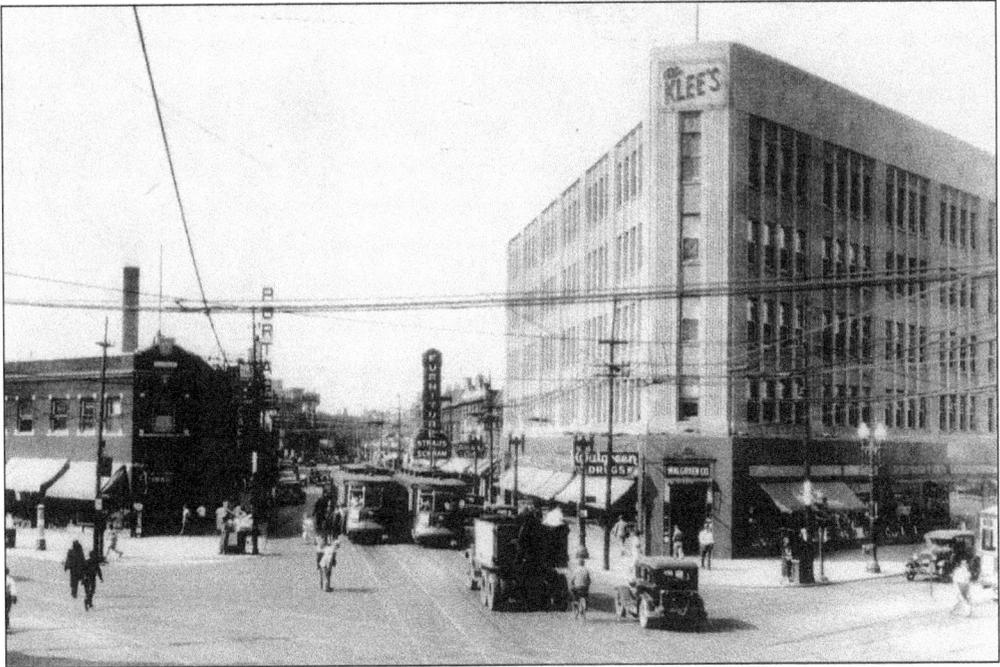

Many Old Irving Park residents have traditionally shopped at Six Corners, a commercial district at Irving Park Road, Milwaukee Avenue, and Cicero Avenue. The district is in Portage Park, a neighborhood just west of Old Irving Park. This is a 1934 view of Six Corners looking northwest on Milwaukee Avenue. The Art Deco Klee building (right) contained various retail shops. Also visible is the Portage Theatre, which opened in 1920. The theater still shows movies. (Courtesy Chicago Public Library, Special Collections Division, LMC Collection.)

In this 1943 photograph are businesses on the north side of the 4200 block of West Irving Park Road. Shown here are, from left to right, a vacant store with a sign pointing toward the nearby YMCA and the phrase, "Join the fun—YMCA"; Bergland Auto Repairs; a tailor; and a laundry. (Courtesy Irving Park Historical Society.)

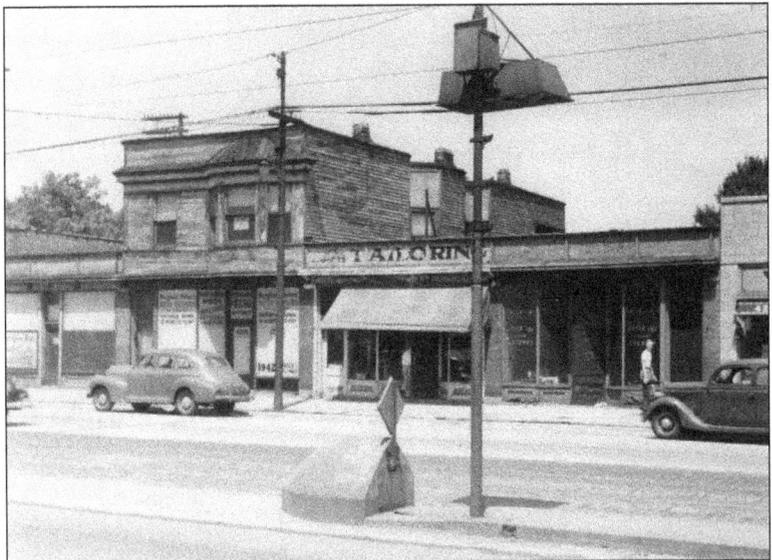

Dr. Masaru A. Masuoka and three unidentified students from Carl Schurz High School stand outside of Parkell Drug Store, 4272 West Irving Park Road, in 1947. Dr. Masuoka arrived in the Irving Park neighborhood shortly after being released from a US internment camp during World War II. He established a practice as an optometrist and was a longtime and highly respected member of St. John's Episcopal Church. (Courtesy Irving Park Historical Society.)

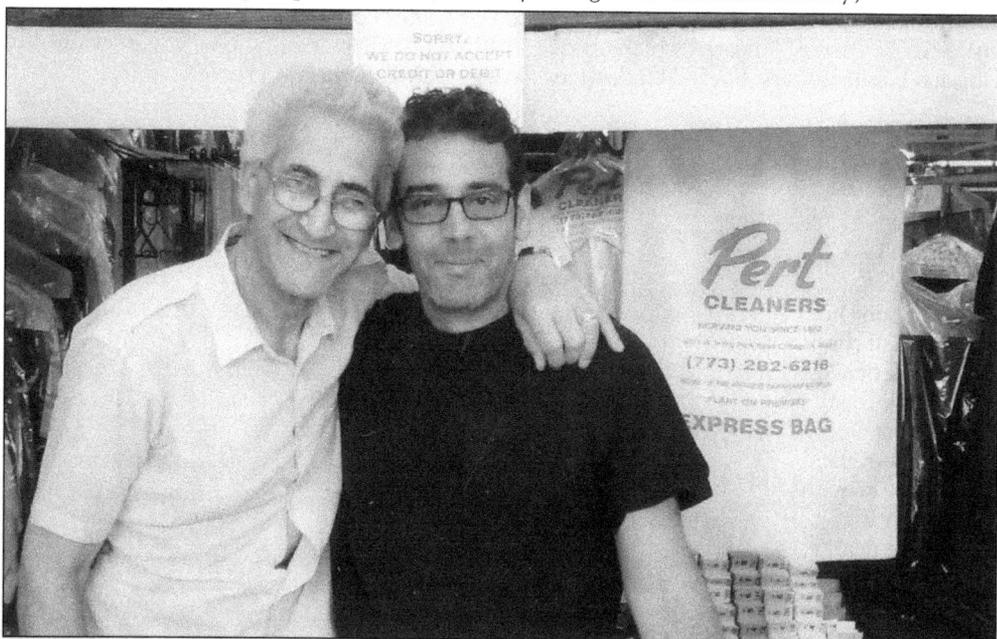

Pert Cleaners has been in business for 61 years. The Old Irving Park fixture has been at its current location, 4213 West Irving Park Road, since 1958. The business was started in 1952 by Tony Lupo when he was 17 years old. He is shown here in 2012 with his son Frank (right). Tony Lupo recalls that nearby businesses on Irving Park Road in the late 1950s were food stores, meat markets, bakeries, bars, drugstores, and a mortgage company. (Courtesy Tony and Frank Lupo.)

A florescent sign inside Pert Cleaners reads "Antique Fabric Care Museum." Owner Tony Lupo proudly displays many interesting antique items dealing with the care of clothing. Over the years, customers have donated irons, sewing machines, washing boards, washing machines, laundry detergent, scissors, thread, needles, and even a potbellied stove. (Photograph by Wilfredo Cruz.)

Shortly after arriving from Italy, Rosario Speziale opened his Rosario Barber Shop, 4302 North Pulaski Road, in 1959. He cut the hair of generations of customers. He is seen here giving a last haircut and shave to Jim Groulx while longtime customer Don Sadofsky waits his turn. Groulx and Sadofsky were a little sad this August 24, 2012, as, two days later, after 53 years of service, Speziale retired and closed his shop. (Photograph by Wilfredo Cruz.)

Mathias Beil, a German immigrant, opened Beil's Bakery, 4229 West Montrose Avenue, in 1944. His son, William Beil, shown here in the early 1950s, took over the family-run business. For 55 years, customers enjoyed the bakery's delicious bread, cakes, cookies, and other sweets. William Beil decided to retire at age 67, and on his last day, January 16, 1999, many loyal customers came to buy their last baked goods, say goodbye to the Beil family, and shed a few tears. (Courtesy Irving Park Historical Society.)

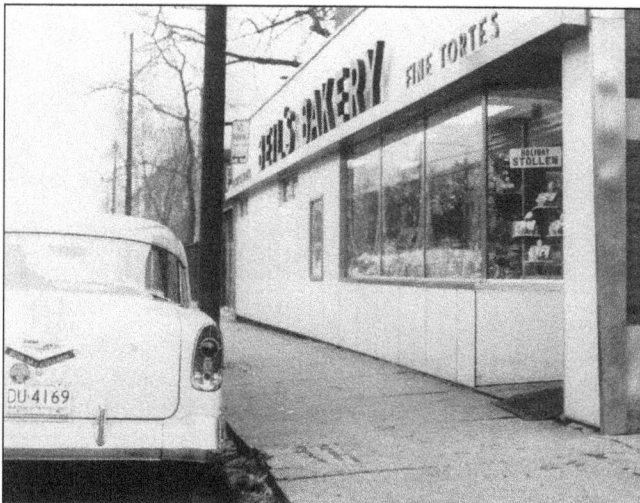

A customer is parked in front of Beil's Bakery in 1956. The Beil family lived above the bakery. The company's goods were made from scratch and based on handed-down recipes brought over from Germany. After the bakery closed in 1999, owner William Beil's son Carl, a third-generation Beil baker, opened a Beil's Bakery in Delavan, Wisconsin. Interestingly, the former Beil's Bakery is now Cuenca, a Mexican-owned bakery. (Courtesy Irving Park Historical Society.)

Michael Fortini is the owner of Fortini Garden Supply, 4387 North Elston Avenue. He inherited the business, which started in 1962, from his father. It has been at the same location for over 50 years. Fortini, a longtime resident of Old Irving Park, delivers truckloads of topsoil, sand, compost, and gravel to his customers. (Photograph by Wilfredo Cruz.)

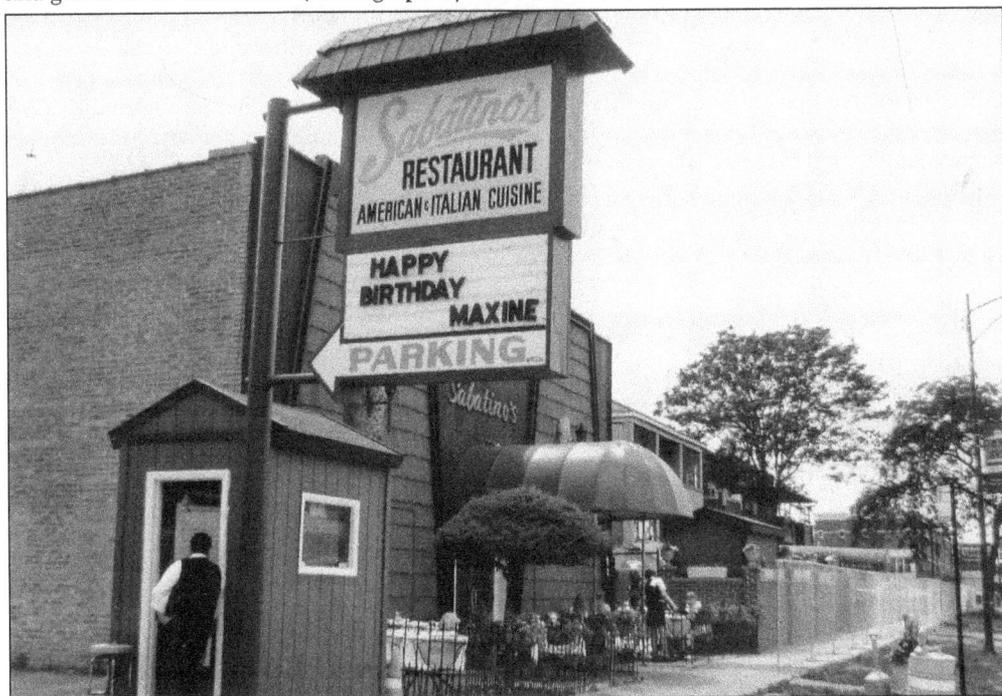

Sabatino's is an upscale restaurant known for delicious Italian cuisine, waiters in tuxedos, and tableside violinists. The restaurant, at 4441 West Irving Park Road, is owned by brothers Angelo and Enzo Pagni, Italian immigrants who bought the restaurant in 1978 from the Sabatino family, which started the business around 1969. The restaurant's original name was not changed. (Photograph by Wilfredo Cruz.)

City Newsstand is a quaint bookstore and coffee shop at 4018 North Cicero Avenue. The store opened in 1989 and claims to carry the largest selection of magazines and newspapers in the Midwest, including over 5,000 magazine titles and many foreign newspapers. It is located in Portage Park, but many Old Irving Park residents are loyal customers. The store started in 1978 as a corner newsstand. Shown here are, from left to right, owner Joe Angelastri and workers Greg Kubala and Darrell Hackler. (Photograph by Wilfredo Cruz.)

Koch Foods, Inc., is a national company that manufactures and delivers chickens and chicken products. The firm started in 1984 and has a large processing plant on the western edge of Old Irving Park at 4404 West Berteau Avenue. Hundreds of workers, mostly African American and Latino, work three shifts in the plant's freezers deboning chicken. After a one-week strike in the mid-1990s, workers won more pay. In this December 2012 photograph, workers (left) buy lunch from a food truck. (Photograph by Wilfredo Cruz.)

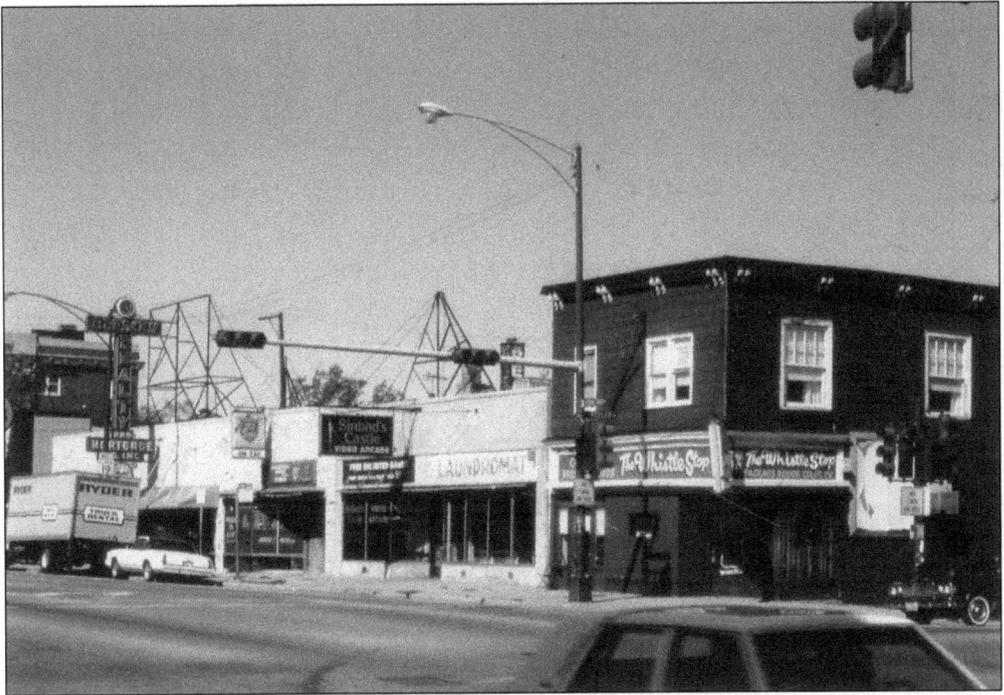

Businesses line the north side of the 4200 block of West Irving Park Road in 1985. Shown are, from left to right, Beesley Realty, Old Style Tavern, Sinbad's Video Arcade, a laundromat, and the Whistle Stop tavern (formerly D.D. Mee Grocery). Beesley Realty was formerly on the other side of the street. The exterior of the Whistle Stop building was significantly altered. It later housed the Irving Park Historical Society (IPHS). The IPHS assisted the owner in restoring the building and winning city landmark status in 1990. (Courtesy Irving Park Historical Society.)

Kevin O'Brien (right) and Tom Ventrelli were owners of O'Briens, an Irish pub at 4328 West Irving Park Road. The pub opened in 1980 but did not succeed. Here, in 1985, the men haul away the sign that once hung over their business. Ralph's Motor Service, visible in the background, is no longer there. (Courtesy McNamara's.)

McNamara's is a popular Irish pub and restaurant at 4328 West Irving Park Road, the location of the former O'Briens pub. McNamara's, which opened in 1997, is a friendly place with a bar, restaurant, and outdoor seating. Its interior is nicely decorated with an Irish theme, including framed photographs of famous Irish American writers and poets. (Photograph by Wilfredo Cruz.)

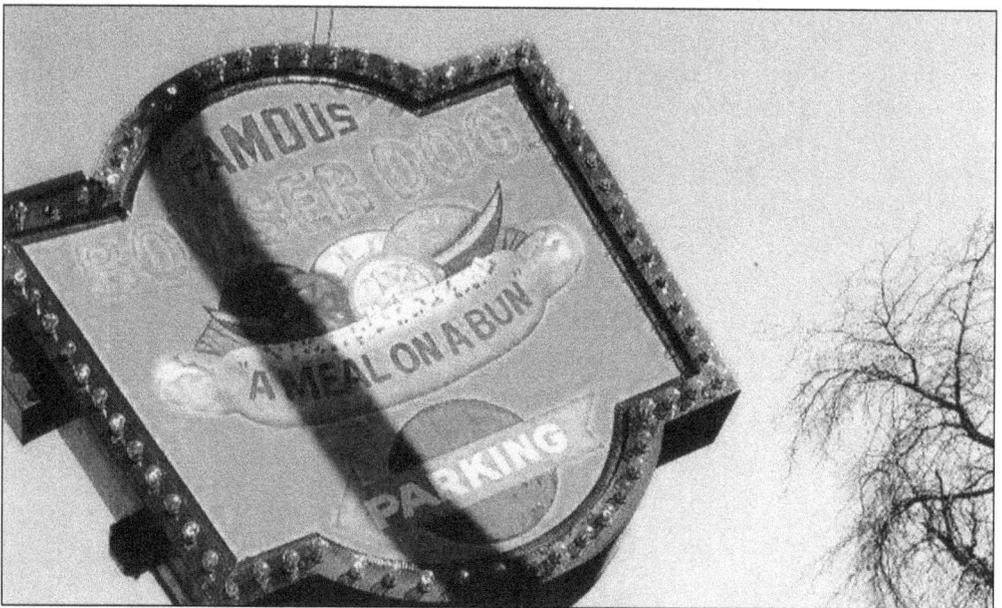

Bowser Dog was a friendly place to enjoy fast food, including hot dogs, hamburgers, tacos, and gyros. Greek identical-twin brothers Cristos and Vlasis Kehagias were the well-liked owners of the establishment at 4504 West Irving Park Road. After about 25 years in business, however, Bowser Dog closed in the early 2000s. Shortly afterward, Cristos Kehagias passed away. The restaurant was razed and its sign taken down. In its place stands a building with four condos and a fitness facility. (Courtesy Jason and Maureen Lontoc.)

Humberto Gamboa helps a customer in 2012. Gamboa is owner of Tres Americas Book Store, 4336 North Pulaski Road. The store, which has been in Irving Park since 1988, carries a large selection of Spanish-language books, including cookbooks, fiction, nonfiction, and literature. Noted authors give lectures and poetry readings and conduct book signings at the store. (Photograph by Wilfredo Cruz.)

Luran Sak (right) is co-owner of Java Thai, a cozy coffeehouse at 4272 West Irving Park Road. She and her partner, Thanit Udompaichitkul, have been in business for 20 years. Their little business has grown, and they now offer breakfast, lunch, and dinner. The establishment features live jazz music every Sunday morning. Here, customers enjoy their morning oatmeal, newspaper, and coffee. (Photograph by Wilfredo Cruz.)

Abid Dossaji (left) is the owner of Convenient Food Mart, a small grocery store located in the Old Irving Park Plaza in the 4300 block of West Irving Park Road. Amrut Patel is his assistant. Many residents like the friendly atmosphere at the store, which Dossaji has operated since 1998. (Photograph by Wilfredo Cruz.)

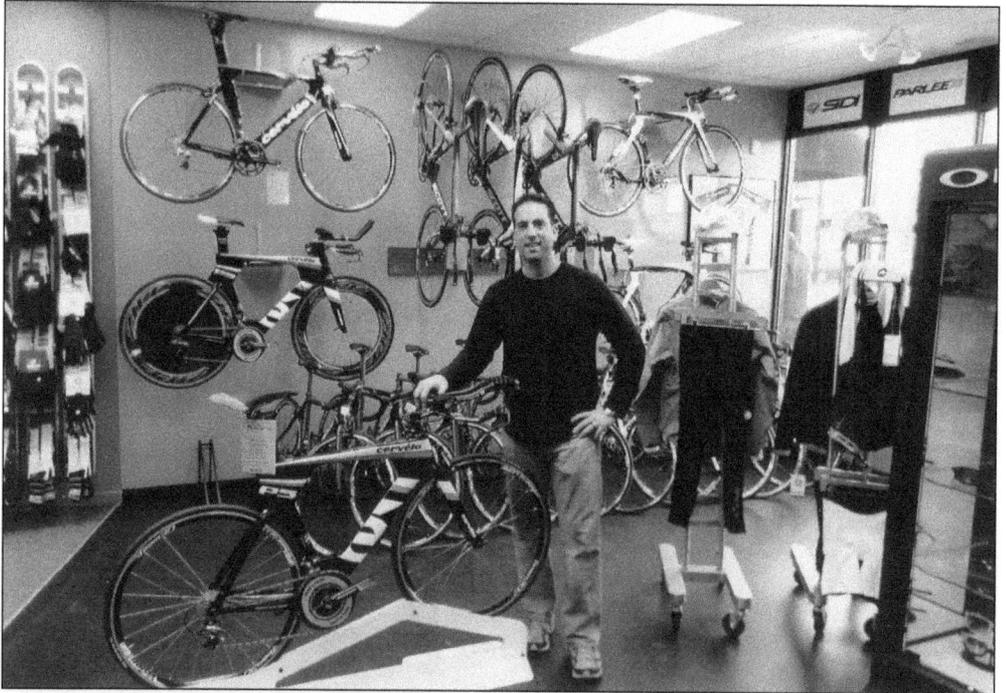

Kevin Corsello is the owner of Get a Grip Cycles, which sells and repairs bicycles, including high-end road bicycles and accessories. Corsello's business at 4359 West Irving Park Road has received rave reviews and has grown since its opening in 2001. In 2007, Corsello opened a second store at 621 West Fulton Street. Corsello's top-of-the-line bicycles sell for over $9,000. (Photograph by Wilfredo Cruz.)

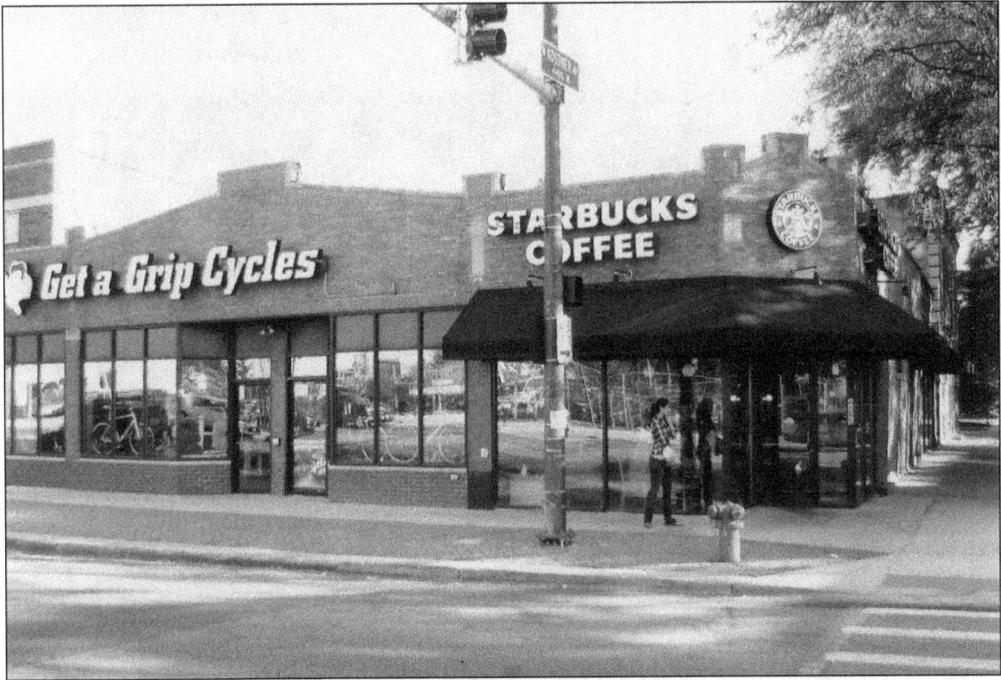

Next door to Get a Grip Cycles is Starbucks Coffee. The coffee shop sees a steady flow of customers throughout the day. New sidewalks on both sides of Irving Park Road were installed in 2012. As shown here, the sidewalks include hand-laid brown brick. (Photograph by Wilfredo Cruz.)

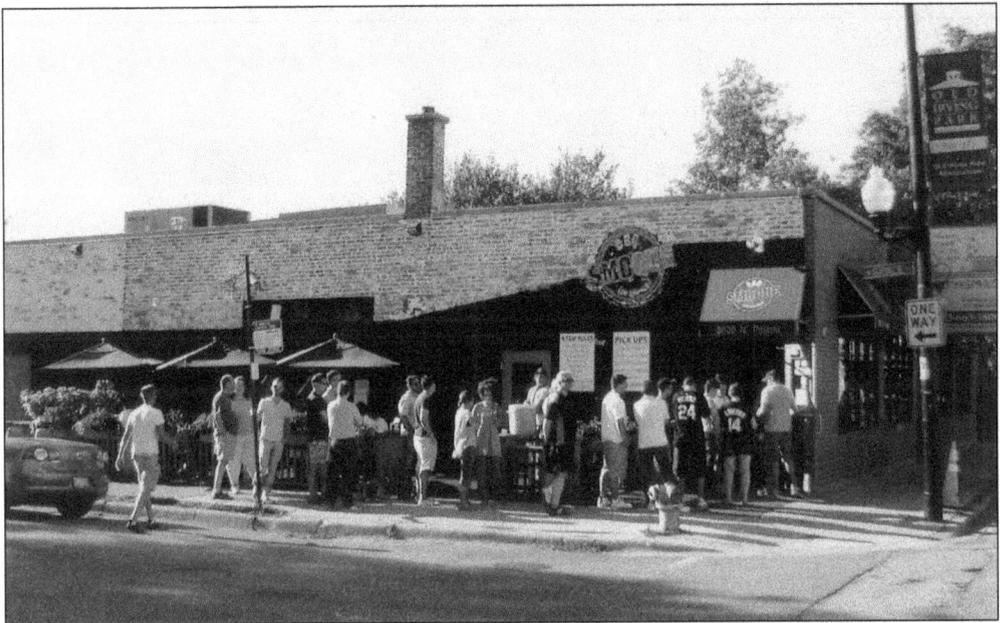

Customers are seen here lining up at Smoque, a causal restaurant started around 2006 by five partners. The establishment at 3800 North Pulaski Road is known for delicious barbeque, brisket, ribs, and chicken dinners, and it has been highly rated on television shows and in newspapers and magazines. Neighborhood-identifying banners, such as the one seen on the far right, hang on light posts along major streets. (Photograph by Wilfredo Cruz.)

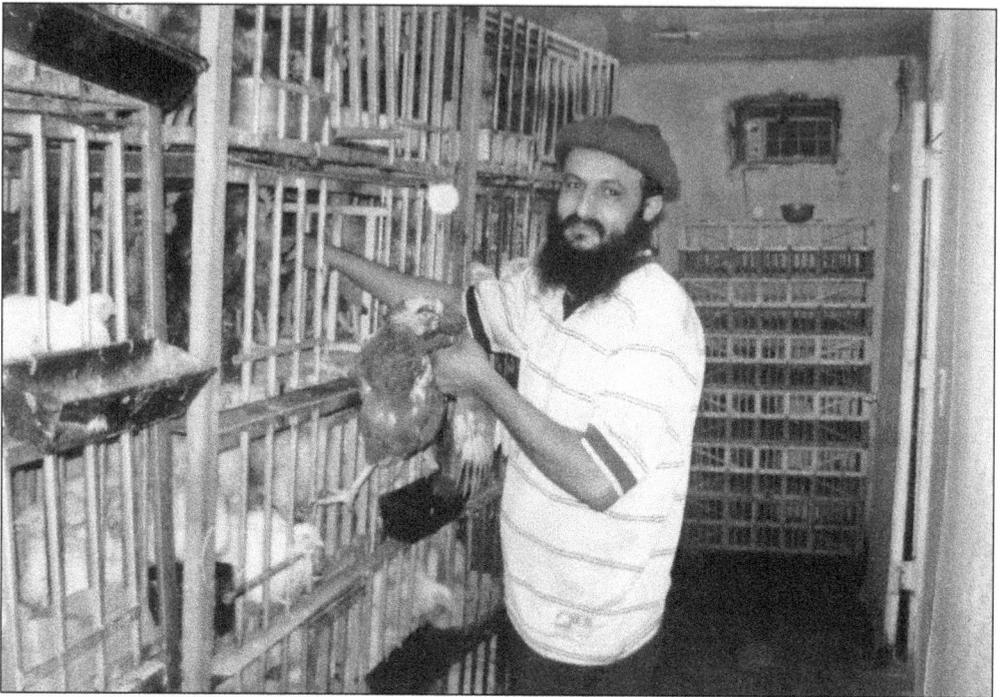

Jamal Atef owns Elston Chicken Poultry at 4350 North Elston Avenue. He kills and prepares rabbits, geese, ducks, roosters, turkeys, and hens for customers. Much of the organic poultry comes from farms in Indiana. Atef started his business in 2007. (Photograph by Wilfredo Cruz.)

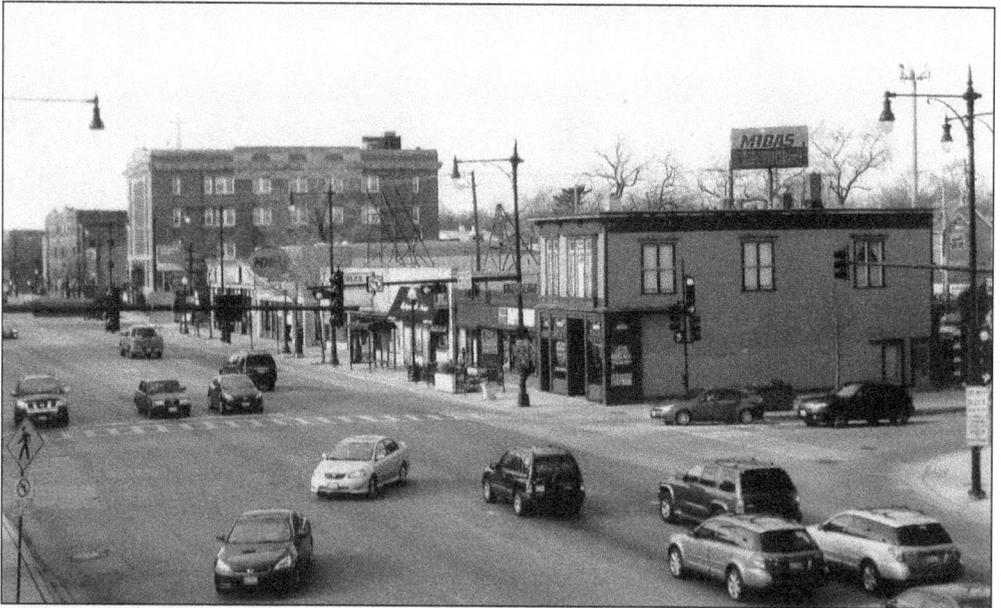

This 2012 view of Irving Park Road is looking west. At right is the former D.D. Mee Grocery building, erected about 1870. It is the oldest surviving commercial structure in the area. Today, this city landmark sports much of its original look. The building has seen many incarnations, including as grocery stores, drugstores, taverns, a restaurant, and a historical society. (Photograph by Wilfredo Cruz.)

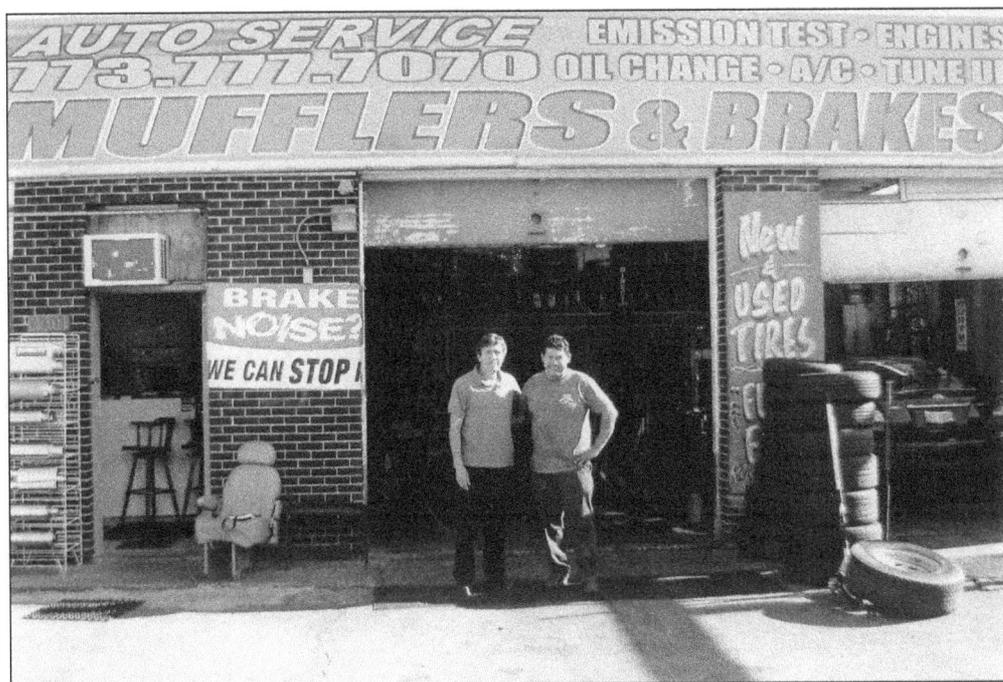

Auto Service Mufflers and Brakes, 4301 West Montrose Avenue, opened in 2011. The previous tenant at this location was a mechanic shop that sat empty for over 10 years. Fernando Rivera (left) and Ricardo Martinez are the co-owners. Thus far, they are doing a brisk business by offering affordable, good service. (Photograph by Wilfredo Cruz.)

The Chicago Weaving School, 4201 West Irving Park Road, opened in the summer of 2012. Owner Natalie Boyett, standing in the back at center, offers classes on weaving. In the foreground, a man is weaving a rug for himself out of old pieces of cloth. This building was the former Irving Park National Bank and Jay-Bee's Grocery store. (Photograph by Wilfredo Cruz.)

This commercial building was constructed in the 4300 block of West Irving Park Road in 2012. The new tenants are, from left to right, a law office, Citywide Mortgage of America, and Simply Custom Window Treatments. The Old Irving Park Association was responsible for getting the old-fashioned electric public clock shown right of center installed in 2012. The clock's face lights up at night. (Photograph by Wilfredo Cruz.)

Five

EDUCATION

By the mid-19th century, America advanced the idea of free compulsory education for its citizens, and many working-class immigrants wholeheartedly welcomed the opportunity. Early settlers to Old Irving Park hoped education would help their children lead better lives. The first neighborhood public elementary school was the Irving Park School, completed in 1875. The architecturally distinctive building conveyed an air of importance. Unfortunately, the school was destroyed by fire in 1896. The children were not hurt, and they were taught in temporary quarters for the next 10 years. In 1906, a new Irving Park School was constructed on the same site, 3815 North Kedvale Avenue. The school was designed by Dwight H. Perkins, an acclaimed architect of the Prairie School style.

Violet Weisen began teaching math at the Irving Park School shortly after it opened. This beloved instructor taught generations of children during her four decades at the school. Weisen had a reputation as an outstanding and firm but fair math teacher. She was a longtime resident of Irving Park and lived well into her 90s.

Another popular public elementary school was Hiram H. Belding, 4257 North Tripp Avenue, built in 1901. Some of the children displaced by the fire at the first Irving Park School transferred to Belding. Early photographs of children at the Irving Park and Belding schools show them as serious and with a sense of purpose.

In 1870, the first Jefferson Township High School was organized in the crowded second floor of its town hall building. The structure was located at the intersection of Irving Park Road, Cicero Avenue, and Milwaukee Avenue. In 1883, a three-story brick Jefferson High School was built. The school had about 75 students enrolled in its early years.

Jefferson High School was replaced in 1910, when Carl Schurz High School was constructed. The modern high school opened with an enrollment of 1,031 students. The handsome school was designed by Dwight H. Perkins in the Prairie School style. The American Institute of Architects described the school as Perkins's "masterpiece."

The school was named in honor of Carl Schurz, a deceased German statesman, war hero, newspaper editor, and US senator from Missouri. The Irving Park Woman's Club managed the lunchroom, preparing hot food in their homes and delivering it to the school at lunchtime. Later, equipment was purchased to cook lunches at the school.

Many newly arrived immigrants flocked to the school in hopes of acquiring skills and training. An addition to the school was completed in 1915. The school offered accredited night classes for over 3,000 students in subjects like English, writing, and vocational training.

Schurz students supported American troops in World War I. The Civics Industrial Club made 4,900 trench torches for the soldiers in France and sent over 16,000 books for military men. In the foundry, hand grenade parts were made and sent to the arsenal at Rockford, Illinois. During World War II, students contributed to the Red Cross, bought war bonds, and held scrap drives. The Industrial Arts Department provided airplane models used in Army and Navy aircraft training.

Over the years, Carl Schurz High School excelled in academics, sports, and music. In 2013, the school began offering an academically rigorous international baccalaureate program that prepares students for college.

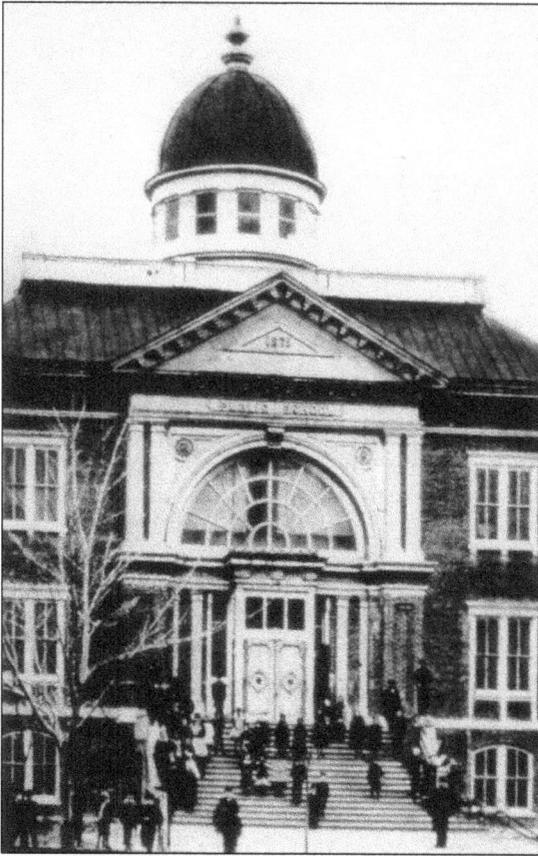

Irving Park School was the first public elementary school built in Old Irving Park, in 1875. The school, at 3815 North Kedvale Avenue, had a distinctive green dome that could be seen for miles. The building was completely destroyed by fire in 1896. (Courtesy Irving Park Historical Society.)

A new Irving Park School was built in 1906 to replace the one destroyed by fire. The school occupied the same location as the previous school, 3815 North Kedvale Avenue. Noted Prairie School architect Dwight H. Perkins designed the school. During his years as chief architect of the Chicago Board of Education (1905–1910), Perkins designed 40 public schools in Chicago. (Photograph by Wilfredo Cruz.)

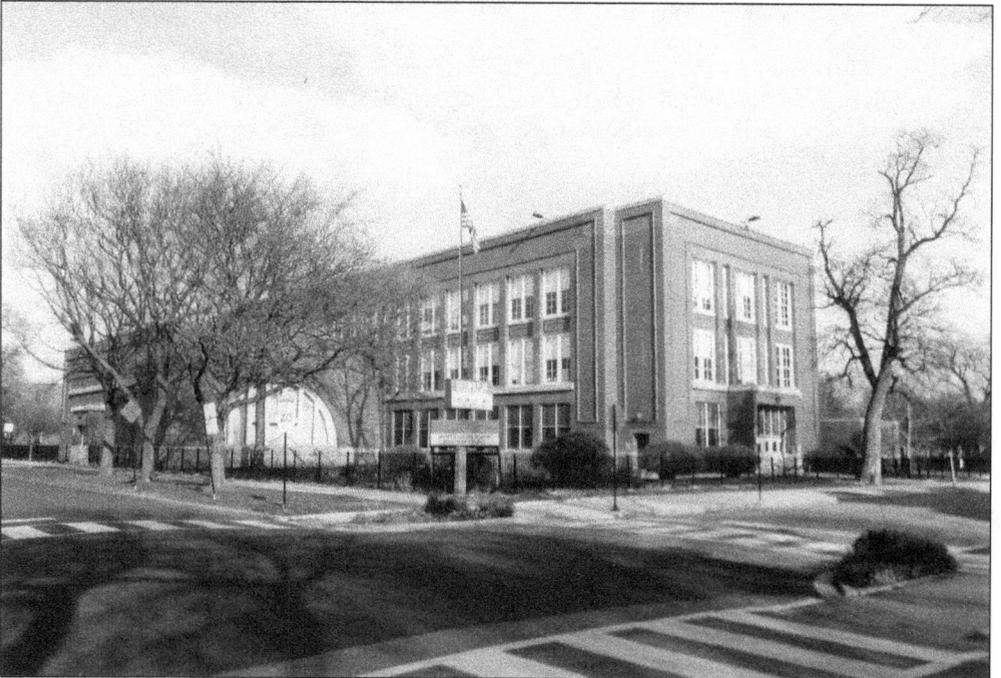

This is the 1919 graduating class of the Irving Park School. The owner of this photograph wrote numbers on the students and teachers to identify them, and the back of the photograph has the corresponding names. The teachers are identified as Miss Hanafin (third row, far left) and Miss McMahon (third row, far right). (Courtesy Irving Park United Methodist Church.)

This group photograph of room 204 of the Irving Park School was taken in 1943. The children are fourth graders. (Courtesy Irving Park Historical Society.)

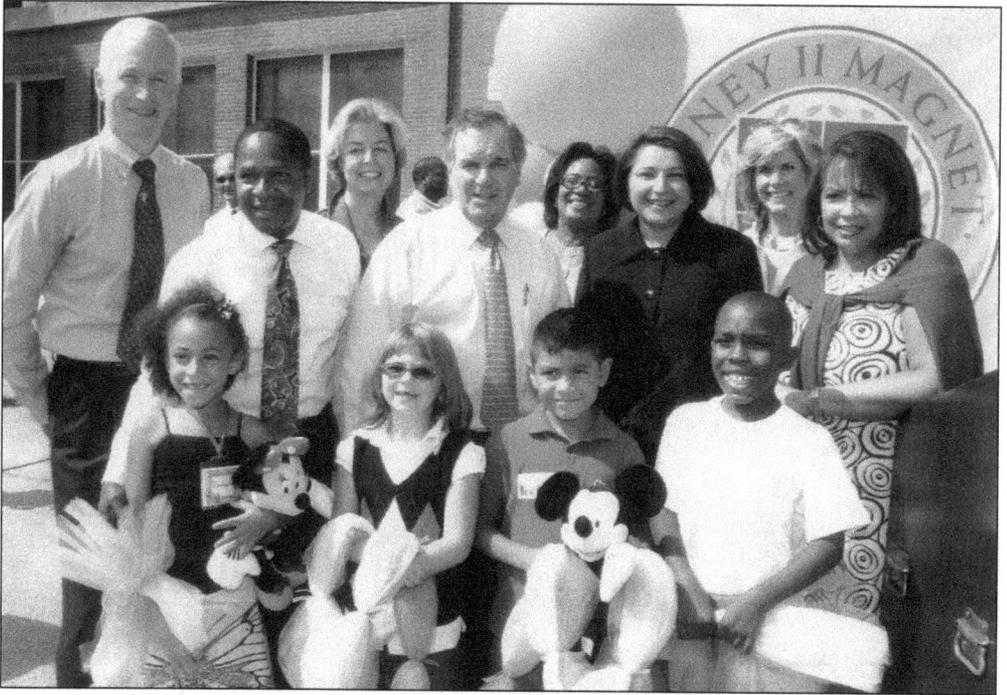

Irving Park School became Disney II Magnet School in 2008. Its curriculum replicates that of the city's first highly rated Walt Disney Magnet School, focusing on arts and technology. City and state officials, along with school staff and students, gathered for the opening ceremony. The officials shown here are, from left to right in the second row, Tom Allen (alderman, 38th Ward), Rufus Williams, Ann Roosevelt, Richard M. Daley (mayor of Chicago), Barbara Eason-Wathing, Bogdana Chkoumbova (principal), Kathleen Hagstrom, and Iris Y. Martinez (state senator, D-Chicago). (Courtesy Disney II Magnet School.)

About 26,000 Chicago public school teachers went on strike in September 2012. The last Chicago teachers' strike had been 25 years earlier. Here, Disney II Magnet School teachers picket in front of their school one morning. A resident, seen at left with a dog, made coffee and cupcakes for the teachers. After seven days of striking, the teachers returned to work after winning pay increases and better job security. (Photograph by Wilfredo Cruz.)

Hiram H. Belding School has served generations of Old Irving Park students. The elementary school was built at 4257 North Tripp Avenue in 1901. Additions to the school were built in 1902 and 1907. The school was named in honor of Hiram H. Belding, a noted Chicago businessman who established a successful silk clothing company called Belding Brothers & Company. The large firm had mills in four states and Canada. (Photograph by Wilfredo Cruz.)

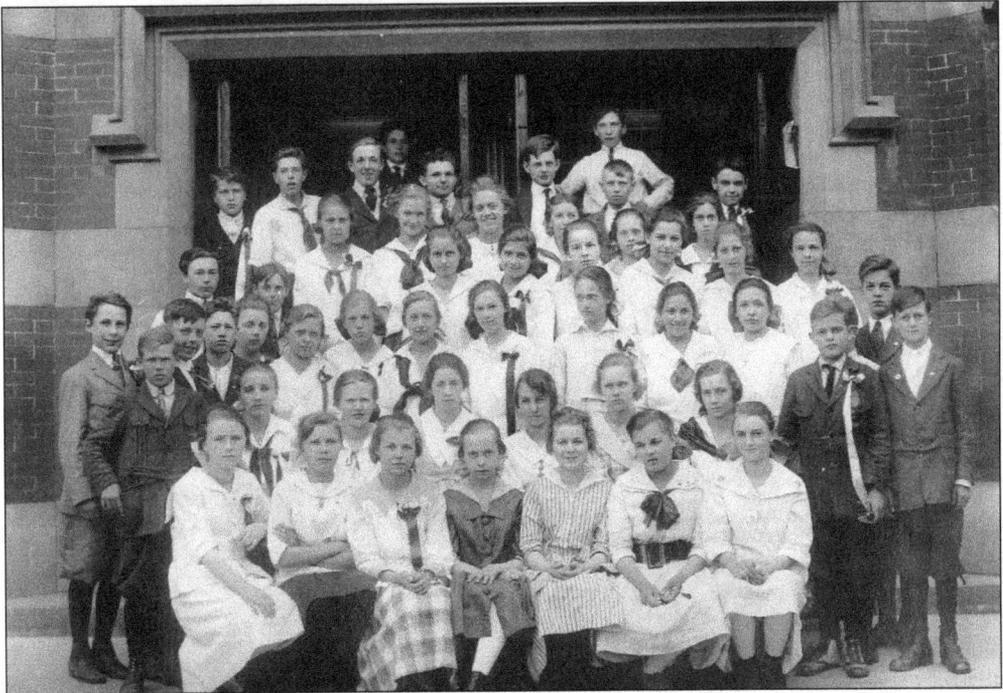

This is the June 1918 graduating class of Hiram H. Belding School. Many group photographs of public school students were taken by Frank C. Lowa, who had a photography studio at 4024–4026 North Keeler Avenue. (Courtesy Hiram H. Belding School, Grace Herhold Collection.)

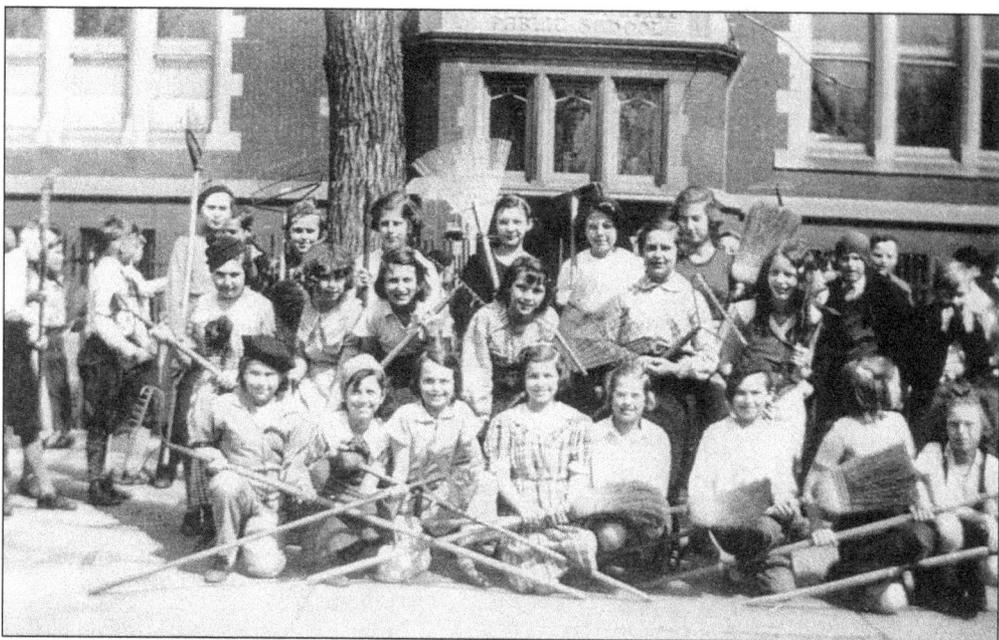

Students from Hiram H. Belding School participated in a "Clean up Day" in May 1936. The students, armed with brooms, rakes, and shovels, tidied up around the school and neighborhood. (Courtesy Hiram H. Belding School.)

This three-panel mural, on a corridor wall at Hiram H. Belding School, was painted in the early 1930s by an artist who simply signed the work "Elvis." Despite the economic struggles of many American families during the Great Depression, the mural interestingly depicts children innocently playing. The mural was part of the federal government's Works Progress Administration projects. The mural was restored. (Photograph by Wilfredo Cruz.)

These Hiram H. Belding students, probably first graders, held a play in the school's auditorium in May 1939. They are dressed in period costumes. (Courtesy Irving Park Historical Society.)

This 1953 photograph features the fourth and fifth grades at Hiram H. Belding School. The smiling children are sitting very properly, hands neatly folded. The non-movable wood desks and polished wood floors were common in older Chicago public school buildings. (Courtesy Hiram H. Belding School.)

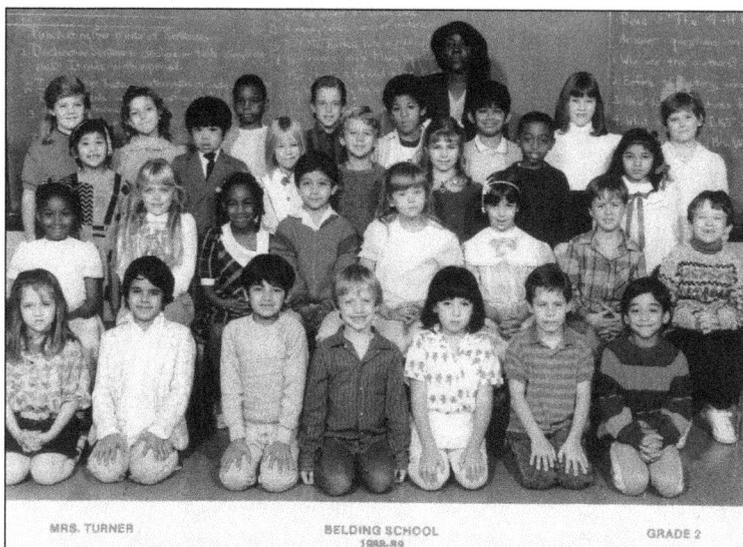

Mrs. Turner's second-grade class at Hiram H. Belden School poses in 1988–1989. Beginning in the early 1960s, Chicago public schools saw a steady increase of African American, Latino, and Asian American students. (Courtesy Hiram H. Belding School.)

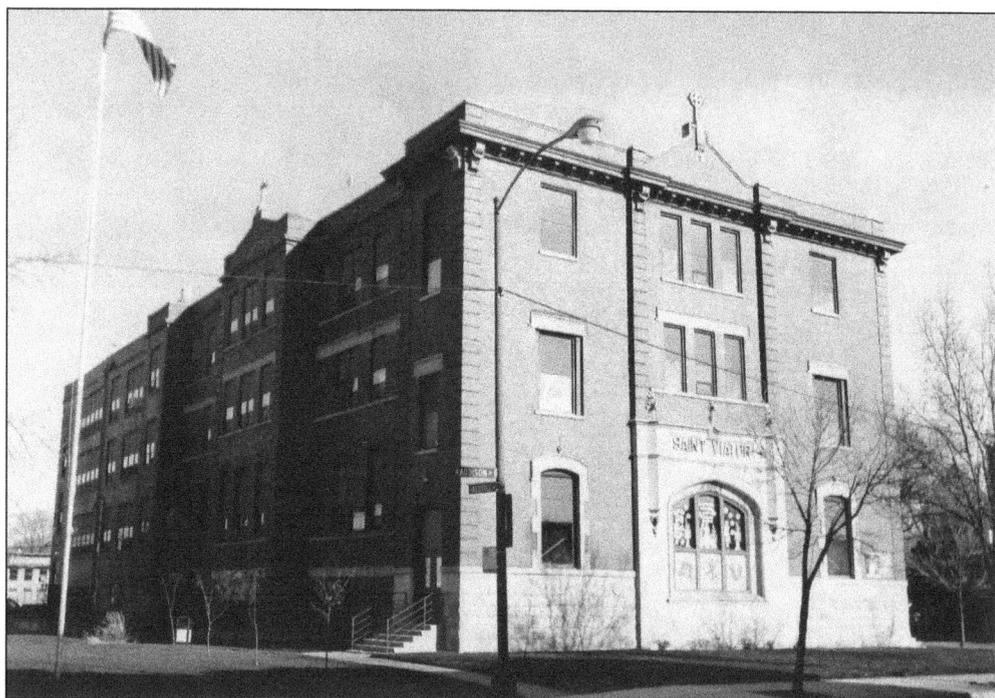

St. Viator Catholic School, 4140 West Addison Street, was built in 1910. When completed, it was praised as one of the best-planned structures of the Archdiocese of Chicago. The Sisters of St. Joseph of Carondelet, a Catholic order of nuns, were teachers at the school. The building served as both school and parish until the church building was constructed in 1928. (Photograph by Wilfredo Cruz.)

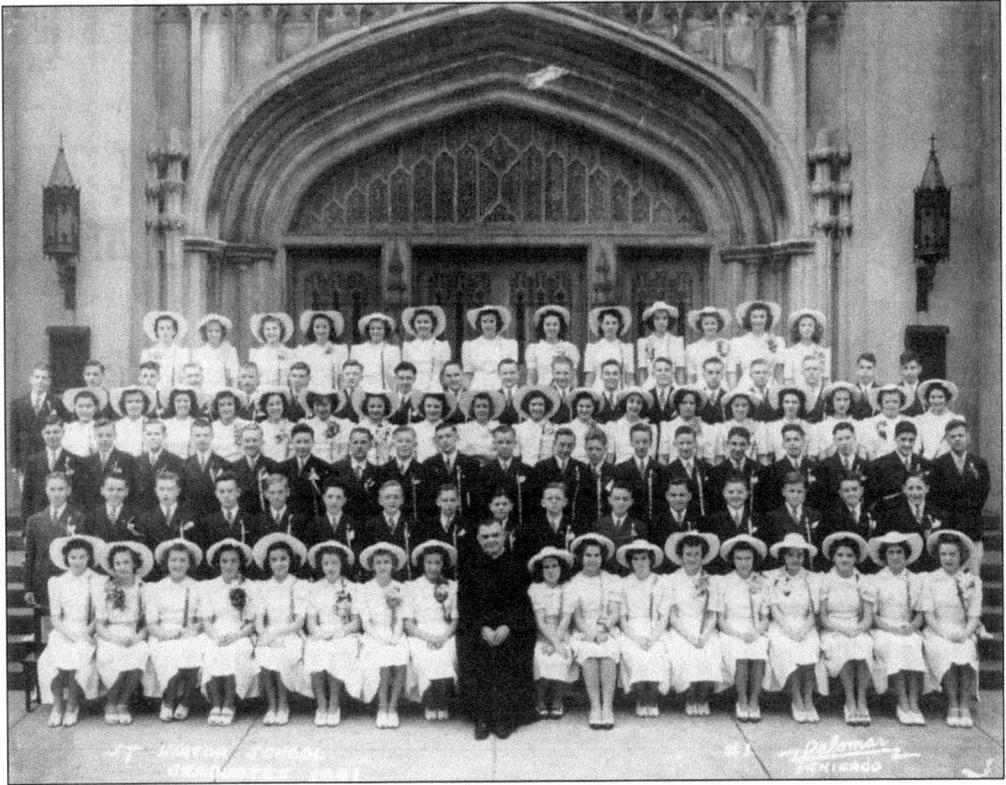

Here is a large graduating class of St. Viator School in 1941. The class is gathered in the front of St. Viator Church. (Courtesy St. Viator School.)

A kindergarten class of St. Viator School poses in the mid-1950s. The colorful wall mural is still at the school. (Courtesy St. Viator School.)

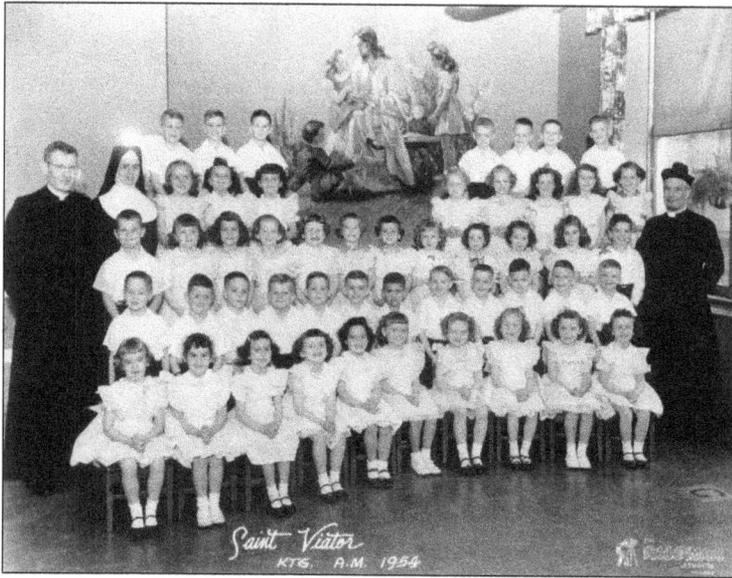

A St. Viator School nun (fourth row, second from left) stands with her kindergarten class in 1954. They are joined by priests from St. Viator Church. The well-dressed boys and girls completed kindergarten and gathered for a graduation photograph. (Courtesy St. Viator School.)

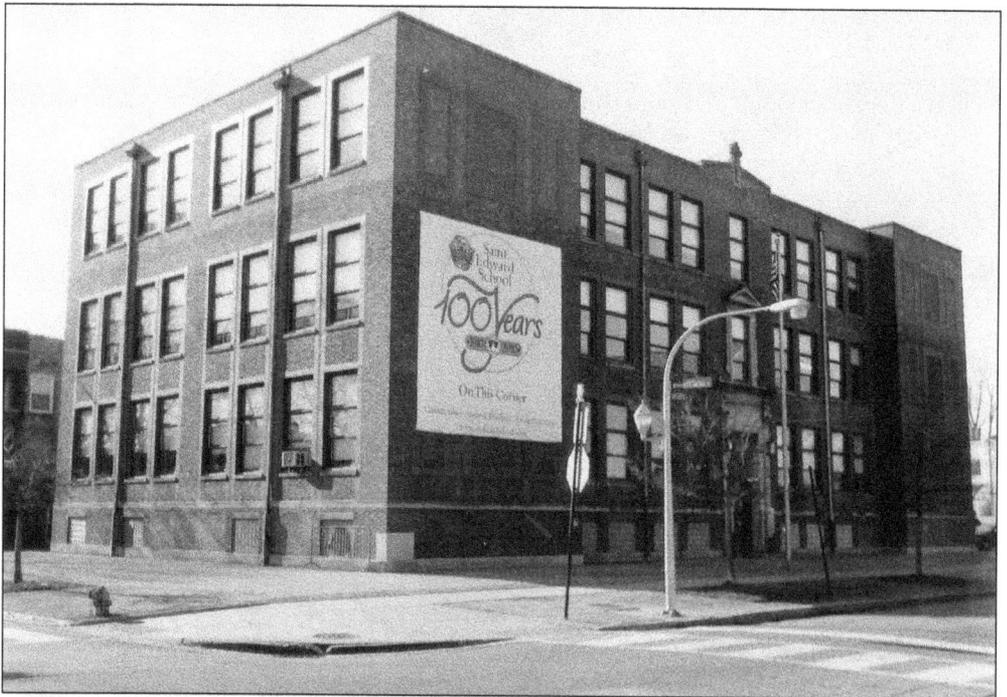

St. Edward School is in the Mayfair neighborhood, one block north of Old Irving Park, but many Old Irving Park families enroll their children in the school. In 1910, the first St. Edward School was built, but it soon outlived its usefulness and was razed. A new school (shown here) was built in 1939 at 4343 West Sunnyside Avenue, directly across from where the old one stood. St. Edward School celebrated its centennial in 2010. (Photograph by Wilfredo Cruz.)

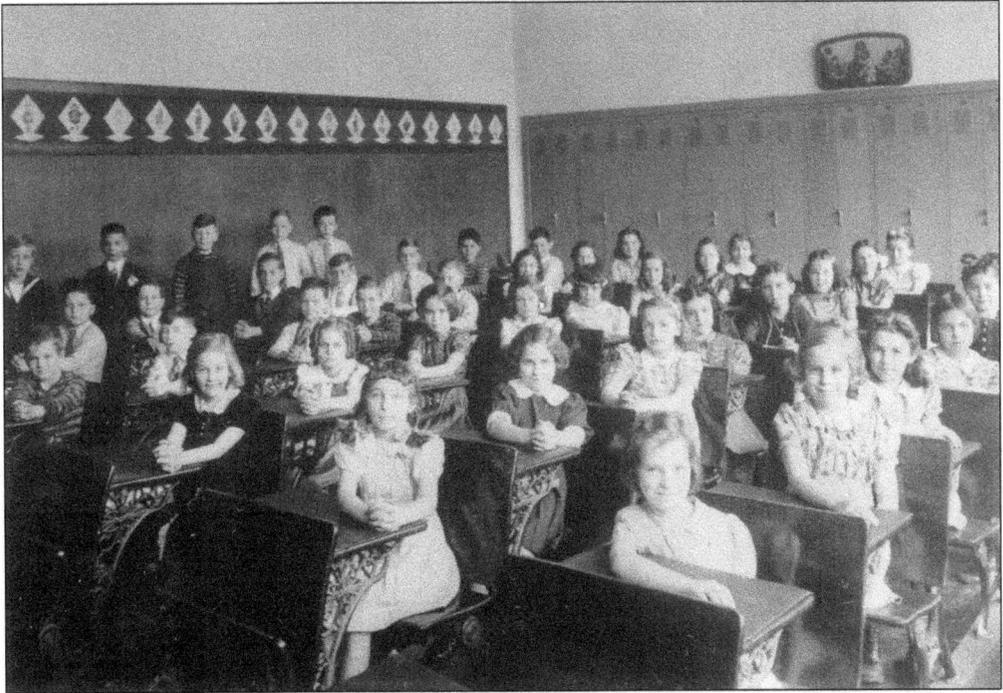

A large class of students, probably third graders, poses for a group photograph at St. Edward School in the early 1920s. (Courtesy St. Edward Church.)

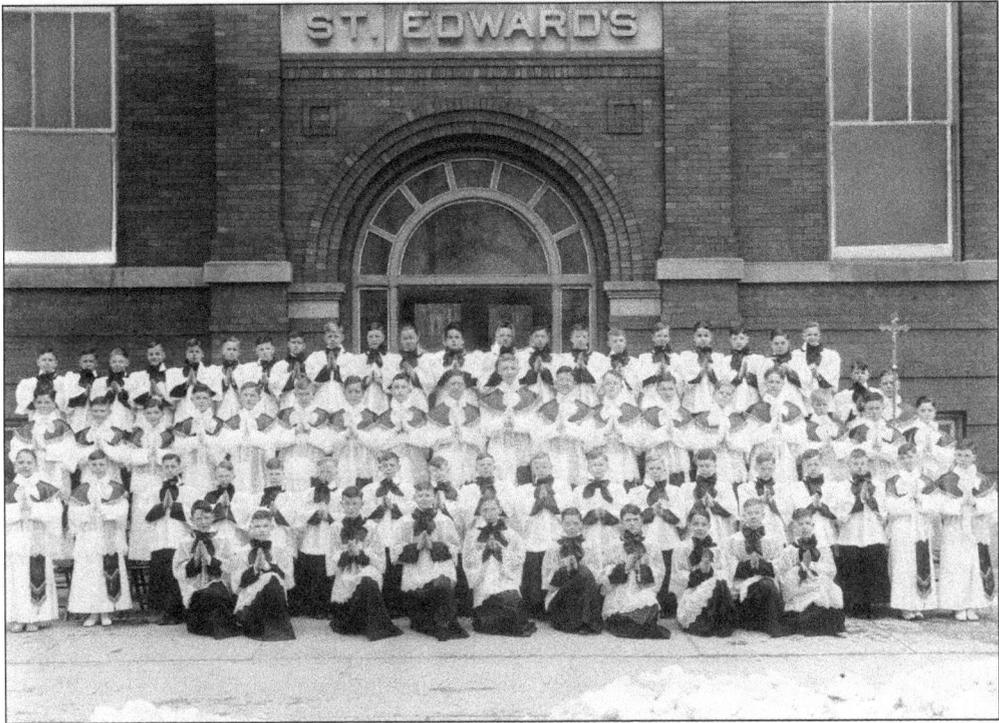

The boys' choir poses for a group photograph in front of the first St. Edward School building in the early 1920s. Snow is piled up on the sidewalk. (Courtesy St. Edward Church.)

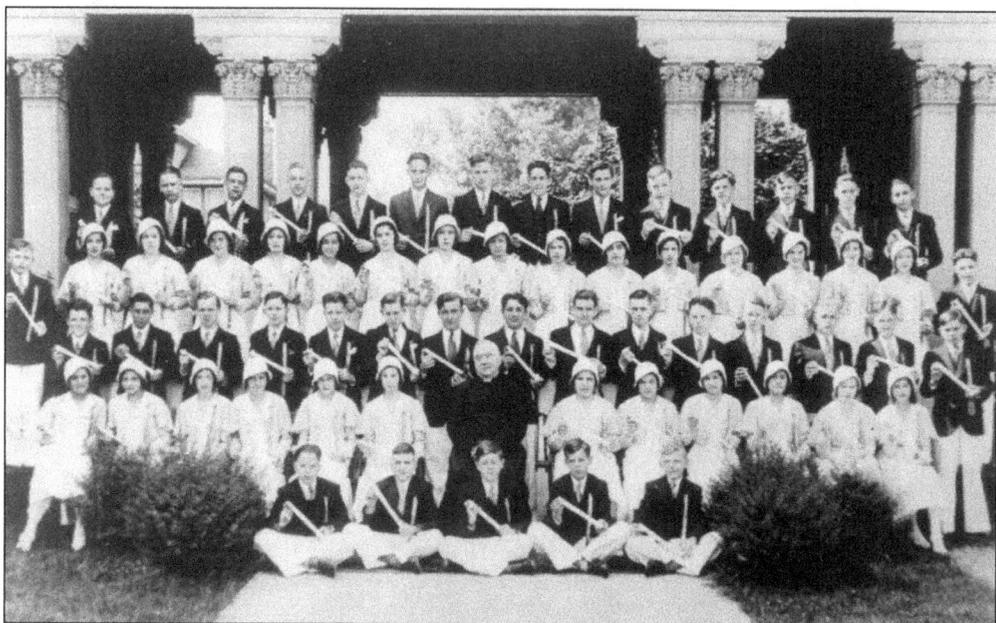

Shown here is the 1932 graduating class of St. Edward School. The students are gathered in a courtyard between the school and parish. The courtyard no longer exists. (Courtesy St. Edward Church.)

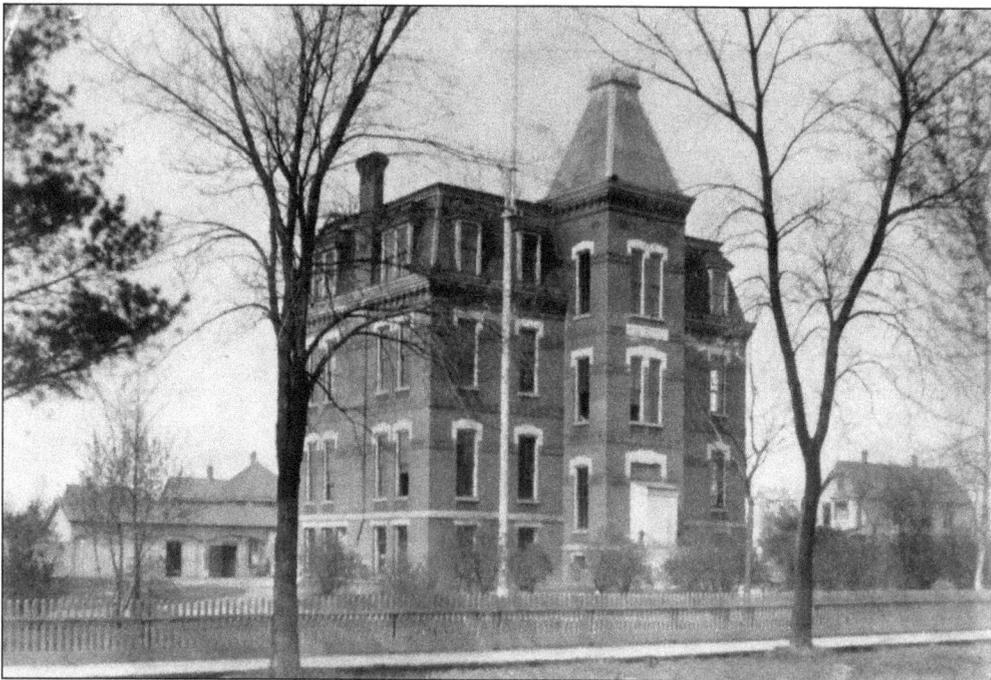

Jefferson Township erected its first free-standing high school, Jefferson High School, in 1883. The brick building had a basement and three floors and was located near the corner of Wilson and Knox Avenues. The school had an enrollment of about 75 students in its early years. This building was later used by the Chicago Board of Education as a grade school until its demolition in 1939. (Courtesy Irving Park Historical Society.)

This is the Jefferson High School senior class of 1892. The students are gathered in front of the steps of the school. Early students at the school came from Jefferson Township's well-known families, including the Race, Budlong, Dunning, Loucks, Wheeler, Dickerson, and Kimbell families. (Courtesy Irving Park Historical Society.)

Shown here is the program for the eighth annual commencement of Jefferson High School in 1892. A small class of 16 students graduated that year. The commencement was held at Irving Hall, better known as the Irving Park Country Club. The hall, built in 1890 and located at 4021 North Keeler Avenue, was an elegant five-story building with meeting rooms, spacious auditoriums, and large dining rooms. It was used for many important community events. It was destroyed by fire in 1899. (Courtesy Carl Schurz High School.)

THE EIGHTH ANNUAL COMMENCEMENT

. . . OF THE . . .

Jefferson High School

Thursday, June 23, 1892

. 7.30 P. M.

IRVING HALL, IRVING PARK, CHICAGO.

DOORS OPEN AT 7 O'CLOCK P. M.

Carl Schurz High School, located at 3601 North Milwaukee Avenue, opened in 1910. Architect Dwight H. Perkins designed the school in the Prairie School style. The impressive building has a steeply pitched roof of orange clay tiles and features earth-toned brick walls and green copper trim. In 1979, it was designated a Chicago Landmark by the Commission on Chicago Landmarks, and in 2011, it was listed in the National Register of Historic Places. The school underwent an $11.2-million renovation in the mid-2000s. (Photograph by Wilfredo Cruz.)

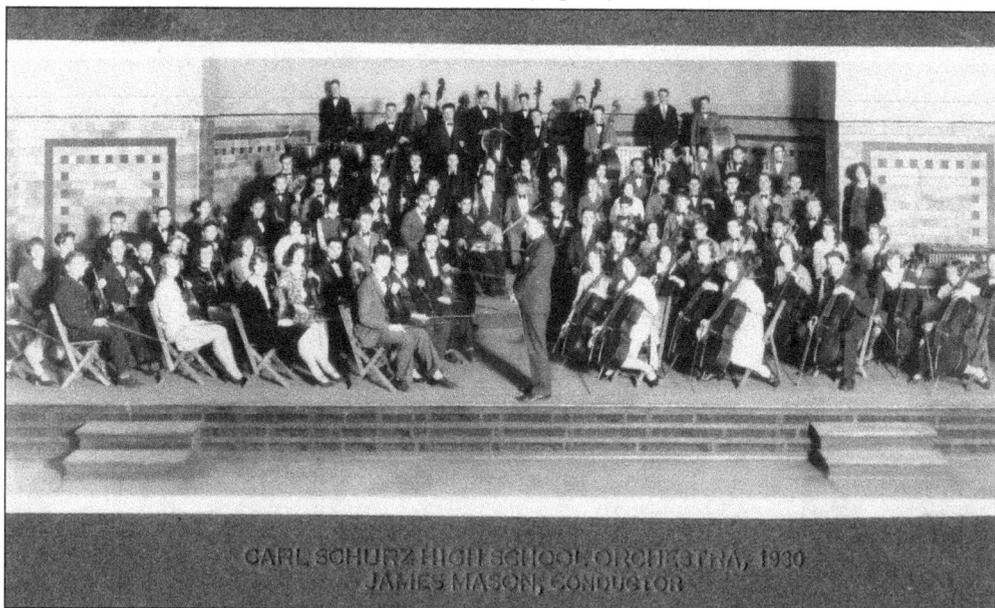

In 1910, James Mason organized the Carl Schurz High School orchestra, the first orchestra established in a Chicago public high school. Every year, the orchestra put on inspiring musical productions in the school's auditorium. Here, conductor Mason (front, center) poses with the orchestra in 1930. (Courtesy Carl Schurz High School.)

This collage shows Carl Schurz High School students in the Reserve Officer Training Corps (ROTC) program. The young men in military uniforms and their dates and escorts in evening dresses attend the ROTC ball in 1940. The United States entered World War II the following year, and many Carl Schurz students served in the military. The war claimed 150 of the school's students, the first casualty occurring at Pearl Harbor. (Courtesy Carl Schurz High School.)

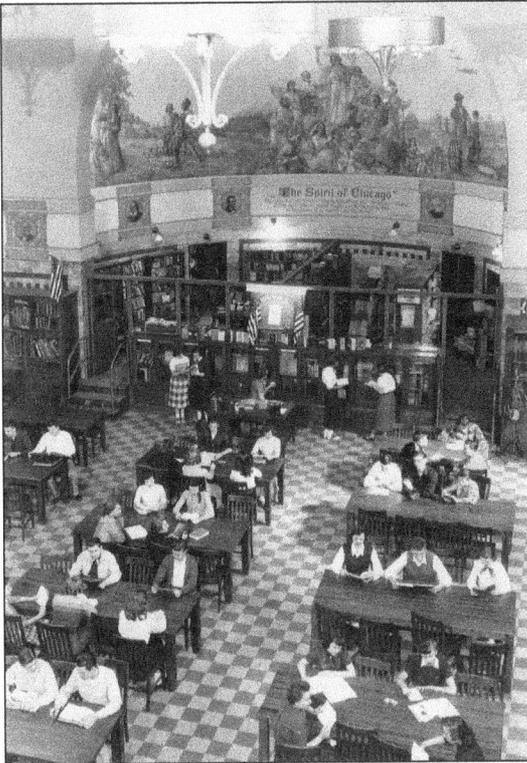

This is a mid-1950s view of the Carl Schurz High School library. In 1940, Gustave A. Brand, a German-born muralist, together with Carl Schurz art students, painted the large ceiling mural, *The Spirit of Chicago*. The mural tells Chicago's history from Native Americans to steel-mill workers. It also depicts themes in the history of writing. A frieze representing 27 famous men and women adorns the walls. (Courtesy Carl Schurz High School.)

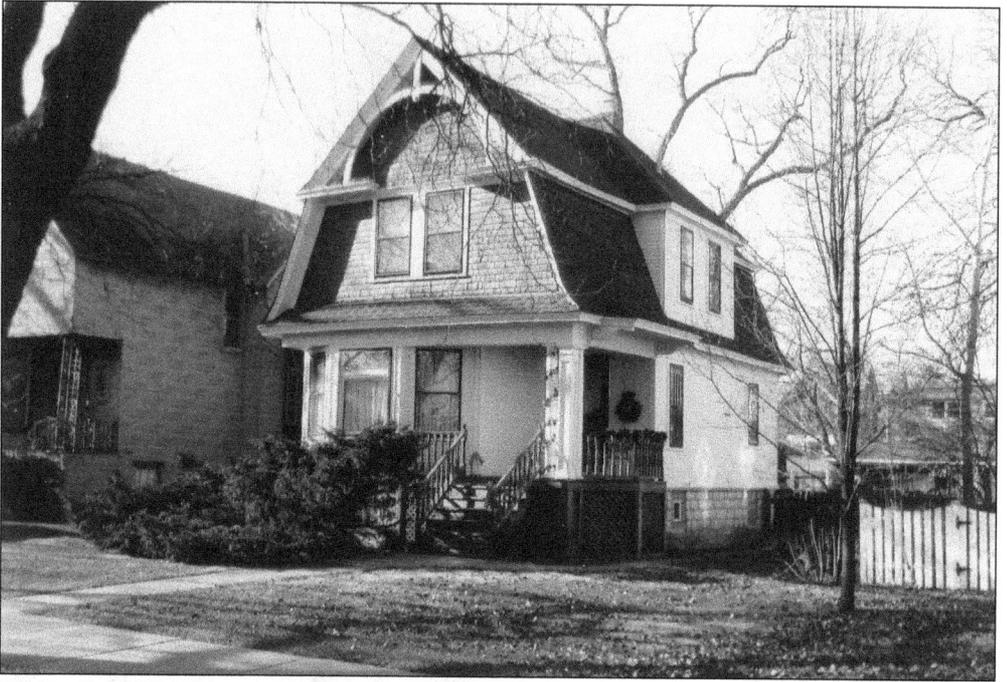

Dr. Frederick Plapp was an assistant principal and science teacher at Jefferson High School in 1883. When Carl Schurz High School opened in 1910, he became a science teacher there. Well-liked by his students, Plapp taught botany at the school for over 20 years. He lived many years in this farm-style house at 4146 North Keeler Avenue. (Photograph by Wilfredo Cruz.)

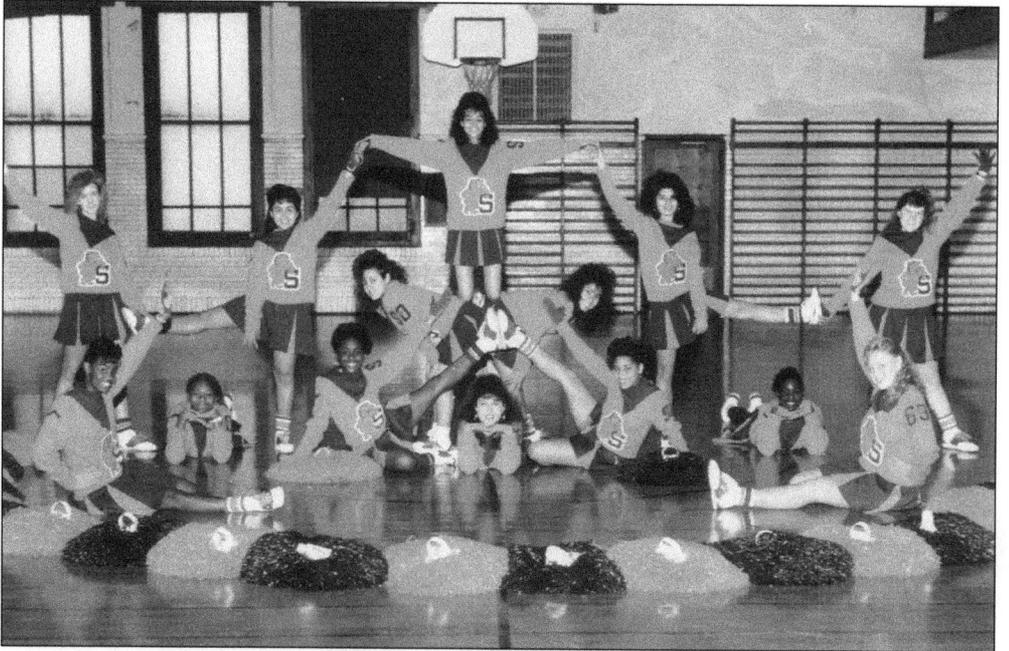

Shown here are Carl Schurz High School cheerleaders in the mid-1980s. Sports was an important part of student life at the school. The mascot for the school's sport teams is the bulldog. (Courtesy Carl Schurz High School.)

Six

BUILDING COMMUNITY

Like their predecessors, residents in Old Irving Park still work hard to create a good neighborhood. During summer months, families organize annual block parties where neighbors socialize, share homemade food, play games, listen to live music, and have a good time. The block parties foster a sense of inclusion and community.

The Old Irving Park Association (OIPA) tries to address issues of crime, traffic, and residential zoning. Members work closely with housing and business developers and meet often with the local alderman and even their US congressman.

The OIPA has scored some victories. For example, Irving Park School was closed for almost 10 years, supposedly due to declining enrollment. The Chicago Board of Education reopened the school in the mid-1980s, busing in students from distant, overcrowded schools. The OIPA pressured education officials to open enrollment at the school to many families with school-age children in Old Irving Park.

In the early 1990s, the OIPA worked with police to stop drug dealing from two apartment buildings and to curtail incidents of gang graffiti. Residents regularly attend the Chicago Police Department's monthly Community Alternative Policing Strategy (CAPS) meetings. Residents help police pinpoint any potential trouble spots.

Also in the early 1990s, Palumbo Brothers, a construction firm with lots of clout, planned to "temporarily" dump truckloads of construction concrete and debris in a neighborhood lot that became vacant when a warehouse was razed. The OIPA and residents vehemently opposed the plan. Residents signed petitions and voiced their opposition to elected officials and the media. The plan was stopped, and new homes were eventually built on the site.

During the last couple of years, the OIPA has worked with city officials on streetscape plans. Now, a stretch of Irving Park Road from Pulaski Road to Kolmar Avenue is spruced up with newly paved sidewalks and streets, fashionable light poles, concrete planters, wrought-iron benches, bike racks, trees, trash receptacles, and neighborhood signage on fancy concrete columns. An old-fashioned public clock—like those in small towns—was installed on Irving Park Road. The OIPA's motto is, "Because good neighborhoods don't just happen."

Moreover, the Irving Park Historical Society (IPHS) continues its housing preservation efforts. It assists in obtaining city landmark status for historic buildings. The society helped the Chicago Transit Authority place historic photographs and written history of Irving Park neighborhoods on plaques underneath the Irving Park Blue Line train station. The IPHS sponsored its 21st housewalk in September 2012.

Unfortunately, today's tough economy has hurt homeowners. Some families have lost their homes due to foreclosures, and the value of homes has greatly depreciated. Yet Old Irving Park has shown remarkable resiliency. Residents believe it is still a decent neighborhood with a promising future.

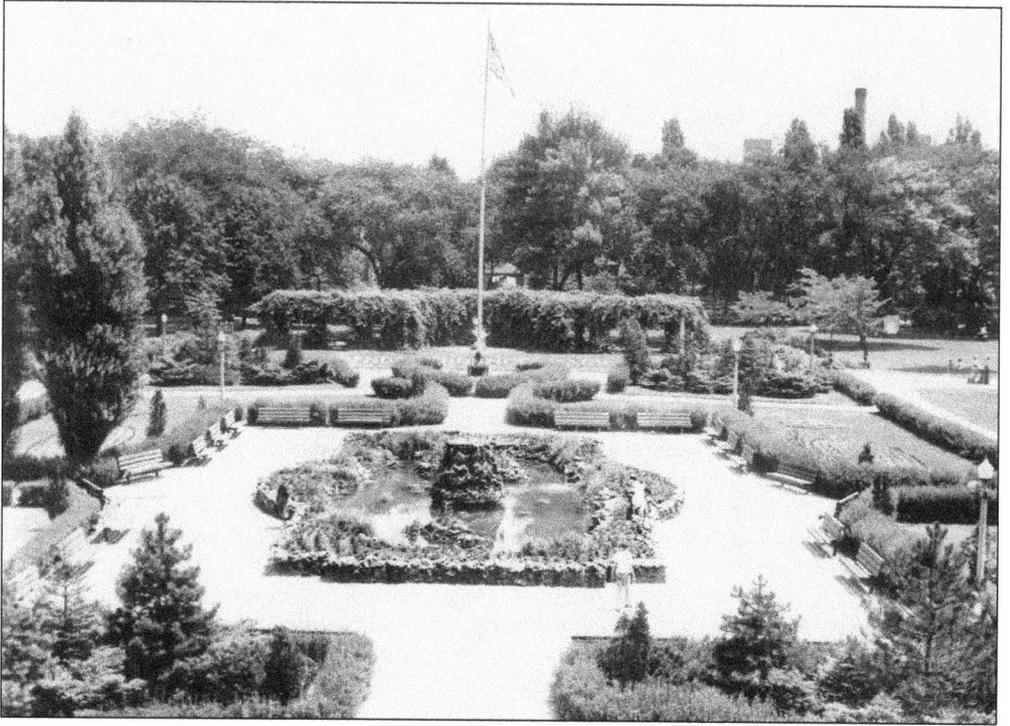

Old Irving Park does not have its own large public park. Residents traditionally use Independence Park to the east in the Independence Park neighborhood. Beginning in 1903, Irving Park residents, including more than 600 children, marched in annual Fourth of July parades proceeding along Irving Park Road to Springfield Avenue. On this site, Independence Park was created in 1910. Architect Clarence Hatzfeld designed the park's field house in the Prairie School style. The park, shown here in 1936, is listed in the National Register of Historic Places. (Courtesy Chicago Park District Special Collections.)

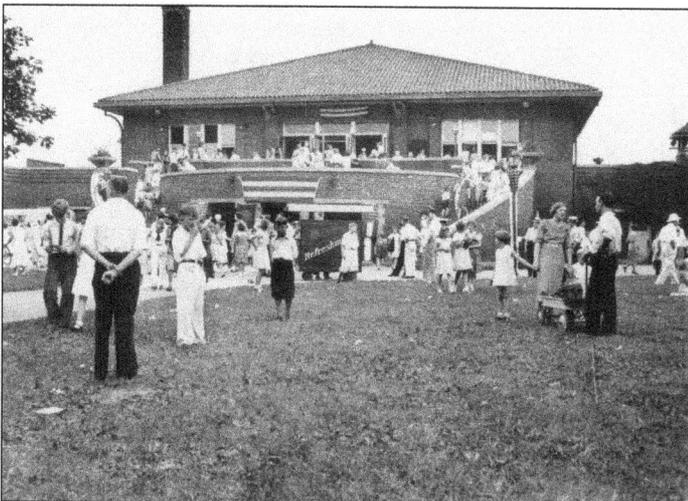

Old Irving Park residents regularly use Portage Park to the west in the Portage Park neighborhood. The park was established in 1913. Here, families enjoy a Fourth of July celebration in the park in 1935. The natatorium, shown here, was designed by architect Clarence Hatzfeld. The park is listed in the National Register of Historic Places. (Courtesy Chicago Park District Special Collections.)

Neighborhood children participate in a bike parade in the early 1950s. The parade was likely sponsored by staff from Portage Park. The riders, seen here in the 4900 block of West Irving Park Road, are headed east to Six Corners near Old Irving Park. (Courtesy Chicago Park District Special Collections.)

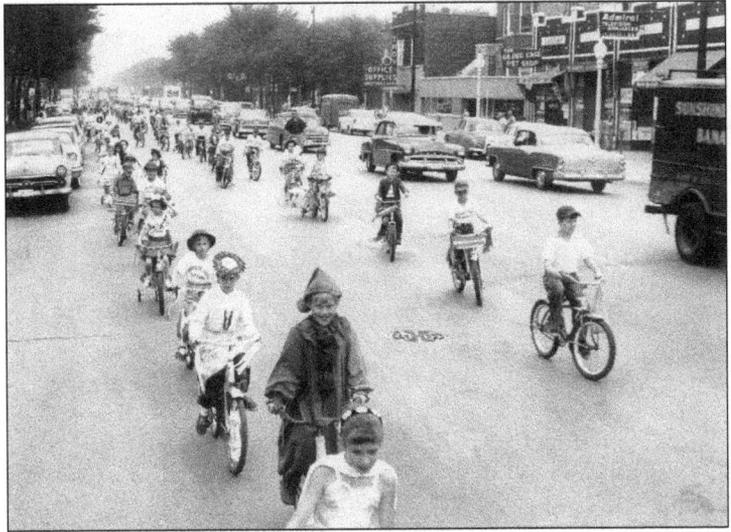

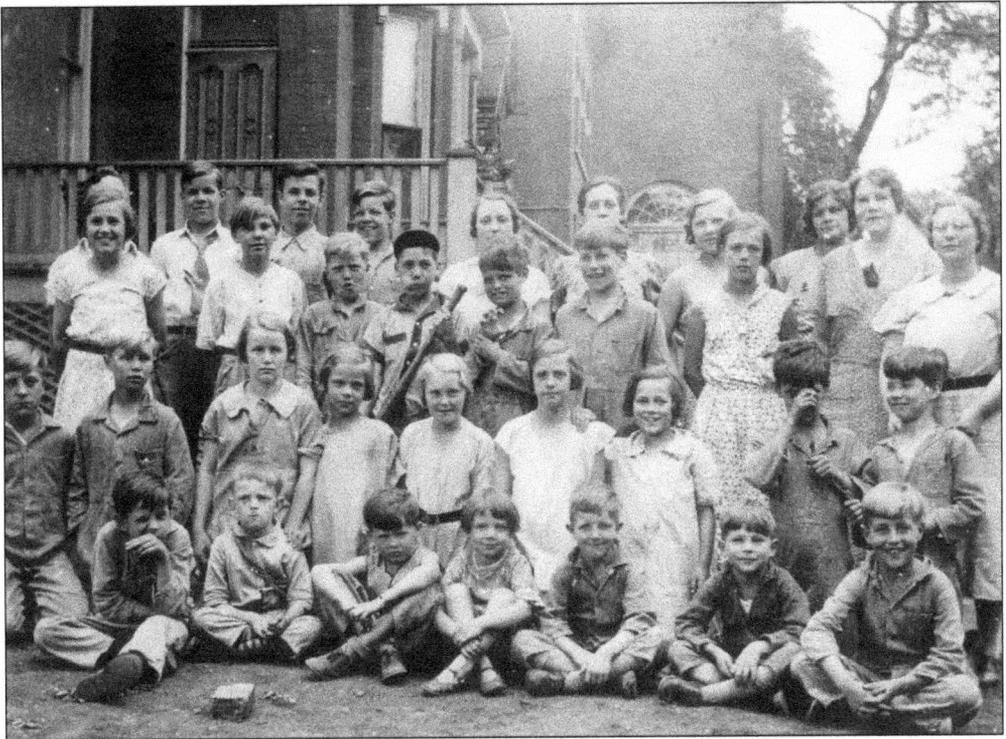

The Ladies' Aid Society of Salem Evangelical Church in Chicago founded Lydia Children's Home (LCH), an orphanage, in 1913. LCH purchased a building at 4300 West Irving Park Road in 1920. The building was formerly an early-1870s mansion built for John S. Brown, a founder of Irving Park. The Irving Park Country Club also used the mansion for special occasions. The building was razed in 1954, and LCH erected a new structure on the same site. Here, LCH children and staff pose for a photograph in 1934. (Courtesy Lydia Home Association.)

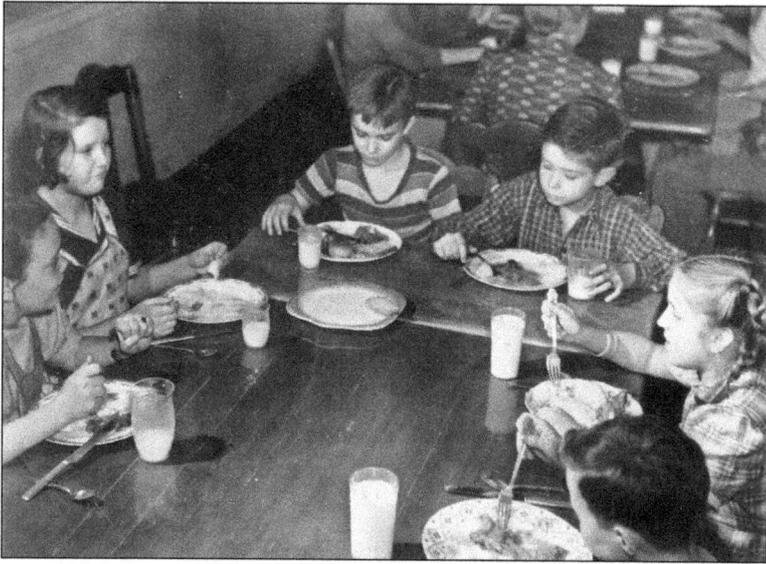

Boys and girls from the Lydia Children's Home are having dinner in the organization's cafeteria in 1938. The orphanage was located at 4300 West Irving Park Road. (Courtesy Lydia Home Association.)

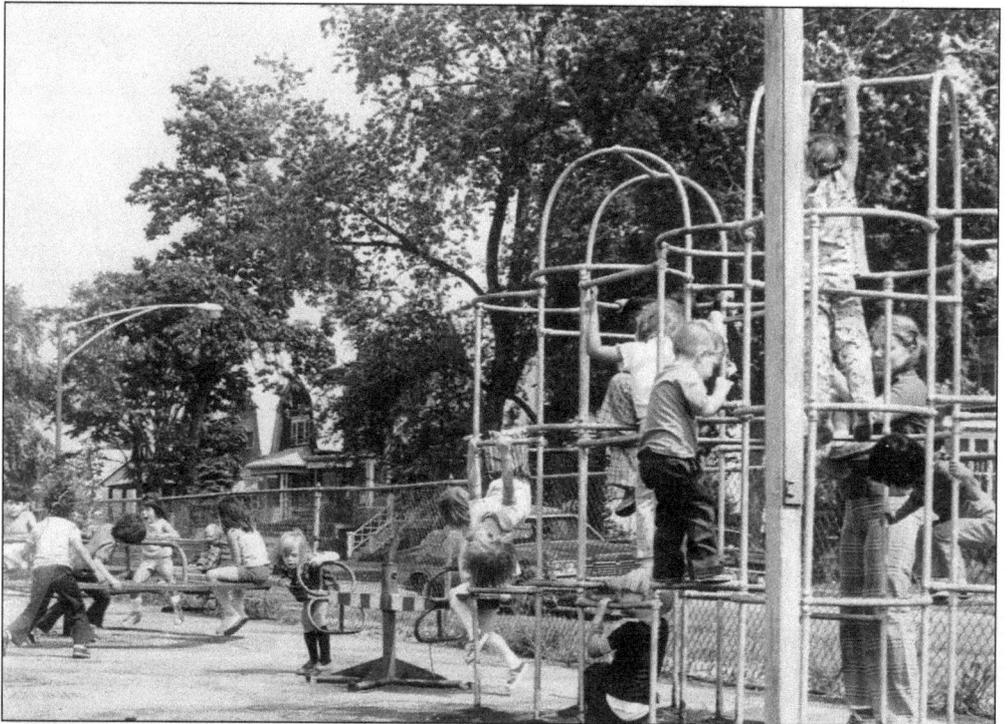

Children enjoy themselves at the playground of Lydia Children's Home (now Lydia Home Association) in the early 1960s. The agency is no longer an orphanage, but it still helps children from broken families. The agency's services include counseling, foster care placement, and short-term residential placement. Many children at the home are wards of the state. The Illinois Department of Children and Family Services places many youth with the agency. (Courtesy Lydia Home Association.)

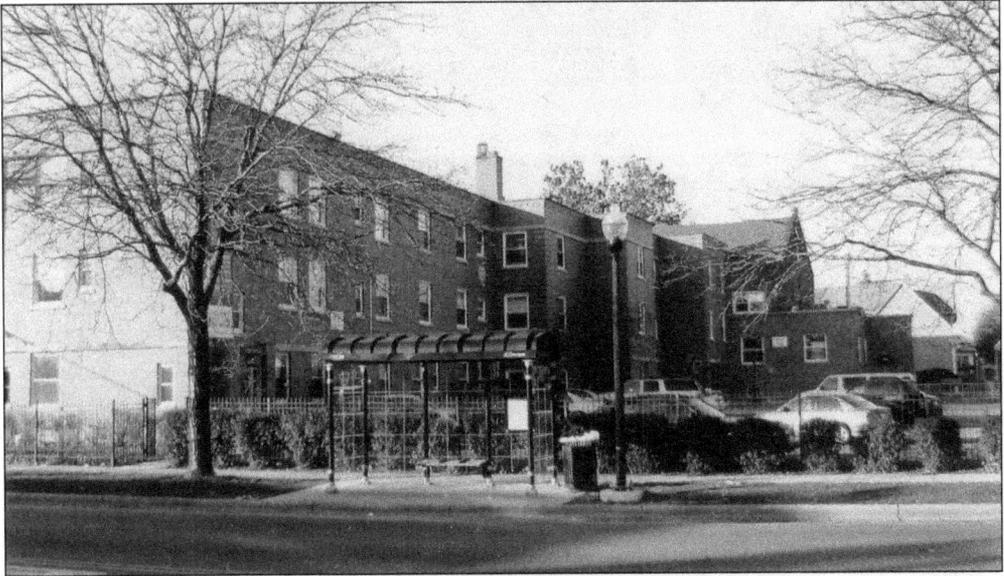

This is the building, parking lot, and playground area of Lydia Home Association, 4300 West Irving Park Road. The agency runs the Urban Academy–Chicago, an accredited alternative high school for troubled youth. (Photograph by Wilfredo Cruz.)

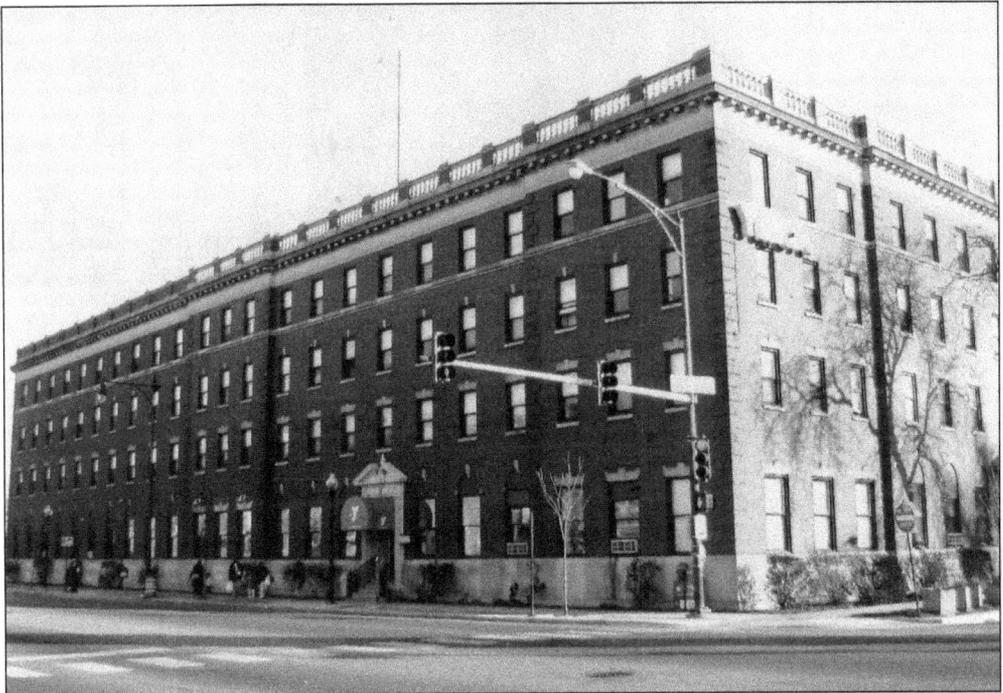

The Irving Park Young Men's Christian Association (YMCA), 4251 West Irving Park Road, was built in 1925. It serves families with diverse recreational and educational programs. From 1962 to 1971, the Chicago Bears used the YMCA for rigorous off-season strength conditioning. It is believed that the players' preparation at the YMCA helped the team win the 1963 NFL championship. The weight room, called the Bears Den, contains vintage photographs of well-known Chicago Bears players. (Photograph by Wilfredo Cruz.)

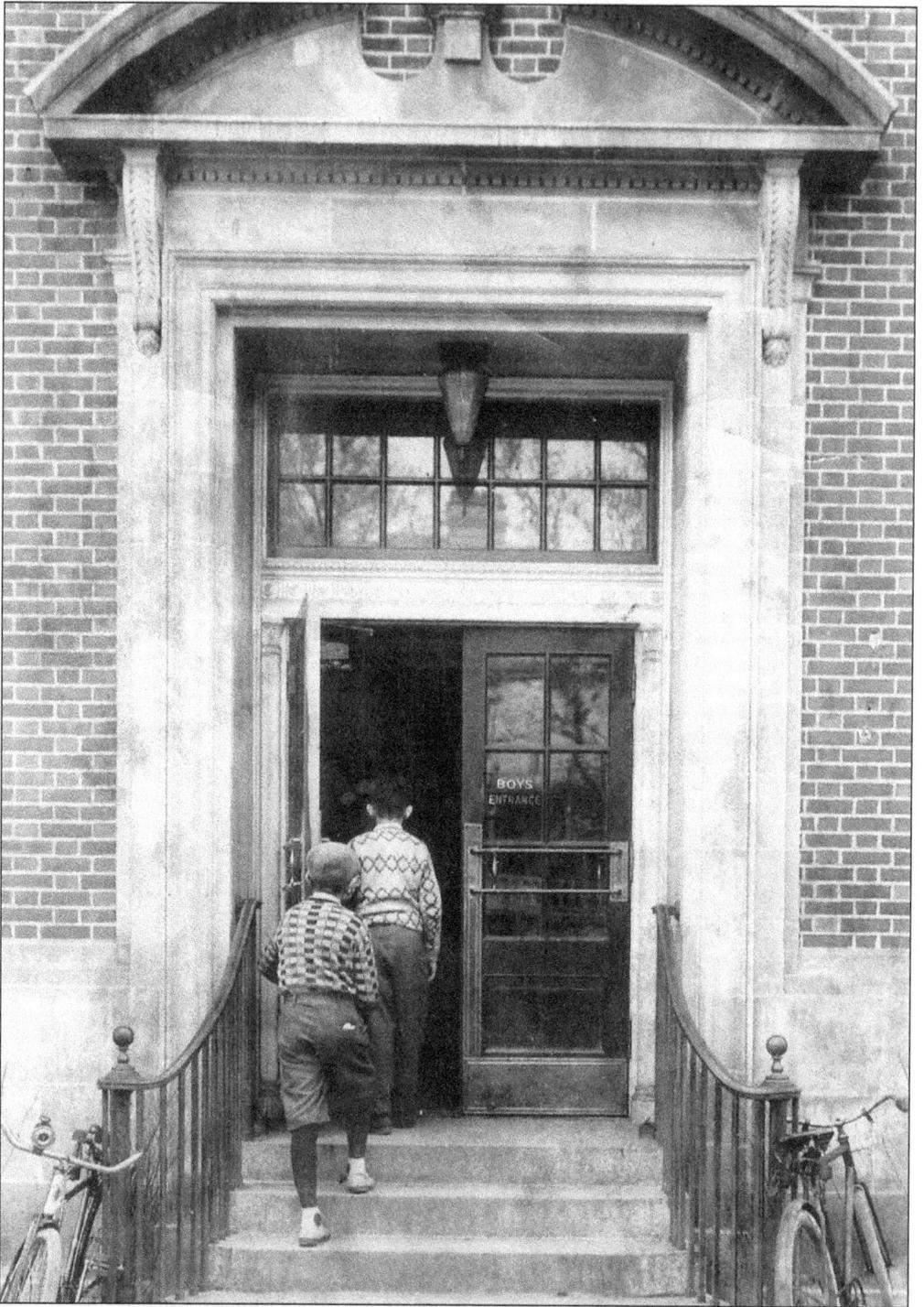

Two boys enter the Irving Park YMCA for the first time in 1926. They are walking through the Boy's Entrance on North Kildare Avenue, which is no longer used. By 1936, most YMCAs began accepting girls and women as members. (Courtesy Irving Park YMCA.)

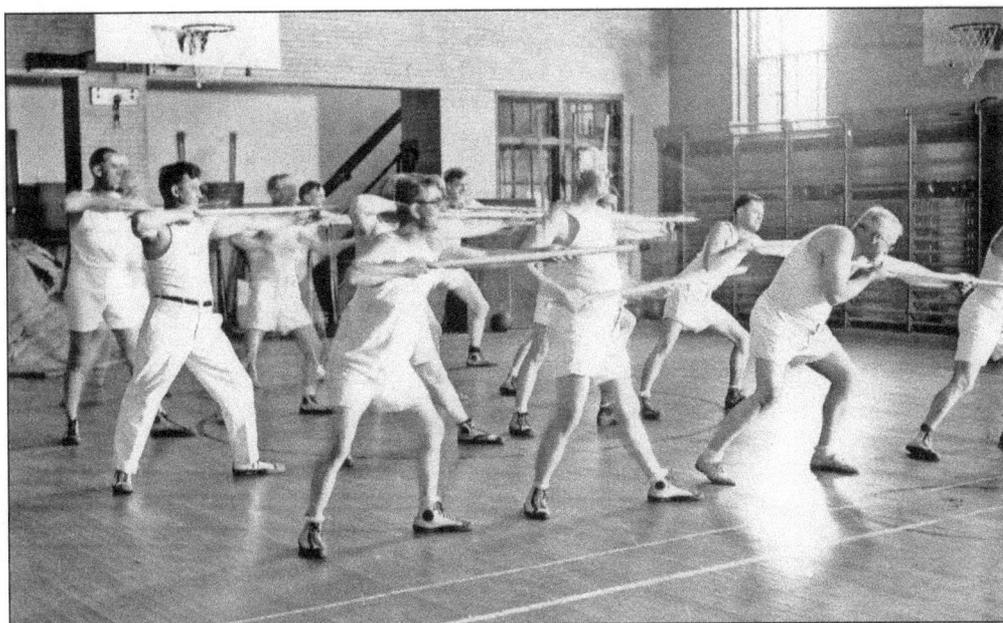

Here, preachers wearing athletic clothing and holding wooden poles perform exercises. They are part of a gym class exercising in the gymnasium at the Irving Park YMCA in 1929. Most of the men are wearing athletic shoes and light-colored shorts and tank-tops. (Courtesy Chicago History Museum.)

Alexandra and Daniel Cruz, seven-year-old twins, enter the Irving Park YMCA in 1989. They are carrying their pillows and sleeping bags as they prepare to join other YMCA children for two weeks of summer camp in Michigan. The Cruz kids were a little nervous, as this was their first time away from home. The YMCA now refers to itself simply as the Y. (Courtesy Irma Cruz.)

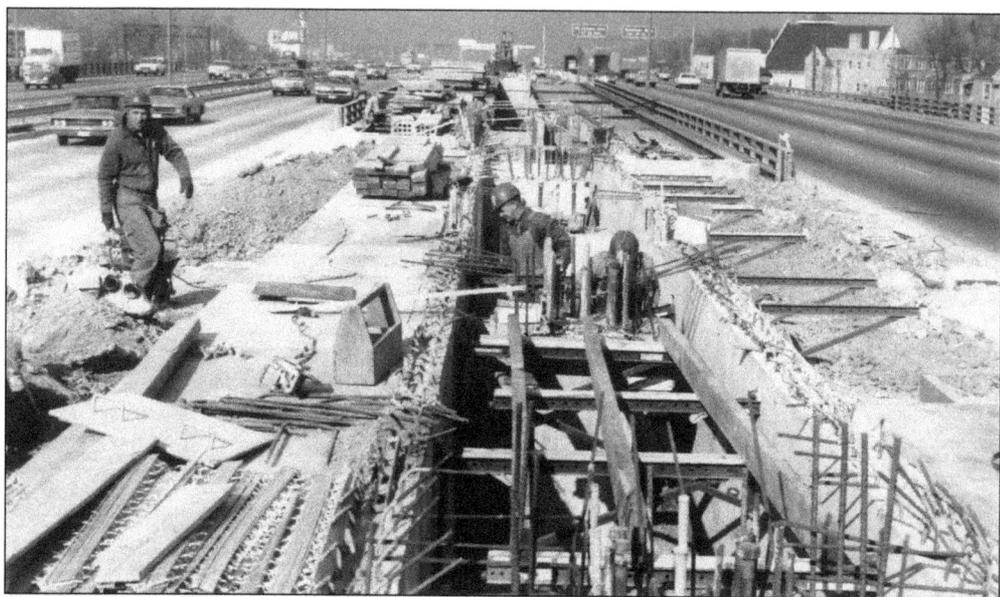

In this 1969 photograph, workers are constructing the Chicago Transportation Authority Irving Park Blue Line train station. The rapid-transit Blue Line went into service in the median strip of the Kennedy Expressway in early 1970. The Blue Line made transportation to O'Hare Airport, downtown Chicago, and other parts of the city quick and convenient. (Courtesy Chicago Transportation Authority.)

Bhashkar Mazumder stands with his wife, Jeanne, son, Carl, and daughter, Maya, in front of their home on North Kilbourn Avenue. The family was enjoying the 2012 block party of the 4000 and 4100 blocks of North Kilbourn Avenue. Bhashkar is a senior economist for the Federal Reserve Bank of Chicago, and Jeanne is a part-time teacher of English as a second language. (Photograph by Wilfredo Cruz.)

Residents of the 4000 and 4100 blocks of North Kilbourn Avenue come together for a group photograph. The neighbors were celebrating their eighth annual block party in August 2010. The lead organizer of the all-day party was Kiki Schotanus (back row, far left, waving peace signs). Families shared food, drinks, pastries, games, and live music. Neighborhood businesses donated food and prizes, and residents participated in a raffle. (Courtesy Brian Grossman.)

Enjoying dinner in front of Beckie Cornelison's home in the 4100 block of North Kilbourn Avenue are, from left to right, Dr. Robert Harris, Cornelison, Vikkie Tucker, and Winnie Chartrand. They were participating in the 2012 block party of the 4000 and 4100 blocks of North Kilbourn Avenue. Cornelison is a music teacher for the Chicago public schools. Her son James plays guitar and studies jazz and business at the University of Michigan. (Photograph by Wilfredo Cruz.)

Maher Harb and his wife, Hala, pose with their children, Tommy (left), Leena (center), and David, in front of their home in the 4100 block of North Kilbourn Avenue. They are sporting shirts highlighting the 2012 block party of the 4000 and 4100 blocks of North Kilbourn Avenue. Maher is vice president of RMB Capital Management, and Hala is a homemaker. (Photograph by Wilfredo Cruz.)

In 1984, neighborhood volunteers established the Irving Park Community Food Pantry. The panty operates out of the Irving Park United Methodist Church, 3801 North Keeler Avenue. Each week, the panty gives food to needy residents. Here, in the summer of 2012, a line of people waits to receive bags of food. Due to the recession that began in 2007, many more people come to the pantry seeking food. (Photograph by Wilfredo Cruz.)

Charles Roy stands with his daughter Amber as they hold a yard sale next to his mother's house in the 3600 block of North Pulaski Road in 2012. Roy rents an apartment in a two-flat building in the 3700 block of North Kostner Avenue. He works in accounting, and his wife, Jolene, administers grants for the Chicago public schools. Amber proudly explains that her nationality is Ojibway, Paiute, and Shonnie. She is a student at Disney II Magnet School. (Photograph by Wilfredo Cruz.)

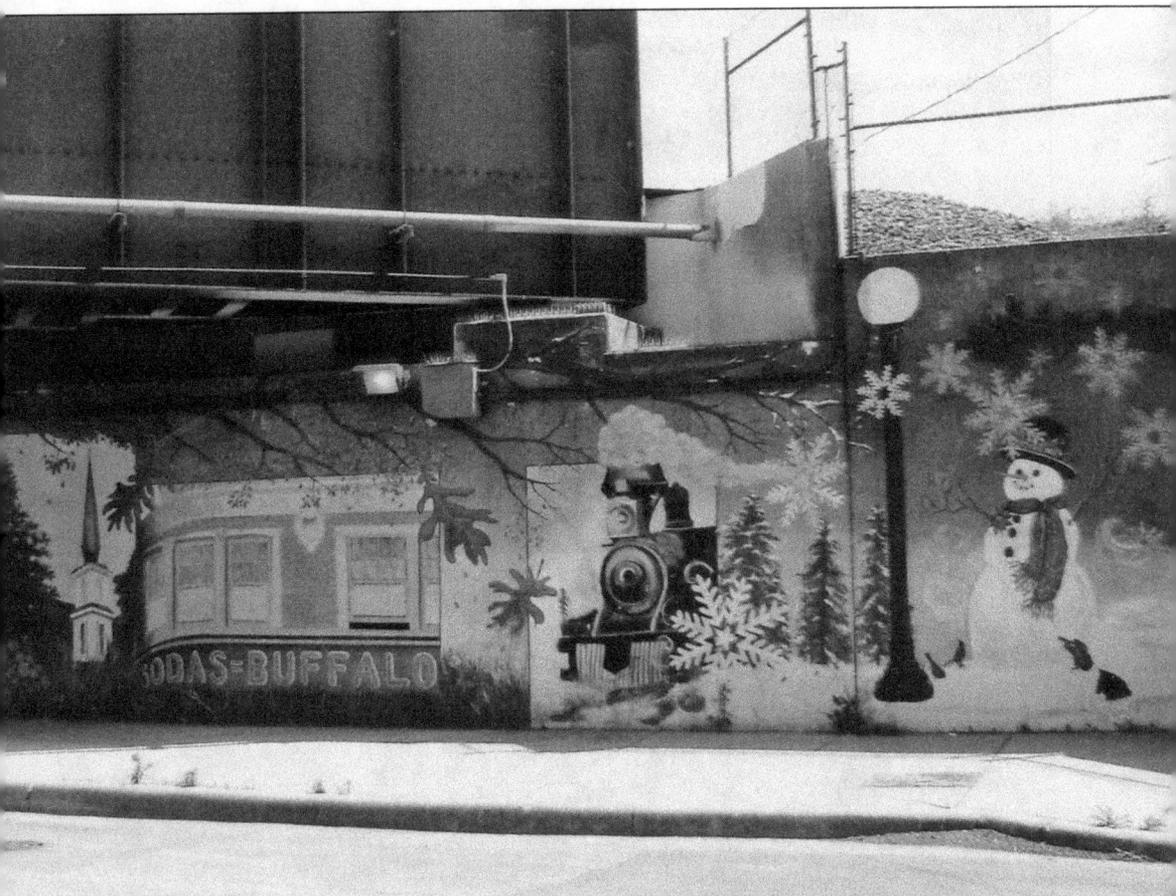

In 2004, the Old Irving Park Association (OIPA), together with neighborhood children, painted a colorful mural on both sides of a railroad viaduct at Kostner and Berteau Avenues. The mural, part of which is shown here, celebrates the neighborhood's history and architecture. The mural's other side quotes Carl Sandburg (son of Swedish immigrants): "Nothing happens unless first we dream." This is one of nine neighborhood murals painted on viaducts sponsored by the OIPA, often in conjunction with other groups. (Photograph by Wilfredo Cruz.)

Heidi Bronowska, 87 (left), and Magdalena Guagliardo, 92, are longtime neighbors in the 4300 block of North Lowell Avenue. They both own brick bungalows, each has a daughter, and each has lived over 45 years in Old Irving Park. Bronowska worked for over 30 years as a loan officer for Liberty Bank for Savings. She speaks fluent English, German, Polish, and Russian. Guagliardo worked for over 30 years as a seamstress for Hart Schaffner & Marx. She speaks English and Italian. (Courtesy Heidi Bronowska.)

Samuel Cordon is shown with his wife, Karol, sons Josue (right) and David, and newborn daughter, Emma. The family is enjoying the festivities at the August 2012 "Rock the Lot" fundraiser for St. Viator School. The family lives in a two-story brownstone building owned by Karol's grandmother in the 4000 block of North Pulaski Road. Samuel works for Clear Channel Communications, and Karol is a registered nurse. (Photograph by Wilfredo Cruz.)

Irving Park Historical Society members attend an August 2012 presentation of the Irving Park YMCA. In the 1930s, it was considered fashionable to live at the YMCA, where nicely furnished rooms rented for $6 a week. At the time, YMCA residents enjoyed daily hot meals served in a fancy dining room, and they had access to a fitness center and a spacious lounge. (Photograph by Wilfredo Cruz.)

Families and children come together in the summer of 2012 to enjoy ice cream and cold drinks. This ice-cream social took place at the Irving Park Baptist Church. The annual summer event is sponsored by the Old Irving Park Association. (Photograph by Wilfredo Cruz.)

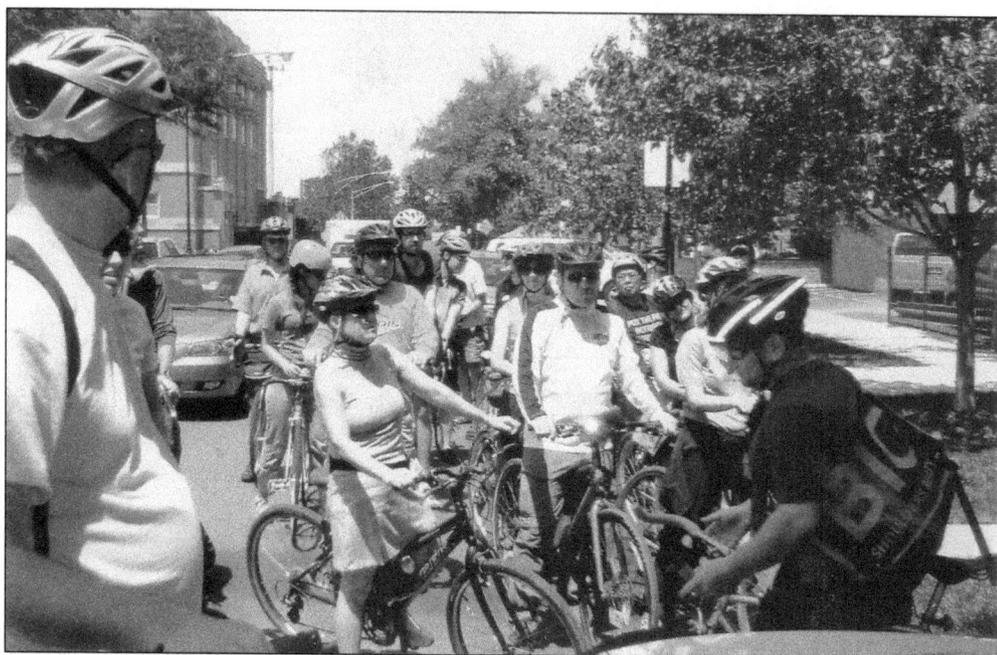

Lee Diamond (right) leads a June 2012 bicycle tour of Chicago's north side. The group came from Evanston, Illinois. A highlight of the group's tour is a visit to Old Irving Park. Here, the group learns about the historical significance of the landmark Stephen A. Race House at Irving Park Road and Tripp Avenue. The group grabbed lunch from a nearby food truck and then visited other historic homes in the neighborhood. (Photograph by Wilfredo Cruz.)

Irving Park Garden Club members sell homemade baked goods and jam at the September 2012 housewalk of Old Irving Park, sponsored by the Irving Park Historical Society. Shown here are, from left to right, Karen Wehrle, Mary Lou Agronomoff, Maureen Taylor (president), and Carol Szalacha. (Photograph by Wilfredo Cruz.)

The Irving Park Garden Club created this garden at 4001 North Tripp Avenue in 1993. The garden, which contains over 500 perennials planted in two beds, is maintained solely by club members. It is one of numerous neighborhood gardens cared for by club members. (Photograph by Wilfredo Cruz.)

George Badillo, his wife, Suzanne, son, Jackson, newborn daughter, Lexi, and dog, Cassius, pose on the steps of their home at 4317 North Kenneth Avenue. The home was built in 1897. The family has lived in Old Irving Park for nine years. George is assistant director of finance at Northwestern University, and Suzanne is a program director at the Rehabilitation Institute of Chicago. (Photograph by Wilfredo Cruz.)

Residents unveiled a granite memorial in the 3900 block of North Kenneth Avenue. The names of 51 individuals who once lived on the block are etched onto the memorial, which was blessed by a local pastor. Here, in October 2012, relatives of deceased family members gather in front of the memorial. A few residents on the block own homes that formerly belonged to their parents and relatives. (Photograph by Wilfredo Cruz.)

Betsy Lozano has lived in Old Irving Park for over 33 years. She is seen here with her children in front of her home at 3655 North Tripp Avenue. Shown here are, from left to right, Danny, Kristie, Besty, and Marcus. Lozano runs a licensed day care and is a deacon at New Life Covenant Church in the Humboldt Park neighborhood. (Photograph by Wilfredo Cruz.)

Some board members of the Irving Park Historical Society gather for its February 2013 board of directors meeting. Shown here are, from left to right, (first row) Laura Marie Sanchez, Sharon Graham, and Richard Lang; (second row) Matthew Krecun, Sandra Gidley, James Natoli (president), and Kate Meints. (Photograph by Wilfredo Cruz.)

Charles Johnson has been a mailman in Old Irving Park for 21 years. He is seen here in the 4000 block of North Kolmar Avenue in August 2012. Well-liked by residents, Johnson is regularly invited to summer neighborhood block parties. Johnson, who enjoys chatting with residents, says he hopes to retire in another five years. He lives with his family in Forest Park, Illinois. (Photograph by Wilfredo Cruz.)

123

Some board members of the Old Irving Park Association gather at their December 2012 holiday party at the Irving Park Baptist Church. Shown here are, from left to right, Anna Zolkowski Sobor, Lynn Ankney, Marlena Ascher (president), Howard Silver, Missy Goldberg, Bart Goldberg, and Tony McHale. Families at the party enjoyed a delicious Italian dinner donated by La Villa, an Italian neighborhood restaurant. Residents also donated Christmas toys for needy children. (Photograph by Wilfredo Cruz.)

Patti Melzer stands in her large backyard garden at 3615 North Tripp Avenue. The unique garden features a large fish pond, vegetable beds, a wide range of plants and flowers, and patios and walkways made of old Chicago brick. Her garden was certified as a natural wildlife preserve by the National Wildlife Foundation. An unidentified elderly woman, visible in the background, sits and enjoys the garden. (Photograph by Wilfredo Cruz.)

Shown here are Jaime Guerrero, his wife, Clara, mother-in-law, Maria Badillo, son, Julian (the taller boy, center), and nephew, Jackson. They are pictured in August 2012 in front of their home at 4121 West Grace Street. Jaime, a digital account director at Ogilvy One Worldwide, is also a personal chef. Clara is a homemaker. Julian attends kindergarten at St. Viator School. (Photograph by Wilfredo Cruz.)

Posing on the steps of their home at 4055 North Kilbourn Avenue are Frank Quinn (right), his wife, Maureen (second from right), and their son, Rory. Also pictured is their niece, Grainne. Frank is a carpenter and housing inspector for the City of Chicago, and Maureen is a nurse. Rory attends Chicago-Kent College of Law, and Grainne is a college student visiting from Ireland. The uncle of television personality Pat Sajak (host of *Wheel of Fortune*) lived in this house for many years. (Photograph by Wilfredo Cruz.)

George Sanabria and Adriana Spada, engaged to be married, purchased a home in the 4300 block of North Kostner Avenue in July 2012. They have made extensive renovations to their home, including a new kitchen, shown here. Sanabria is a supervisor for Commonwealth Edison, and Spada is an emergency management coordinator for the City of Chicago. (Photograph by Wilfredo Cruz.)

Neighborhood parents play baseball with their boys and girls on a nippy Saturday morning in June 2012. The parents and children are at the Kolmar Playlot, located in the 4100 block of North Kolmar Avenue. The quiet lot is part of the Chicago Park District. In the background is Le Parisien Bakery, 4140 North Kolmar Avenue, and its two white trucks. The small bakery sells croissants to Chicago-area restaurants. (Photograph by Wilfredo Cruz.)

Officers Tim Hunt (left) and Chris Andersen work with the mounted patrol unit of the Chicago Police Department. In this photograph, they are dropping in on the September 2012 block party in the 3700 block of North Kostner Avenue. They talked to children about their job duties and allowed the kids to pat their horses. (Photograph by Wilfredo Cruz.)

Visit us at
arcadiapublishing.com

www.ingramcontent.com/pod-product-compliance
Lightning Source LLC
Chambersburg PA
CBHW050710110426
42813CB00007B/2146